F V

WITHDRAWN

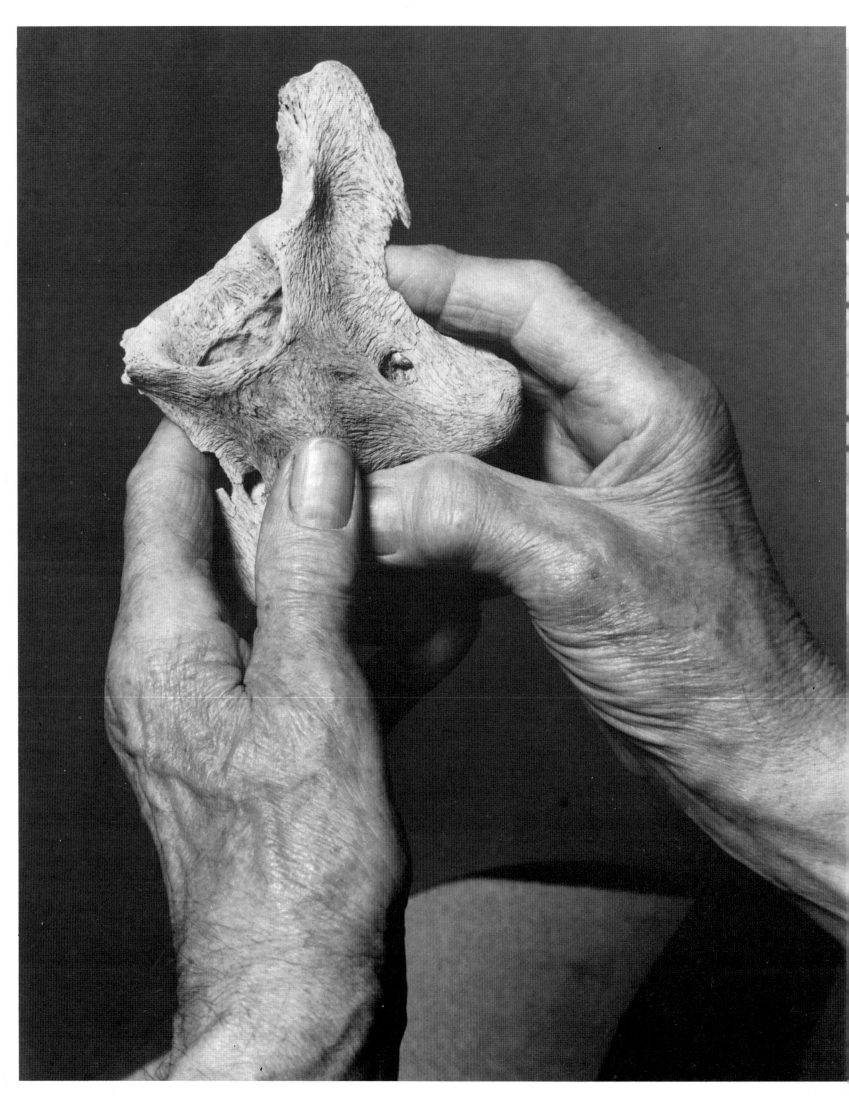

Complete Sculpture
Volume 6
Sculpture 1980–86

Henry Moore

Edited by Alan Bowness

London

Lund Humphries

Copyright © 1988 Lund Humphries Publishers Ltd

First published 1988

Published by
Lund Humphries Publishers Ltd
16 Pembridge Road London W11

British Library Cataloguing
in Publication Data
Moore Henry, *1898-1986*
Henry Moore: complete sculpture.
Vol. 6: Sculpture,
1. Moore, Henry, *1898–1986*
I. Title II. Bowness, Alan
730'. 92'4 NB497 .M6
ISBN 0 85331 524 8

Designed by Herbert Spencer

Made and printed in Great Britain by
Lund Humphries, Bradford

Frontispiece:
Henry Moore's hands, 1985

CONTENTS

Acknowledgements

This is the sixth and final volume in the sequence, *Henry Moore: Complete Sculpture,* published by Lund Humphries. It catalogues and illustrates all sculptures made by Henry Moore between 1980 and 1986. It also includes in an addenda section in the catalogue certain pieces from the periods covered by volumes 4 and 5 which have not been previously documented and some of these have also been illustrated in the plate section.

All important works are shown in the plate section, often from several viewpoints and in detail. The layout and design of the book is the work of Herbert Spencer; John Taylor and Charlotte Burri have been active in its preparation.

The editor is particularly grateful to David Mitchinson of The Henry Moore Foundation for his invaluable help in selecting and providing photographs, information and every kind of documentary material.

The sculptures catalogued in this sixth Lund Humphries volume date from between early 1980 and 1985: 135 works created by an artist in his eighties, who had made more than 900 sculptures in a long and distinguished career. It was a time for completing things, and for this reason we have included in a preliminary section a substantial selection of the sculptures (plates 1–33) which were actually made during this period, but which were conceived during the previous decade. In a variant form – maquette, working model, smaller bronze – they are catalogued in volumes 4 and 5 of the *Complete Sculpture.* Some earlier sculptures also found their final forms in the 1980s: for example, the 1938 lead *Reclining Figure* (192) was realised on a monumental scale as a result of a commission from the architect, I.M. Pei. This will be included in the revised edition of Volume 1, now in preparation.

In certain cases the artist had second thoughts. He took up the idea of the totemic upright motive again in the late 1970s, and made three standing figures which have a most arresting and disturbing presence. The maquette was cast in bronze in 1977 (715) and then work began on an over life-size version in a strangely pitted travertine marble. For a time the three figures stood uneasily in the garden at Much Hadham but then one disappeared to leave the pair that are recorded in this volume (715a) in plates 29 and 30.

Occasionally a bronze maquette has been realised in stone, or the increase of scale has led to a rethinking of the essential nature of the piece. One of Moore's greatest sculptures *Three Vertebrae* (580) was doubled in size to become the *Three Form Vertebrae* (580a) of 1978–9. The most notable transformation has been of *Helmet Head No. 7,* a small maquette of 1975 (651) with an interior form which caught the artist's imagination. This became the *Stone Form* (652b) of 1984 and eventually the monumental *Figure in a Shelter* (652c) that has only recently been completed.

Moore's last important stone carving was the over life-size version of *Mother and Child: Hood* of 1983 (851). In its working-model form this is perhaps the finest of the late bronzes: a perfectly controlled sequence of sculptural forms in which any literalness of expression is absorbed into the idea. In his final years, Moore as a sculptor was preoccupied with the mother and child relationship, more than any other, and it led him to a series of sculptural statements that vary considerably and show more invention and innovation than do the reclining figures of this period.

Obviously the notion of shelter and containment is at the heart of the mother and child sculptures. In the *Draped Reclining Mother and Baby* of 1983 (822) the mother's body is extended like a range of hills, into the hollows of which the child can shelter. The baby in this sculpture, and in the seated *Mother and Child: Curved* (792), is treated with great delicacy and formal restraint, as if Moore's tenderness

prevented his abstracting further. As with the reclining mother's hand, one finds that curious mixture of the more naturalistic and the more formal that still challenges us in such earlier works as the *King and Queen* (350). This is also apparent in the arm and hand of the mother in the *Mother and Child: Block Seat* (838), the most aggressive and disturbing of the large mother and child sculptures, in which the child becomes even more of a cipher than it is in the *Mother and Child: Hood.* It is hard to like some of the features of this work: similarly the final cast of the woman's legs in *Mother and Child: Curved* presents a challenge to the viewer. One should remember that Moore never sought the easy way out, and was always ready to disturb the spectator in his rejectipn of the harmonious. Right until the very end this remained a characteristic of his sculpture.

The reclining women of the final years do not break new ground in the way of the mothers and children. *Reclining Figure: Circle* (903) is a very pure form, with the strong rhythmic impulses that carry one into a fuller understanding of the nature of three-dimensional form. *Reclining Figure: Umbilicus* (907) has an intrinsic suggestion of great size: but at this stage Moore no longer wished to work on the monumental scale – the enlargement of the 1938 *Reclining Figure* was the last time that he could be persuaded to embark on such an operation. As with many imaginative drawings of the 1980s he was happy to envisage the work on a grander scale, recognising that he did not have the requisite energy to make it.

As has often been said, it is in the small maquettes that we see the artist's imagination most vividly at work. The transformation of a natural object – a shell or rock for example – into a sculpture is sometimes achieved very directly: Moore is always looking to nature for inspiration. This is of course one of the strengths of his work, because the resulting sculpture is a concretion, to use a word that Moore himself employed on a number of occasions. There are new subjects among the maquettes, even at this late stage, expressed in new forms: the *Reclining Man and Woman* (825), or *Three Figures* (853) or the *Mother with Twins* (873) for example.

A word of explanation about the later of these works. Throughout this catalogue the date given of a bronze is that when the casting was completed, and the work approved by the artist himself. Many of the maquettes existed in plaster form at an earlier date: they can sometimes be seen in photographs of the maquette studios. As his career neared its end, the artist decided to preserve the best of the maquettes in bronze, and sometimes there was a final spell of working on the plaster maquette before the decision was reached. Many of the newly catalogued maquettes were begun in the 1970s, or even earlier, but took their final form only at the date given, so in certain respects these late years were not as prolific as they may seem to be.

Another point: titles should not be taken too seriously. Moore's is a very unliterary art, and only rarely is the title more than a convenient label to distinguish one work from another. Some easily distinguishable feature is picked upon and used as a sub-title – pea-pod, cyclops, rock, circle, umbilicus. A certain flippancy occasionally creeps in: it is usually best to disregard the title as one looks for the meaning of the work. And that meaning exists in the form, and not in whatever words we may use to describe it.

Unlike the earlier volumes in this Lund Humphries series the photographs of the sculptures have not been selected by the artist himself. At the time of his 85th birthday, on 30 July 1983, the artist was extremely ill, and unfortunately never recovered his health completely. The last three years of his life, until his death on 31 August 1986, were a gentle coda. Certain works were in progress at the time of his illness: these were completed and cast to the artist's approval, but no new sculpture was undertaken.

Moore was fortunate to have lived long enough to be able to feel that he had completed his life's work, and there was no more that he wished to say. For those who had known him as a man of great energy and vitality, there was sometimes a sadness about these last years. Cared for by his devoted wife, Irina, herself in uncertain health, and by the faithful circle of assistants and helpers at Much Hadham, Moore lived quietly. There were occasional excursions to London, usually to see an exhibition or a much-loved museum: more regular was the afternoon drive. Increasingly, Moore took pleasure in simple things: a tree, an animal, a child's gesture. Indeed one could sometimes see that reversion to the child's view of life that often accompanies great age: a completing of the circle, a rounding off of things, that carries with it a certain satisfaction that the good work has been done.

Moore's sculpture always centred on a very limited number of subjects, to which he has returned again and again with new formal innovation. His art is one of durability, permanence: a statement about the eternal relationship of man to man, and of man to the natural environment in which we live. Fundamental is the image of woman, as regenerator, providing the continuity of human existence. Moore's sculpture is witness to this essential fact: no man has paid such a tribute, and it is one that will endure as long as life itself.

Henry Moore was born at Castleford, Yorkshire, in 1898. He studied at the Leeds School of Art, 1919–21, and at the Royal College of Art, London, 1921–5. In 1925 he spent six months in Italy, and from 1923 until 1939 made more or less annual visits to Paris. He taught part-time at the Royal College of Art, 1925–32, and then at Chelsea School of Art, 1932–9. During this time he showed his work at six one-man and many group exhibitions. In 1940 when his London studio was damaged by bombing he moved to the house at Much Hadham, Hertfordshire, where he died in 1986. He married Irina Radetzky in 1929; their daughter Mary was born in 1946. He had a one-man retrospective exhibition at the Museum of Modern Art, New York, in 1946, and in 1948 was awarded the International Sculpture prize at the Venice Biennale. In 1967 he made a major donation of sculpture to the Tate Gallery in London, in the following year there was a major exhibition at the Tate on the occasion of his 70th birthday, and a major exhibition at the Forte di Belvedere, Florence in 1972 was attended by over 350,000 people. In 1977 he formed The Henry Moore Foundation and in 1978 he made a further major donation of sculpture to the Tate Gallery. In the same year there were 80th birthday exhibitions at the Serpentine Gallery in Kensington Gardens, London, and the City Art Gallery, Bradford. His many degrees and decorations included the Companion of Honour in 1955 and the Order of Merit in 1963. Fuller biographies of the period up to 1980 will be found in the earlier volumes of this series.

1980 Donation of *Large Arch* to the Department of the Environment for permanent siting in Kensington Gardens

Presented the bronze Working Model for *Draped Reclining Figure* 1976–9 to Castleford where it was placed outside the Civic Hall

Presented by Chancellor Schmidt with the Grand Cross of the Order of Merit of the Federal German Republic

1981 Elected Full Member of Academie Européenne des Sciences des Arts et des Lettres, Paris

Created Honorary Freeman of the City of Leeds

1982 Created Honorary Freeman of the City of Forte dei Marmi

Created Honorary Doctor of Philosophy, University of Tel-Aviv

Created Honorary Freeman of the City of Monterrey (Mexico)

The Henry Moore Gallery and the Henry Moore Centre for the Study of Sculpture were opened at the Leeds City Art Gallery in the presence of HM The Queen. The first exhibition was devoted to his early carvings

1983 Awarded Mexican Order of Aguila Azteca
Created Honorary Doctor of Literature, National University of Ireland

1984 Created Commandeur de l'Ordre national de la Légion d'honneur on the occasion of President Mitterand's visit to Much Hadham

1985 Awarded Bulgarian Order of St Cyril and St Methodius (First Degree)

1986 31 August. Died, aged 88, at his home in Hertfordshire. A Service of Thanksgiving for the Life and Work of Henry Moore was held at Westminster Abbey on 18 November

1981 Tokyo, Contemporary Sculpture Centre and Osaka, Contemporary Sculpture Centre: 15 sculptures, 6 drawings, 20 graphics.

Cologne, Internationale Ausstellungen: 10 drawings.

Sofia, for 1300th Anniversary of the State of Bulgaria: 15 sculptures, 10 drawings, 20 graphics.

Ilkley, Literature Festival, The Manor House Museum and Art Gallery: 4 drawings.

Canterbury, Royal Museum: 14 sculptures, 11 drawings, 21 graphics.

Harrogate, Northern Artists Gallery: 8 sculptures, 4 drawings, 22 graphics.

Saint-Paul, Fondation Maeght: 2 sculptures.

Salzburg, Galerie Welz: 13 drawings.

Milan, Galleria Bergamini: 14 sculptures, 11 drawings.

London, Wildenstein Gallery: 49 drawings.

Touring exhibition organised by the British Council and The Henry Moore Foundation: Madrid, Retiro Park, Palacio Velasquez and Palacio Cristal; Lisbon, Calouste Gulbenkian Foundation; Barcelona, Miró Foundation: 230 sculptures, 195 drawings, 121 graphics (with modifications at each centre).

Whitechapel Art Gallery, 'British Sculpture in the 20th Century': Part 1, 1 sculpture; Part 2, 3 sculptures.

1981/82 Barcelona, Galeria Prats: 10 drawings, 29 sculptures.

Toronto, Art Gallery of Ontario, 'Primitivism in Modern Sculpture – Gauguin to Moore': 4 drawings, 16 sculptures, 1 print.

Auckland, City Art Gallery, and then touring New Zealand: 7 drawings (with 8 tapestries and photographs).

1982 Touring exhibition organised by the British Council in Spain, Gerona, Tarragona, Lerida: 107 prints; Malaga, Cordoba, Granada, Valencia, Santandar, Gijon, Salamanca, Bilbao: 2 sculptures, 107 prints.

Touring exhibition organised by the Scottish Arts Council (Highlands and Islands): 6 drawings, 11 sculptures, 10 prints.

New York, Christie's Contemporary Art: 20 drawings, 4 sculptures, 60 prints.

New York, Weintraub Gallery: 12 drawings, 29 sculptures, 66 prints.

Colorado Springs (Colorado), Fine Arts Center: 40 drawings.

Harlow, Playhouse Gallery: 10 drawings, 10 sculptures, 10 prints.

La Jolla (California), Tasende Gallery: 13 drawings, 18 sculptures.

Durham, Durham Light Infantry Museum: 22 drawings, 62 sculptures, 5 prints.

London, Fischer Fine Art: 23 drawings, 24 sculptures, 10 prints, 3 tapestries.

Spoleto, Palazzo Ancaiani: 7 drawings, 21 sculptures, 28 prints.

Forte dei Marmi, Galleria Comunale d'Arte Moderna: 26 drawings, 43 sculptures, 26 prints.

Seoul, Hoam Art Museum: 24 drawings, 52 sculptures, 60 prints.

Tel Aviv, Horace Richter Gallery and Tel Aviv University: 24 drawings, 47 sculptures, 26 prints.

Mexico City, Museum of Modern Art: 88 drawings, 145 sculptures, 46 prints.

Monterrey, Museo de Monterrey: 6 drawings, 10 sculptures, 36 prints.

Sydney, Rex Irwin Gallery: 5 drawings, 8 sculptures, 10 prints.

Leeds, City Art Gallery: 5 drawings, 33 sculptures, 2 ceramics, 13 historical loans.

Basel, Galerie Beyeler: 71 drawings, 29 sculptures.

Sunderland, Ceolfrith Gallery: 13 sculptures, 30 prints.

Copenhagen and touring Denmark: 30 graphics.

1983 Rochdale, Langley Community School: 56 graphics.

Caracas, Museu de Arte Contemporáneo: 140 sculptures, 94 drawings, 46 graphics.

Venezuela, exhibition organised by the British Council in Maracaibo, Puerto Ordaz, Barquisimeto, Cumano, Porlamar, Merida: 10 sculptures, 36 graphics.

Madrid, Museo Municipal, Exhibition of Contemporary British Painters: 4 drawings.

Chicago (Illinois), Art Fair, John Cavaliero: 10 drawings, 10 sculptures.

New York, Metropolitan Museum of Art, Britain Salutes New York – The World of Henry Moore': 31 sculptures, 75 drawings, 71 graphics.

Ljubljana, Town Gallery and touring Zagreb, Belgrade, Skopje, Sarajevo: 100 graphics.

New York, Paul Anglim Gallery: drawings.

Royston, Parish Church: 56 graphics.

Paris, Galerie Maeght: 71 drawings, 29 sculptures.

Rome, Due Ci: 50 drawings.

London, Marlborough Fine Art: 18 sculptures, 20 drawings.

London, Curwen Gallery: 46 graphics.

Washington (D.C.), International Exhibitions Foundation: 7 drawings and tapestries.

Folkestone, Arts Centre: 56 sculptures, 49 drawings, 31 graphics.

Sunderland, Ceolfrith Gallery and touring, 'Sculptors' drawings of the last 100 years':
3 drawings.

London, The Tate Gallery, 85th Birthday Exhibition: 31 sculptures, 31 drawings.

Middleham, Leyburn: 9 sculptures, 42 graphics.

Winchester, City Council: 17 sculptures.

Salisbury, Playhouse Gallery: 33 graphics.

Vienna, Orangerie, Palais Auersperg: 62 sculptures, 54 drawings, 55 graphics.

Munich, Galerie Ruf, Residenz: 62 sculptures, 54 drawings, 55 graphics.

Honolulu (Hawaii), Academy of Arts: 10 sculptures, 75 graphics.

Bogotá, Galeria Quintana: 7 sculptures, 36 graphics.

Oslo, Sonja Henies-Niels-Onstads Kunstsenter: 30 sculptures, 44 drawings.

1984 Exeter, Exeter University: 35 graphics.

Herning, Kunstmuseum: 62 sculptures, 54 drawings, 55 graphics.

London, Christie's Contemporary Art: 87 graphics.

London, The Mayor Gallery, Unit One 50th Anniversary Exhibition (group): 2 sculptures,
3 drawings.

Le Havre, L'Espace Oscar Niemeyer: 62 sculptures, 54 drawings, 55 graphics.

East Berlin, National Gallery; Leipzig, Museum der Bildenden Künste; Halle, Staatliche Galerie
Morizburg; Dresden, Albertinum (British Council): 102 drawings, 4 sculptures.

Edinburgh, Printmakers Workshop: 70 graphics.

London, The Tate Gallery, 'The Hard Won Image': 1 sculpture, 8 drawings.

London, Marlborough Fine Art: 57 drawings.

New York, Nathan Silberberg Gallery: 12 drawings.

New York, Weintraub Gallery: 11 drawings.

Zug, Landis & Gyr Foundation: 90 graphics.

Zürich, Galerie Maeght: 90 graphics.

Paris, Galerie Maeght: 90 graphics.

Vienna, Künstlerhaus, International Exhibition and Symposium W. H. Auden: 55 graphics.

Singapore, Art Forum: 40 graphics.

Crewe & Alsager College, Alsager Art Gallery, 'Henry Moore Recent Works 1969/82':
29 sculptures, 26 drawings, 24 graphics.

Leeds, City Art Gallery, 'Henry Moore: sculpture in the making': 34 Sculptures,
4 Drawings.

Marl, Skulpturenmuseum Glaskasten: 28 sculptures, 25 drawings, 20 graphics.

Lisbon, Hotel Ritz and Galeria Sesimbra: 21 graphics.

1985 London, Bernard Jacobson Gallery, 'Animals': 24 graphics.

London, Barbican Art Gallery: 30 graphics.

Athens, Pinacothèque Nationale Musée Alexandre Soutzos: 100 graphics.

New York, Museum of Modern Art, 'Primitivism in 20th Century Art: Affinity of the Tribal
and the Modern', and touring Detroit, Dallas: 2 sketchbooks.

Columbus (Ohio), Columbus Museum of Art, and touring Huntington Gallery, Austin (Texas);
Utah Museum, University of Utah, Salt Lake City (Utah); Portland Museum, Portland (Oregon);
Modern Museum, San Francisco (California): 78 sculptures, 36 drawings, 2 facsimile
sketchbooks.

Safffron Walden, Castle Museum: 1 sculpture, 20 graphics.

Cambridge (Massachusetts), Massachusetts Institute of Technology, Albert & Vera List
Visual Arts Center, 'Henry Moore Interior/Exterior': 2 sculptures, 10 drawings.

1986 Hong Kong, City Art Museum, Arts Centre, Urban Walkway, Academy for the Performing
Arts (with British Council): 165 sculptures, 60 drawings, 32 graphics.

Tokyo, Metropolitan Art Museum; Fukuoka, City Art Gallery: 174 sculptures, 67 drawings,
72 graphics.

Haverfordwest, Picton Castle Trust, Graham & Kathleen Sutherland Foundation: 43 graphics.

Leeds, City Art Gallery, 'Surrealism in Britain – 50th Anniversary Exhibition': 6 sculptures,
1 drawing, 1 graphic.

Albuquerque (New Mexico), University of New Mexico, University Art Museum, 'The Maya
Image in the Western World': 4 drawings.

Public Collections

This is a list of museums, municipalities and institutions that own sculptures by Henry Moore. The numbers refer to the complete catalogue in the six volumes of the series:

Cat. 1–268 Volume 1
Cat.269–364 Volume 2
Cat.365–515 Volume 3
Cat.516–639 Volume 4
Cat.640–782 Volume 5
Cat.783–919 Volume 6

The list does not include private collections or that of The Henry Moore Foundation. The collections of plasters (notably in The Art Gallery of Ontario, Toronto and The Tate Gallery, London) are not listed, and the information basically relates to carvings in wood or stone and bronze casts. It has been prepared from information available in The Henry Moore Foundation archive as at June 1987. Although this information is more comprehensive than it was when each of the volumes was first published, it cannot be considered definitive for two reasons: museums are still acquiring and deaccessioning works, which is obviously a continuing process. Other museums and institutions may hold works of which The Henry Moore Foundation is not aware. David Mitchinson at The Henry Moore Foundation (Dane Tree House, Perry Green, Much Hadham, Hertfordshire SG10 6EE) would be pleased to receive additional information in order that the Foundation's archive can be kept up to date.

When revised editions of Volumes 2 and 3 were published in 1986 the catalogues included some items which did not appear in earlier editions but which related to the periods concerned. These were given 'a' numbers. Volume 6 contains addenda with 'a' numbers for Volumes 4 and 5. Volume 1 (when it is published in a revised edition in 1988) will also contain 'a' entries for the period 1921 to 1948.

Australia	Adelaide, Art Gallery of South Australia 422
	Adelaide, University 612
	Brisbane, Art Gallery of Queensland 676
	Canberra, National Capital Development Commission: National Library Terrace 576
	Canberra, National Gallery of Australia 636
	Melbourne, National Gallery of Victoria 91, 267, 428
	Perth, Observation City Resort Hotel 435
	Perth, Western Australian Art Gallery 402
	Sydney, Art Gallery of New South Wales 281, 675
Austria	Vienna, City of: Karlsplatz 636
	Vienna, Museum des 20.Jahrhunderts 439
Belgium	Antwerp, Musée de Sculpture en plein air, Middelheim 350
	Brussels, Banque Lambert 515
	Brussels, IBM 528
	Brussels, Musées Royaux des Beaux-Arts 332, 359, 428
Brazil	Rio de Janeiro, Museu de Arte Moderna 359, 651
	São Paulo, Museu de Arte Moderna 605
Bulgaria	Sofia, Bulgarian Government Collection 651
Canada	Fredericton, Beaverbrook Art Gallery 487, 809
	Montreal, Canadian Imperial Bank of Commerce 500
	Montreal, Museum of Fine Arts 298, 577
	Ottawa, Canadian Parliament 532
	Ottawa, National Gallery of Canada 84

Short Bibliography 1980–86

This is a selection of works on Henry Moore published since the listing in Volume 5. A comprehensive bibliography is being prepared by The Henry Moore Foundation which will document in detail all publications on the artist. Information and items for inclusion should be sent to Henry Moore Bibliography, Dane Tree House, Perry Green, Much Hadham, Hertfordshire, SG10 6EE.

1980 *Tapestry : Henry Moore & West Dean* (Victoria and Albert Museum, London and touring exhibition catalogue)

1981 *Large Two Forms : a sculpture by Henry Moore ;* preface by Kenneth Clark, introduction by William T. Ylavisaker, photography by David Finn (Abbeville Press, New York)

Henry Moore: *Henry Moore at the British Museum ;* photographs by David Finn (British Museum Publications, London/Abrams, New York)

Henry Moore: *Shelter Sketch-Book* (Rembrandt Verlag, Berlin limited edition)

Henry Moore : sculptures, drawings, graphics 1921–1981 (Madrid and Barcelona exhibition catalogue, in English)

Henry Moore : exposició retrospectiva (Fundació Joan Miró, Barcelona exhibition catalogue, in Catalan)

Henry Moore (Fundação Calouste Gulbenkian, Lisbon exhibition catalogue, in Portuguese)

Henry Moore Sculpture ; with comments by the artist, introduction by Franco Russoli, edited by David Mitchinson (Polígrafa, Macmillan, Rizzoli, Klett-Cotta, Cercle d'Art exhibition book version of the Madrid and Barcelona catalogue)

Henry Moore : opere recenti (Galleria Bergamini, Milan exhibition catalogue)

1982 Henry Moore: *Sketchbook 1928 : The West Wind Relief* (Raymond Spencer Company, Much Hadham facsimile)

Henry Moore : early carvings 1920–1940 (Leeds City Art Galleries exhibition catalogue)

Henry Moore : Head-Helmet (DLI Museum and Arts Centre exhibition catalogue)

Henry Moore : sculptures, drawings (Galerie Beyeler, Basel exhibition catalogue)

Henry Moore in Israel (Horace Richter Gallery and Tel-Aviv University exhibition catalogue/ Nathan Silberberg Fine Arts, New York)

Moore a Spoleto (Palazzo Ancaiani exhibition catalogue)

Henry Moore : sculture, disegni, opera grafiche (Galleria Comunale d'Arte Moderna, Forte dei Marmi exhibition catalogue)

Henry Moore (Hoam Art Museum, Seoul exhibition catalogue)

Exhibition of Drawings & Sculpture by Henry Moore (Tasende Gallery, La Jolla exhibition catalogue

Henry Moore en Mexico (Museo de Arte Moderna exhibition catalogue)

3 Temas en la Obra de Henry Moore (Museo de Monterrey exhibition catalogue)

1983 W. J. Strachan: *Henry Moore: Animals* (Aurum Press, London)

Henry Moore: wood sculpture; commentary by Henry Moore, photographs by Gemma Levine (Sidgwick & Jackson, London/Universe Books, New York)

Henry Moore: Sculpture and Drawings, Volume 5: sculpture 1974-1980; edited by Alan Bowness (Lund Humphries/Zwemmer, London/Wittenborn, New York)

William S. Lieberman: *Henry Moore: 60 years of his art* (Thames and Hudson and The Metropolitan Museum of Art, New York exhibition book)

Henry Moore: Skulpturen, Zeichnungen, Grafiken (Palais Auersperg, Vienna exhibition catalogue)

Henry Moore esculturas, dibujos, grabados: obras de 1921 a 1982 (Museo de Arte Contemporáneo, Caracas exhibition catalogue)

Henry Moore: opera su carta (Due Ci, Rome)

1984 Alan G. Wilkinson: *The Drawings of Henry Moore* (Garland, New York and London reprint of 1974 thesis)

Henry Moore: sculpture in the making (Leeds City Art Gallery exhibition catalogue)

Henry Moore: the reclining figure (Columbus Museum of Art and touring exhibition catalogue)

Henry Moore: skulptur, tegning, grafik fra de sidste tyve år (Herning Kunstmuseum exhibition catalogue)

Henry Moore: sculptures, dessins, gravures (Maison de la Culture du Havre exhibition catalogue)

Henry Moore: shelter and coal mining drawings (Berlin, Leipzig, Halle, Dresden exhibition catalogue)

Henry Moore: Mutter und Kind (Skulpturenmuseum Glaskasten, Marl exhibition catalogue)

1985 Henry Moore: *Sketchbook 1980* (Raymond Spencer Company, Much Hadham facsimile)

Henry Moore: *A Szobrászatról* (Helikon Kiadó, Budapest)

William Packer: *Henry Moore: an illustrated biography;* with photographs by Gemma Levine (Weidenfeld and Nicolson, London/Grove Press, New York)

Museum Without Walls: Henry Moore in New York City from the Ablah Collection; introduction by J. Carter Brown, photography by David Finn and Amy Binder (Book-of-the-Month Club, Camp Hill)

1986 *The Art of Henry Moore* (Hong Kong Museum of Art exhibition catalogue)

The Art of Henry Moore (Metropolitan Art Museum, Tokyo/Fukuoka Art Museum exhibition catalogue)

Stephen Spender: *In Irina's Garden, with Henry Moore's sculpture ;* photographs by David Finn (Thames and Hudson, London)

Henry Moore : my ideas, inspiration and life as an artist ; text by Henry Moore, photographs by John Hedgecoe (Ebury Press, London)

Henry Moore : Complete Sculpture, Volume 2 : sculpture 1949–54 ; edited by Alan Bowness (Lund Humphries, London, 3rd revised edition)

Henry Moore : Sculpture and Drawings, Volume 3 : sculpture 1955–64 ; edited by Alan Bowness (Lund Humphries, London, 2nd revised edition)

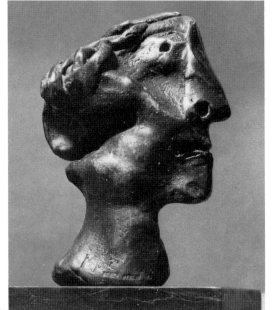

522a

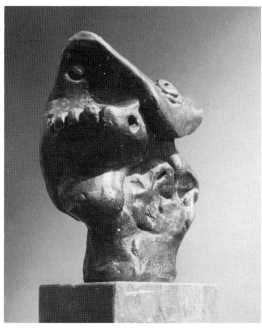

522b

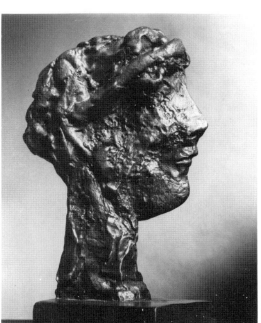

522c

Volume 4: 1964–73

522a **Profile Head**
c. 1964, cast 1976 3/7·5 H
Bronze, edition of 9 including
Nelson-Atkins Museum of Art, Hall Family Foundation,
Kansas City, Missouri

522b **Small Head**
c. 1965, cast 1976 $2\frac{7}{8}$/7·5 H
Bronze, edition of 6

522c **Head : Profile** (plates 1, 2)
c. 1964 $8\frac{3}{4}$/22 H (with base)
terra cotta Bronze, unique cast
Private Collection

522d **Head** (plates 3–6)
c. 1964, cast 1982 $12\frac{1}{4}$/31 H
terra cotta Bronze, edition of 6

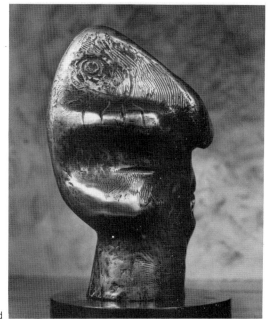

522d

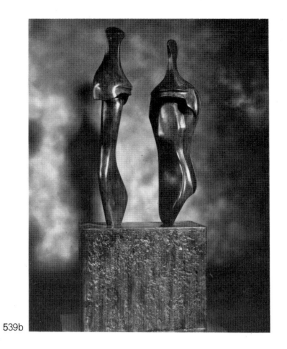

539b

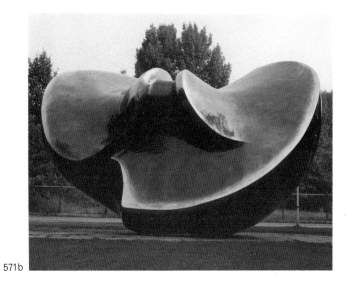

571b

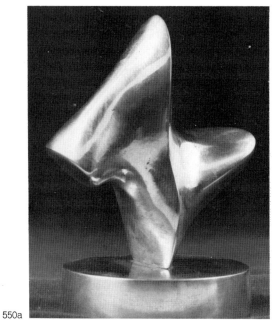

550a

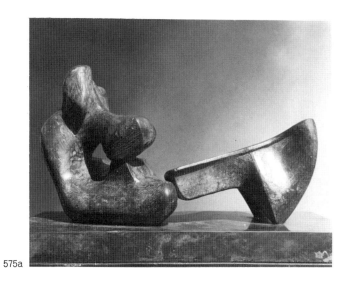

575a

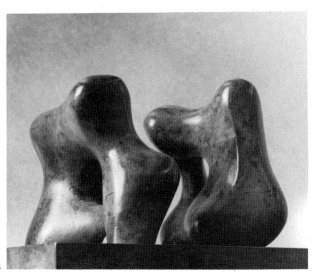

554a

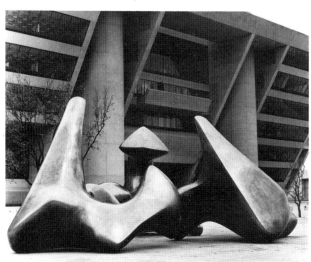

580a

539b **Two Three-Quarter Figures on Base** (plates 7–10)
cast 1984 40/101·5 H
Bronze, edition of 9 including
Nelson-Atkins Museum of Art, Hall Family Foundation,
Kansas City, Missouri

550a **Maquette for Upright Form**
1966, cast 1983 2¾/7 H
Bronze, edition of 9

554a **Maquette for Two Forms**
1966, cast 1976 6½/15·5 L
Bronze, edition of 9 including
Art Gallery of Ontario, Toronto

571a **Working Model for Divided Oval: Butterfly** (plates 11, 12)
1967, cast 1982 36/91·5 L
Bronze, edition of 6

571b **Large Divided Oval: Butterfly**
cast 1985/6 26 ft 4 in/800 L
Bronze, unique cast

575a **Maquette for Two Piece Reclining Figure No. 9**
1967, cast 1977 9/23 L
Bronze, edition of 9 including
Art Gallery of Ontario, Toronto
Museum of Art, Dallas, Texas

580a **Three Forms Vertebrae** (plates 13–16)
1978/9 approx. 40ft/1219 L
Bronze, unique cast
City Center Park Plaza, Dallas, Texas

580b **Maquette for Two Piece Sculpture No. 10: Interlocking**
1968, cast 1984 5/12·5 L
Bronze, edition of 9

586a **Upright Motive No. 9** (plates 17–20)
1979 11ft/335·5 H
Bronze, edition of 6 including
Northwestern Mutual Life Insurance Company,
Bishop Square, Tamarind Park, Honolulu, Hawaii
Nelson-Atkins Museum of Art, Hall Family Foundation,
Kansas City, Missouri

593a **Large Spindle Piece**
carved 1981 14ft 8in/450 H
Travertine marble
Intercontinental Hotel, Miami, Florida

580b
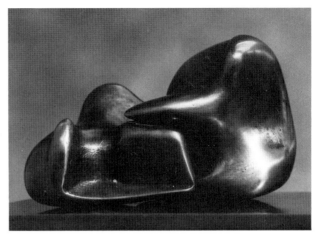

586a
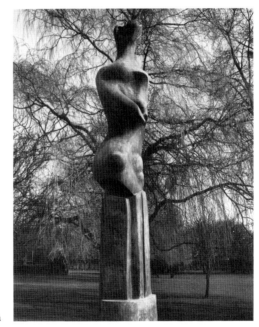

593a
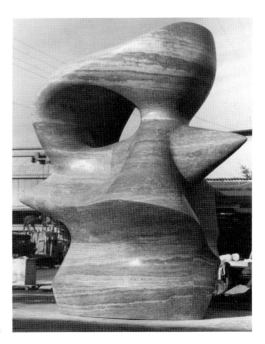

Volume 5: 1974–80

643a **Maquette for Carving: Points**
1974, cast 1985 4⅞/12.5 L
Bronze, edition of 9

652a **Figure in a Shelter** (plate 25)
cast 1983 66/167·5 H (without base)
Bronze, edition of 6

652b **Stone Form** (plates 21–24, 25)
carved 1984 8ft 10in/269 H
Granite

652c **Large Figure in a Shelter**
cast 1985/6 approx. 25ft/762 H
Bronze, unique cast

652d **Bronze Form** (plate 25)
cast 1985/6 14ft 6in/442 H (with base)
Bronze, edition of 6 including
AP Møller Group Headquarters, Copenhagen

677a **Reclining Figure** (plates 26–28)
1982 93/236 L
Bronze, edition of 9 including
Museo de Arte Contemporáneo, Caracas
Calouste Gulbenkian Foundation, Lisbon (on long loan from
The Henry Moore Foundation)

715a **Two Standing Figures** (plates 29, 30)
1981 8ft 1in/246·5 H
Travertine marble
The Henry Moore Foundation

715b **Single Standing Figure**
1981 8ft1in/246·5 H
Travertine marble
Raymond Spencer Company Limited

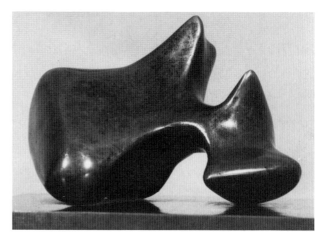

643a

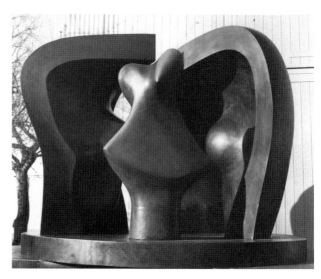

652a

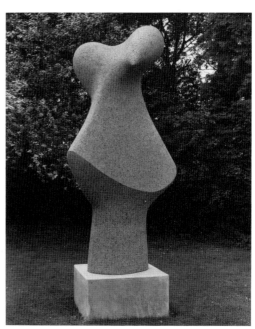

652b

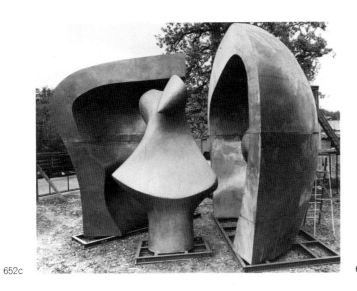

652c

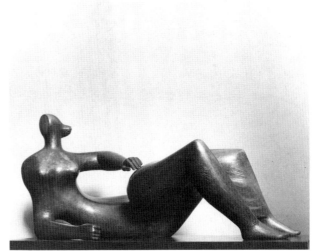

677a

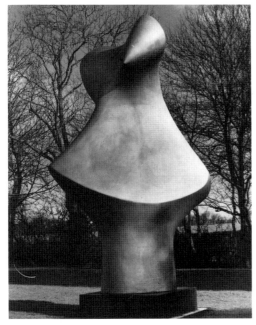

652d

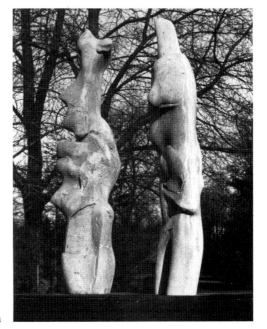

715a

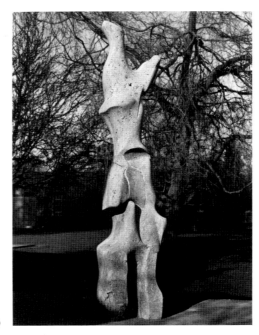

715b

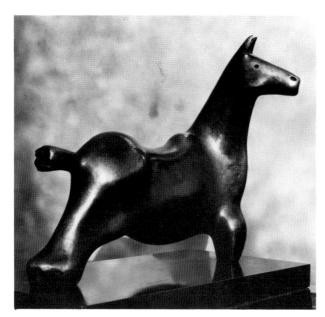

740a

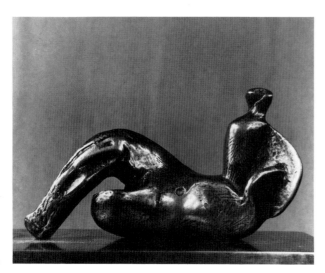

749a

740a **Horse** (plates 31–33)
cast 1984 27/68·5 L
Bronze, edition of 9

749a **Maquette for Reclining Figure : Wing**
1978, cast 1984 6$\frac{1}{4}$/16 L
Bronze, edition of 9

This is the sixth and final part of the complete catalogue of sculpture by Henry Moore. It continues that begun in the fourth edition of *Henry Moore Volume 1 : Sculpture and Drawings 1921–48* and continued in volumes 2–5. This sixth volume includes all works of sculpture executed between the early part of 1980 and 1986. It also includes an addenda section listing works relating to the periods covered by volumes 4 and 5 which have not previously been documented. As in earlier sections of the catalogue, the order is more or less chronological, but certain related groups of works have been listed together for general convenience. In the numbering, maquettes and studies precede the definitive state of the work. The measurement given is normally only that of the largest dimension, listed first in inches and then in centimetres.

In the case of bronzes, an artist's copy generally exists, but this is not included in the size of the editions unless, as in a few cases, it has subsequently been acquired by a public collection. Many of the artist's copies now belong to The Henry Moore Foundation.

Only works in public collections show details of ownership.

All sculptures are illustrated in the catalogue section on the same spread as the entry.

Up-to-date information about ownership, and especially museum acquisitions, will always be welcomed by David Mitchinson at The Henry Moore Foundation, Dane Tree House, Perry Green, Much Hadham, Hertfordshire SG10 6EE.

Alan Bowness

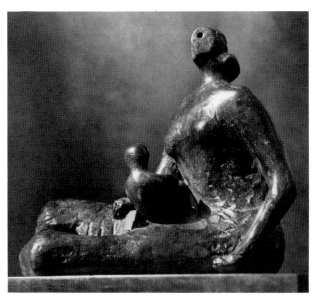

783

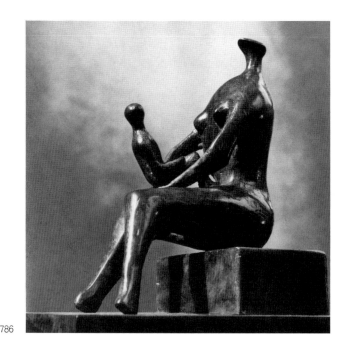

786

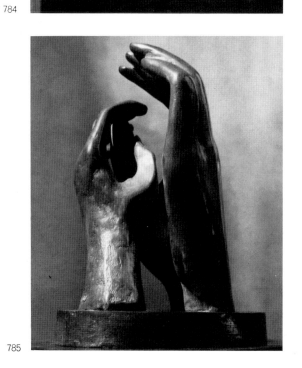

784

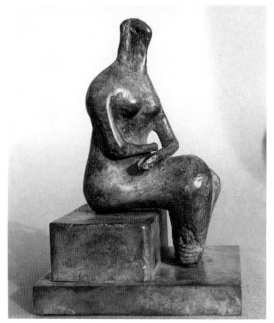

787

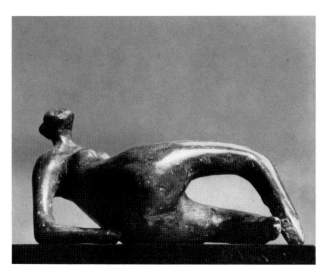

785

788

783 Draped Seated Mother and Child on Ground (plates 34, 35)
1980 8/20·5 L
Bronze, edition of 9

784 Draped Mother and Child on Curved Bench
1980 7½/19 H
Bronze, edition of 9

785 Mother and Child : Hands (plates 36, 37)
1980 7¾/19·5 H
Bronze, edition of 7 including
Museum of Art, Dallas, Texas

786 Thin Nude Mother and Child
1980 6⅝/17 H
Bronze, edition of 9

787 Draped Woman on Block Seat
1980 6⅛/15·5 H
Bronze, edition of 9

788 Reclining Nude : Crossed Feet
1980 6¼/16 L
Bronze, edition of 9

789 Mother and Child : Round Form (plates 38, 39)
1980 7½/19 H
Bronze, edition of 9

790 Mother and Child : Circular Base
1980 5⅜/13·5 H
Bronze, edition of 9

791 Maquette for Curved Mother and Child
1980 7¼/18·5 H
Bronze, edition of 9

792 Mother and Child : Curved (plates 40–43)
1983 23/58·5 H
Bronze, edition of 9

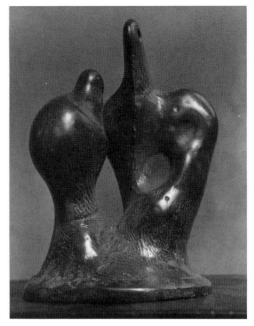

790

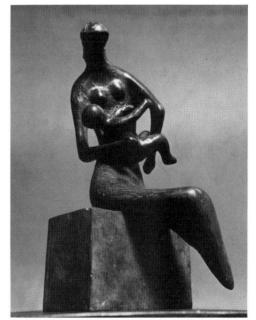

791

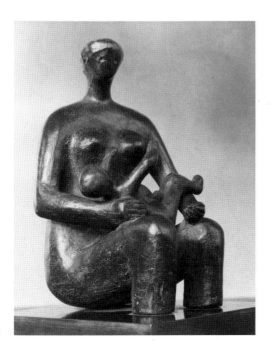

789

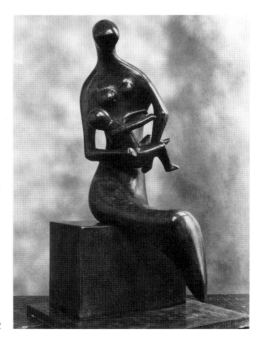

792

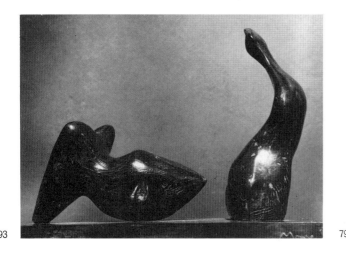

793

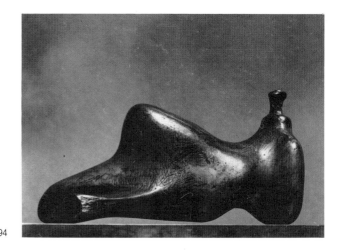

794

793 **Two Piece Point and Hole** (plates 44, 45)
1980 9¼/23·5 L
Bronze, edition of 7

794 **Reclining Figure : Small Head**
1980 5⅜/13·5 L
Bronze, edition of 7

795 **Male Torso**
1980 6¼/16 H
Bronze, edition of 9

796 **Maquette for Three-Quarter Figure : Lines**
1980 8½/21·5 H
Bronze, edition of 7

797 **Three-Quarter Figure : Lines** (plates 46–49)
1980 33/84 H
Bronze, edition of 9

798 **Resting Animal**
1980 8½/21·5 H
Bronze, edition of 7

799 **Small Animal**
1980 3¼/8 L
Bronze, edition of 6 including
Museum of Art, Dallas, Texas

800 **Dog's Head** (plate 50)
1980 4¾/12 L
Bronze, edition of 9

801 **Horse's Head** (plate 51)
1980 7¾/19·5 L
Bronze, edition of 7

802 **Small Shell Mother and Child**
1980 4⅛/10·5 H
Bronze, edition of 7

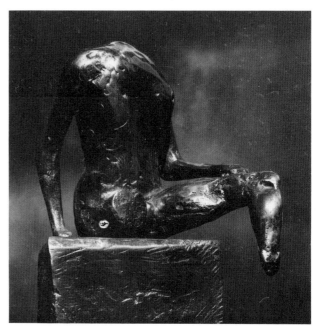

795

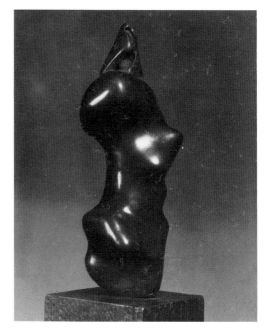

796

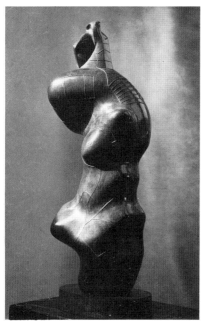

797

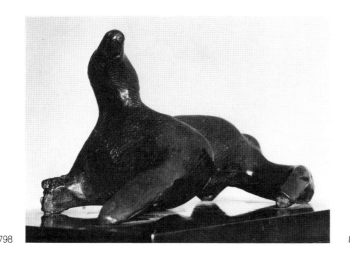

798

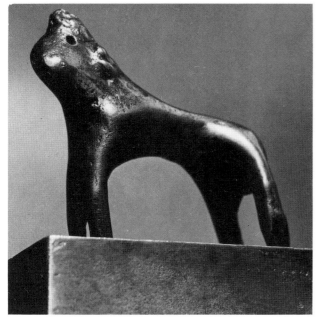

799

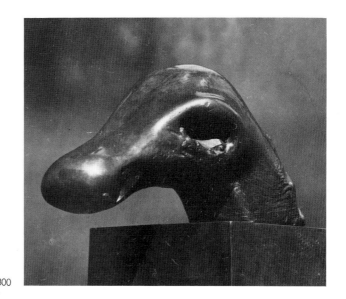

800

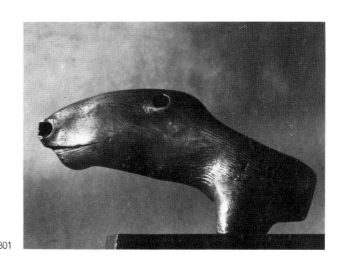

801

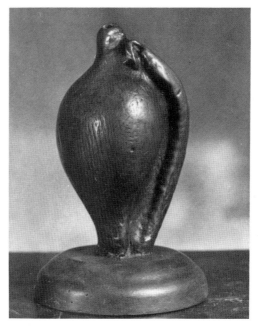

802

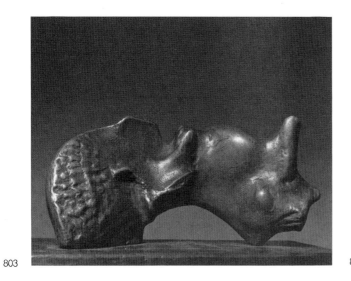

803

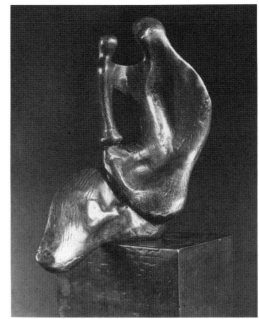

804

803 **Reclining Girl: Shell Skirt**
1980 7¼/18·5 L
Bronze, edition of 9

804 **Seated Mother and Child: Thin** (plates 52–55)
1980 9½/24 H
Bronze, edition of 9

805 **Reclining Figure: Skirt** (also catalogued as
Reclining Figure: Bone Head)
1980 6/15 L
Bronze, edition of 9 including
Nelson-Atkins Museum of Art, Hall Family Foundation,
Kansas City, Missouri

806 **Three-Quarter Figure: Wedge** (plate 56)
1980 6¾/17 H
Bronze, edition of 9

807 **Torso Relief**
1980 5⅜/13·5 H
Bronze, unique cast

808 **Reclining Woman No. 1**
1980 9¾/25 L
Bronze, edition of 9

809 **Working Model for Reclining Woman: Elbow** (plates 57, 58)
1981 34/86·5 L
Bronze, edition of 9 including
Beaverbrook Art Gallery, Fredericton

810 **Reclining Woman: Elbow** (plates 59–62)
1981 87/221 L
Bronze, edition of 9 including
City Art Gallery, Leeds (on long loan from The Henry Moore
Foundation)

811 **Reclining Woman No. 2** (plate 63)
1980 11½/29 L
Bronze, edition of 7

812 **Half-Figure on Bone Base**
1981 6⅜/16 H
Bronze, edition of 7

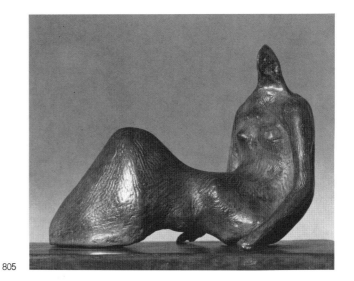

805

806

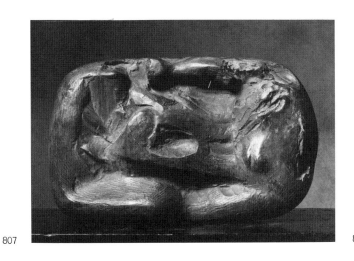

807

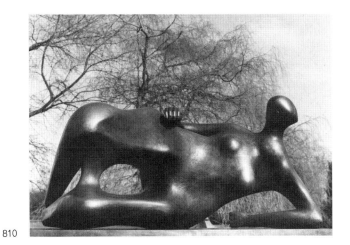

810

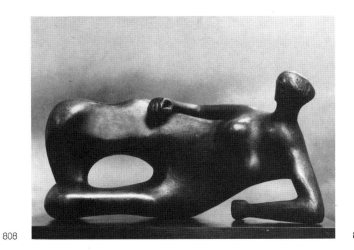

808

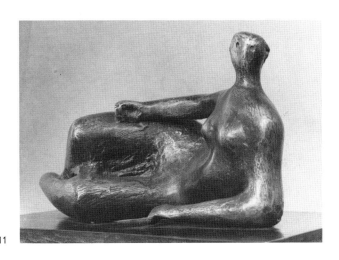

811

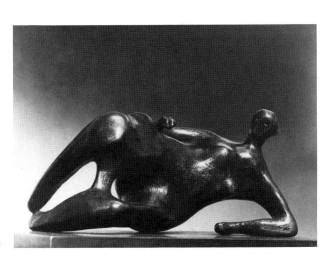

809

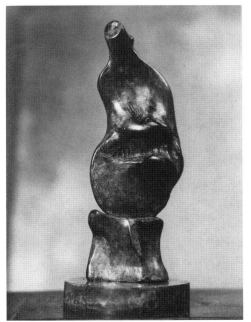

812

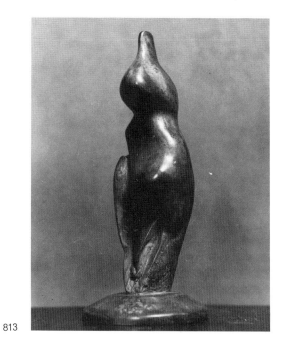

813

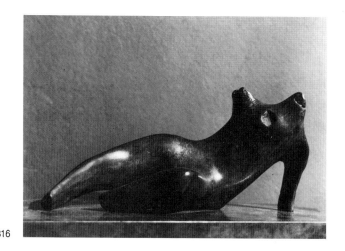

816

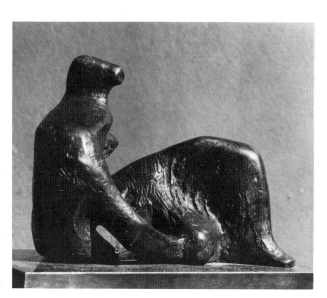

814

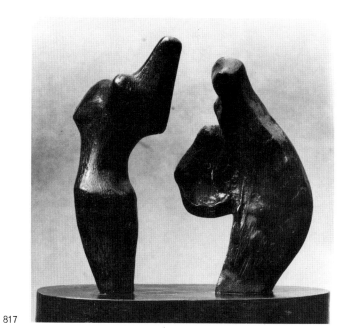

817

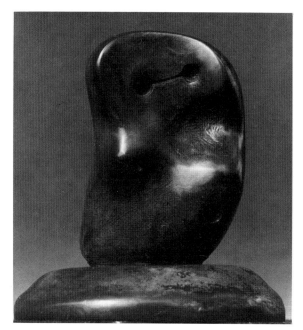

815

818

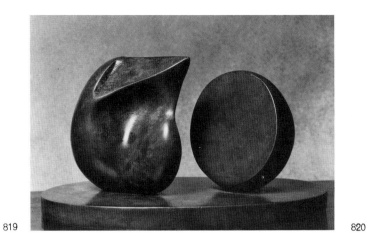
819

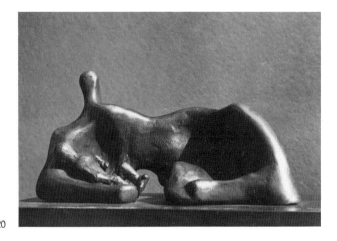
820

813 **Standing Figure on Round Base**
1981 6½/16·5 H
Bronze, edition of 7

814 **Two Torsos** (plates 64–66)
1981 8/20·5 L
Bronze, edition of 7

815 **Draped Reclining Figure : Knee** (plate 67)
1981 7½/19 L
Bronze, edition of 9

816 **Reclining Torso**
1981 8½/21·5 L
Bronze, edition of 9 including
Miller Art Center, Door County Library, William S. Fairfield
Collection, Sturgeon Bay, Wisconsin

817 **Family Group : Two Piece** (plates 68, 69)
1981 6/15 L
Bronze, edition of 7

818 **Curved Head**
1981 2¾/7 H
Bronze, edition of 7

819 **Point and Oval**
1981 5⅜/13·5 L
Bronze, edition of 7 including
Museum of Art, Dallas, Texas

820 **Maquette for Draped Reclining Mother and Baby**
1981 8¼/21 L
Bronze, edition of 9

821 **Working Model for Draped Reclining Mother and Baby**
1982 31/78·5 L
Bronze, edition of 9

822 **Draped Reclining Mother and Baby** (plates 70–72)
1983 8ft 8½in/265·5 L
Bronze, edition of 9 including
Hoam Museum of Art, Seoul
Biltmore Commerce Center, Phoenix, Arizona

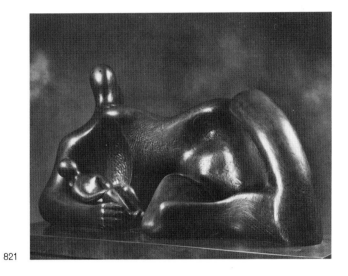
821

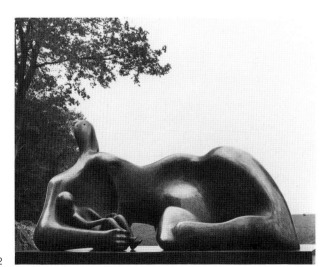
822

823 Two Piece Reclining Figure: Arch
1981 8/20·5 L
Bronze, edition of 9

824 Reclining Figure: Flat Face
1981 7⅛/18·5 L
Bronze, edition of 9 including
Nelson-Atkins Museum of Art, Hall Family Foundation,
Kansas City, Missouri

825 Reclining Man and Woman (plate 73)
1981 9⅜/24 L
Bronze, edition of 9 including
Nelson-Atkins Museum of Art, Hall Family Foundation,
Kansas City, Missouri

826 Maquette for Reclining Figure: Pointed Head
1981 7⅛/18·5 L
Bronze, edition of 9

827 Reclining Figure: Pointed Head
1982 34/86·5 L
Bronze, edition of 9 including
Nelson-Atkins Museum of Art, Hall Family Foundation,
Kansas City, Missouri

828 Three Piece Maquette (plate 74)
1981 12½/32 L
Bronze, edition of 9

829 Fat Torso
1981 5⅝/14·5 H
Bronze, edition of 7

830 Reclining Figure: Right Angles (plates 76, 77)
1981 7⅞/20 L
Bronze, edition of 9

831 Maquette for Reclining Figure: Open Pose
1981 9⅜/24 L
Bronze, edition of 9 including
Nelson-Atkins Museum of Art, Hall Family Foundation,
Kansas City, Missouri

832 Reclining Figure: Open Pose (plates 78, 79)
1982 36/91·5 L
Bronze, edition of 9 including
Nelson-Atkins Museum of Art, Hall Family Foundation,
Kansas City, Missouri

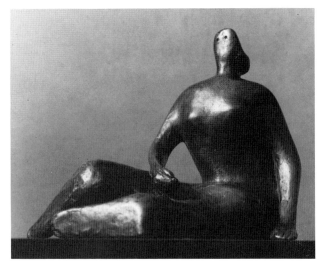
824

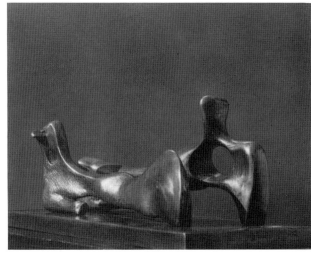
825

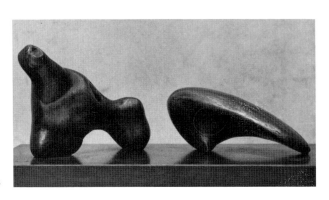
823

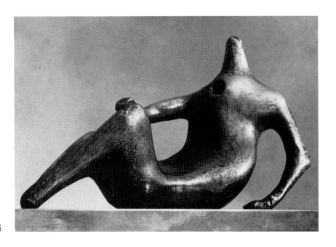
826

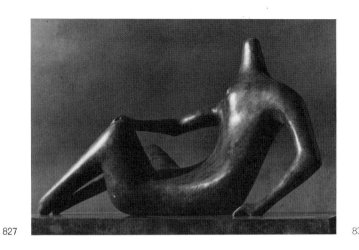

827

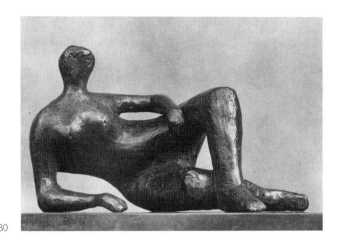

830

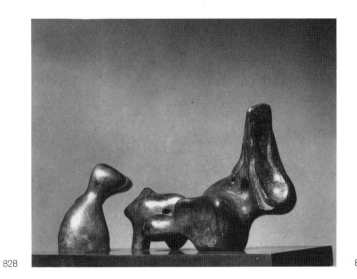

828

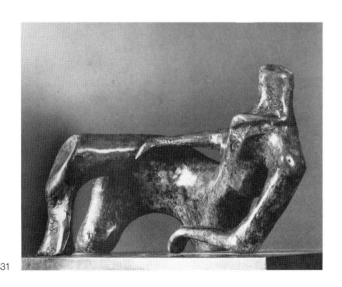

831

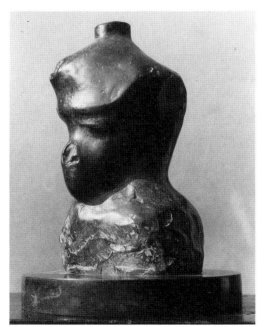

829

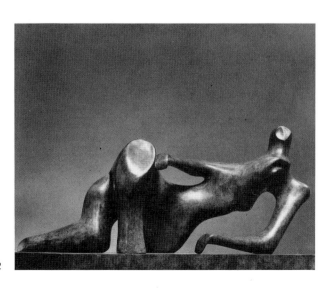

832

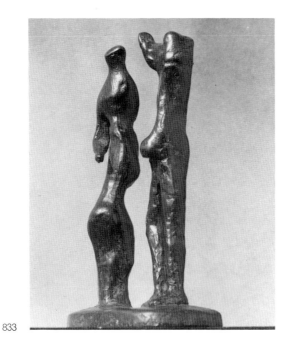

833

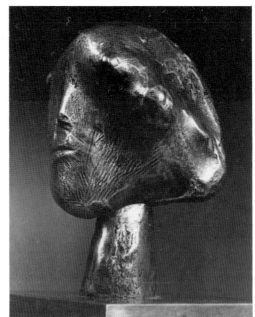

834

833 **Standing Man and Woman** (plate 75)
1981 7¼/18·5 H
Bronze, edition of 9 including
Nelson-Atkins Museum of Art, Hall Family Foundation,
Kansas City, Missouri

834 **Head**
1981 4/10 H
Bronze, edition of 9

835 **Semi-Seated Mother and Child** (plates 80, 81)
1981 7¾/19·5 L
Bronze, edition of 9

836 **Maquette for Mother and Child : Block Seat**
1981 7/18 H
Bronze, edition of 9

837 **Working Model for Mother and Child : Block Seat**
(plates 82–85)
1983 27/68·5 H
Bronze, edition of 9 including
Nelson-Atkins Museum of Art, Hall Family Foundation,
Kansas City, Missouri

838 **Mother and Child : Block Seat** (plate 86)
1983/4 96/244 H
Bronze, edition of 9 including
Hakone Open Air Museum

839 **Mother Holding Child**
1981 5½/14 H
Bronze, edition of 9

840 **Mother and Child : Chair**
1981 12/30·5 H
Bronze, edition of 9

841 **Reclining Woman : Hair**
1981 9¾/25 L
Bronze, edition of 9

842 **Reclining Woman : Skirt**
1981 6⅞/17·5 L
Bronze, edition of 9

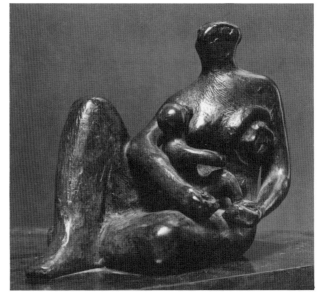

835

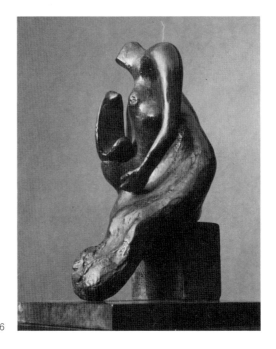

836

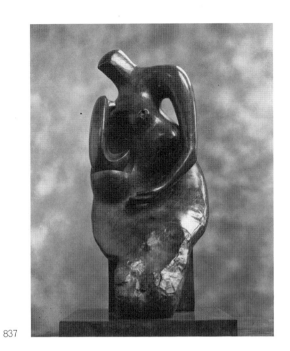

837

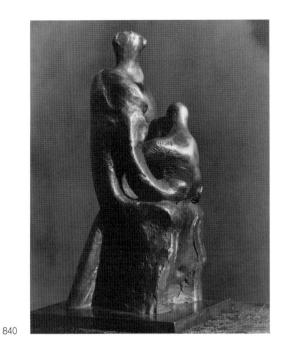

840

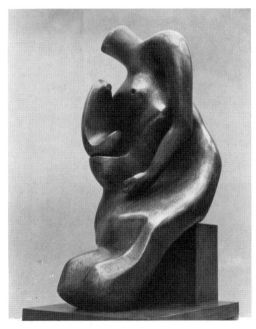

838

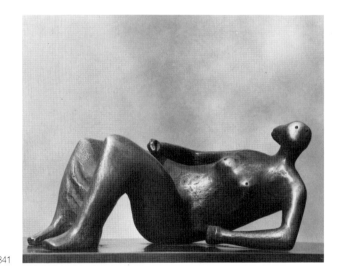

841

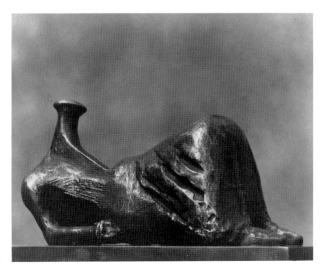

839

842

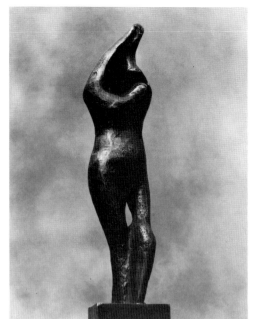

843

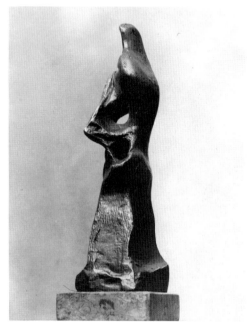

844

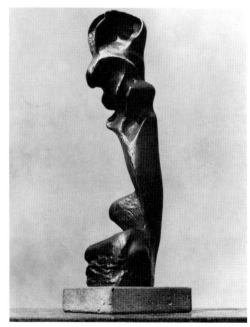

845

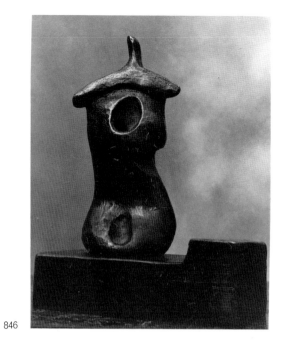

846

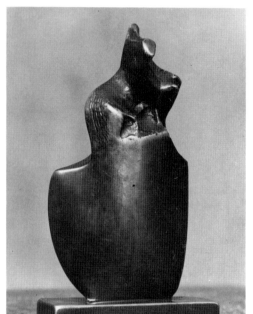

847

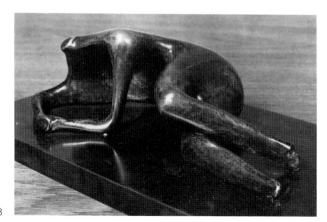

848

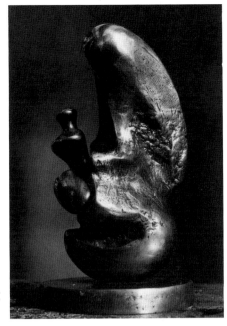

849

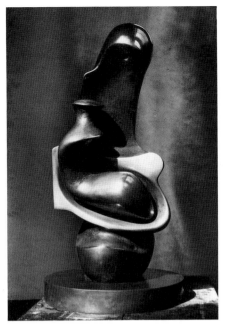

850

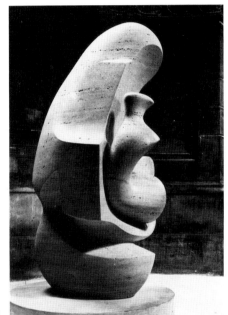

851

843 **Standing Woman**
1981 9¼/23·5 H
Bronze, edition of 9

844 **Standing Man**
1981 8¼/21 H
Bronze, edition of 9

845 **Standing Girl**
1981 8⅛/21 H
Bronze, edition of 9 including
Miller Art Center, Door County Library, William S. Fairfield
Collection, Sturgeon Bay, Wisconsin

846 **Three-Quarter Figure : Chest**
1981 4½/11·5 H
Bronze, edition of 9

847 **Small Three-Quarter Figure : Simple Skirt**
1981 3¾/9·5 H
Bronze, edition of 9

848 **Reclining Man : Headless**
1982 10/25·5 L
Bronze, edition of 9

849 **Maquette for Mother and Child : Hood**
1982 6/15 H
Bronze, edition of 9

850 **Working Model for Mother and Child : Hood**
1982 30/76 H
Bronze, edition of 9

851 **Mother and Child : Hood** (plates 87–89)
1983 6ft/183 H
Travertine marble
St Paul's Cathedral, London (on loan from The Henry
Moore Foundation)

852 **Maquette for Three Figures**
1982 3⅝/9 L
Bronze, edition of 6

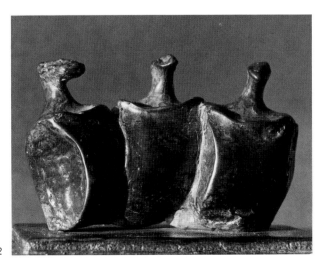

852

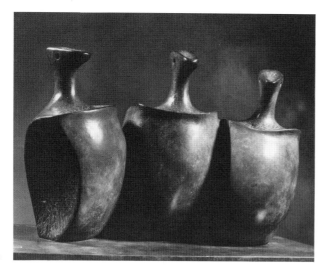

853

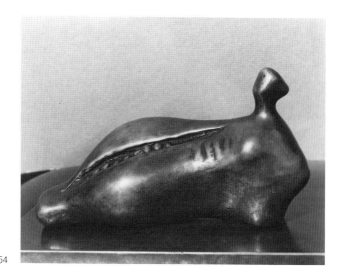

854

853 **Three Figures** (plates 90, 91)
1982 $14\frac{1}{4}$/36 L
Bronze, edition of 7 including
Nelson-Atkins Museum of Art, Hall Family Foundation,
Kansas City, Missouri

854 **Reclining Figure : Pea Pod** (plates 92, 93)
1982 $8\frac{1}{2}$/21·5 L
Bronze, edition of 9

855 **Reclining Figure : Twisting**
1982 9/23 L
Bronze, edition of 9

856 **Reclining Figure : Fragment**
1982 8/10·5 L
Bronze, edition of 9

857 **Reclining Figure : Holes**
1982 5/12·5 L
Bronze, edition of 9

858 **Draped Torso**
1982 $7\frac{1}{2}$/19 H
Bronze, edition of 9

859 **Torso Column**
1982 8/20·5 H
Bronze, edition of 9

860 **Male Torso**
1982 $5\frac{1}{4}$/13·5 H
Bronze, edition of 9

861 **Rock Form** (plate 94)
1982 6/15 H
Bronze, edition of 9

862 **Half-Figure : Round Head** (plate 95)
1982 $6\frac{1}{4}$/16 H
Bronze, edition of 9

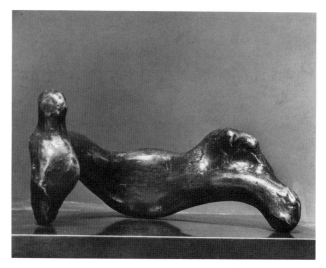

855

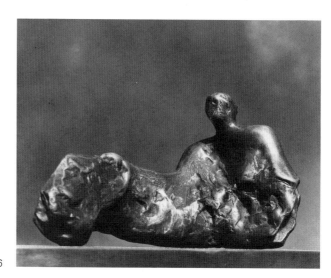

856

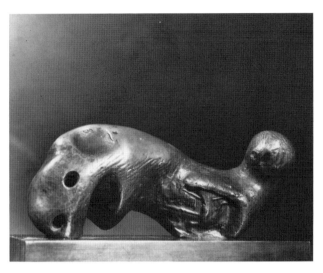

857

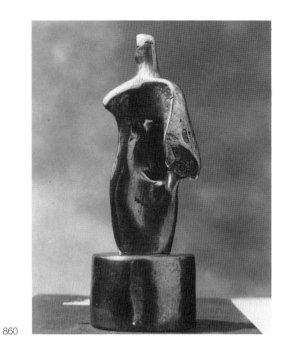

860

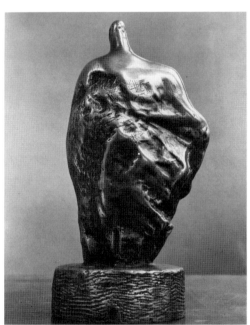

858

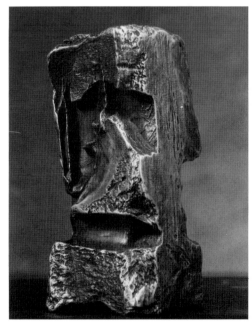

861

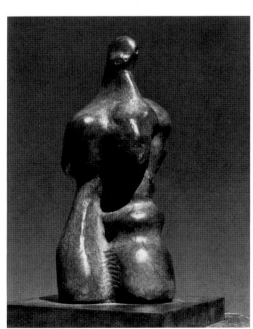

859

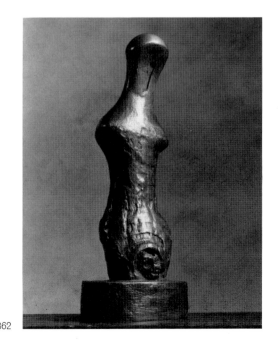

862

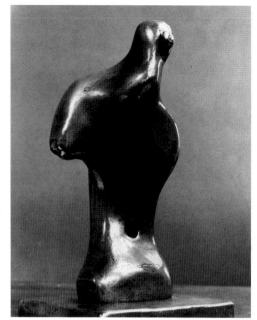

863

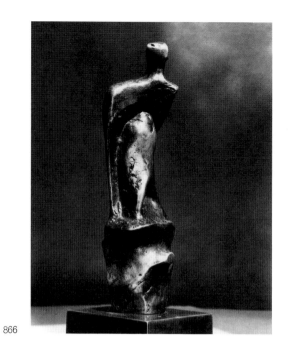

866

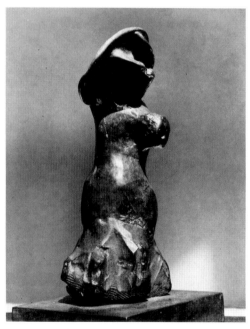

864

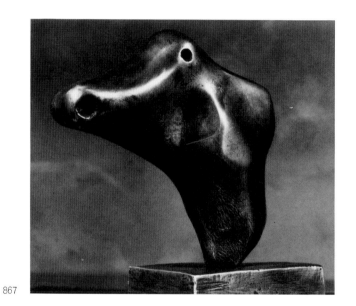

867

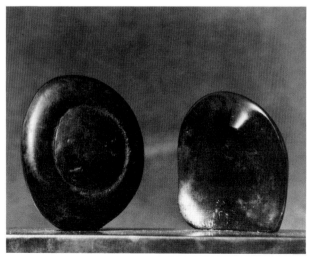

865

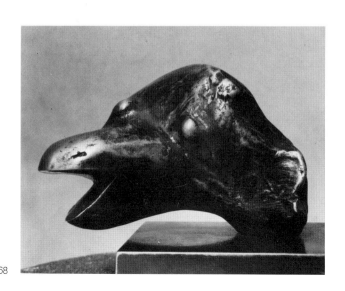

868

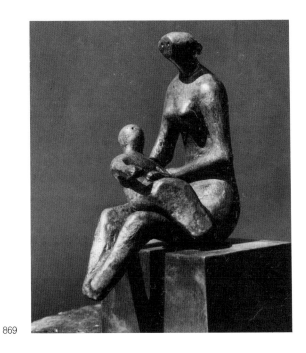

869

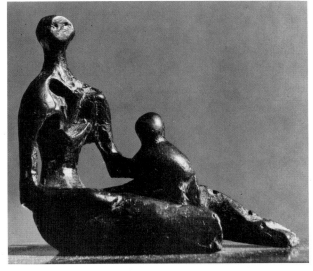

870

863 Torso : Shoulders
1982 7/18 H
Bronze, edition of 9

864 Bonnet Figure
1982 6¼/16 H
Bronze, edition of 9

865 Two Small Forms
1982 4⅜/11 L
Bronze, edition of 9

866 Standing Figure
1982 9/23 H
Bronze, edition of 9

867 Head of Horse (plate 96)
1982 5½/14 H
Bronze, edition of 9

868 Animal Head : Open Mouth
1982 5⅛/13 L
Bronze, edition of 9

869 Maquette for Mother with Child on Lap
1982 6/15 H
Bronze, edition of 9

870 Mother with Child on Lap (plates 97–99)
cast 1985 31/78·5 H
Bronze, edition of 9 including
Hakone Open Air Museum

871 Small Mother and Child (plates 100–102)
1982 5/12·5 L
Bronze, edition of 9 including
Museum of Art, Dallas, Texas

872 Oblong Mother and Child
1982 5¼/13·5 L
Bronze, edition of 9

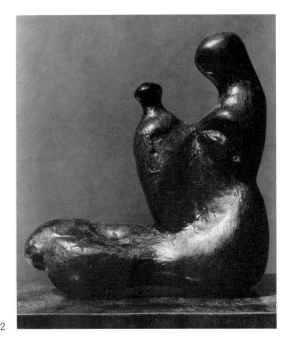

871

872

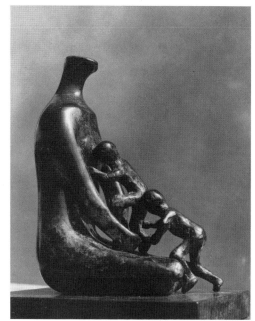

873

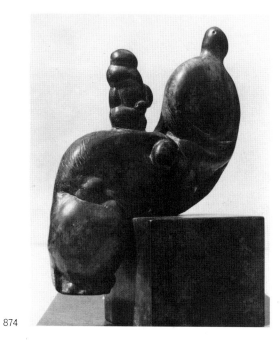

874

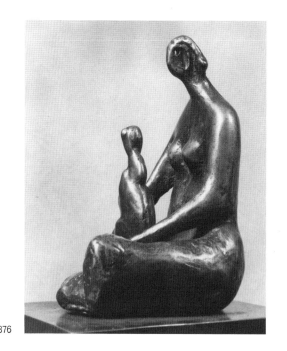

876

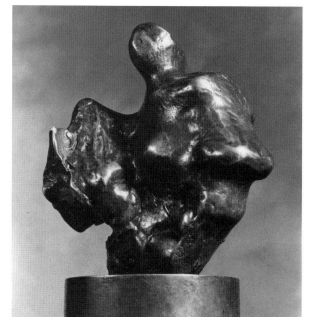

877

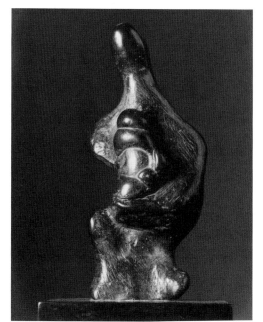

878

875

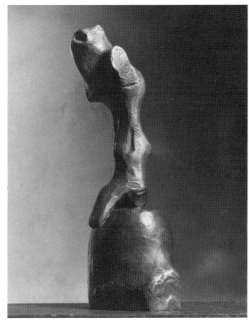

879

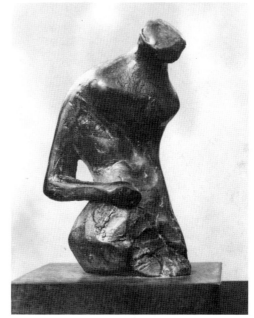

880

873 **Mother with Twins** (plate 103)
1982 6/15 H
Bronze, edition of 9

874 **Mother with Child on Knee**
1982 6¼/16 H
Bronze, edition of 9

875 **Three-Quarter Mother and Child on Round Base**
1982 7/18 H
Bronze, edition of 9

876 **Seated Woman Holding Child**
1982 6⅞/17·5 H
Bronze, edition of 9

877 **Mother and Child : Rock** (plates 104, 105)
1982 6½/16·5 H
Bronze, edition of 9

878 **Mother and Child on Rectangular Base**
1982 6¼/16 H
Bronze, edition of 9

881

879 **Seated Figure on Log** (plates 106, 107)
1982 6½/16·5 H
Bronze, edition of 9

880 **Girl**
1982 7¼/18·5 H
Bronze, edition of 9

881 **Girl : One Arm**
1983 4⅜/11 H
Bronze, edition of 9

882 **Three-Quarter Woman**
1983 3¾/9·5 H
Bronze, edition of 9

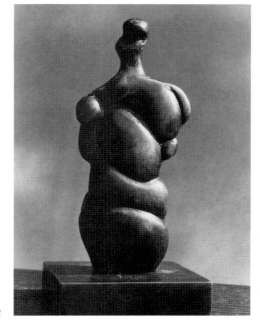

882

883 **Three-Quarter Figure on Tubular Base**
1983 7⅜/19 H
Bronze, edition of 9

884 **Figurine**
1983 4/10 H
Bronze, edition of 9

885 **Tube Form**
1983 5/12·5 H
Bronze, edition of 9

886 **Boat Form**
1983 4/10 L
Bronze, edition of 9

887 **Two Bulb Forms**
1983 4⅛/10·5 H
Bronze, edition of 9

888 **Three-Quarter Figure : Cyclops** (plates 108–110)
1983 7½/19 H
Bronze, edition of 9

889 **Half-Figure**
1983 6/15 H
Bronze, edition of 9

890 **Maquette for Carving**
1983 4¾/12 L
Bronze, edition of 9

891 **Bone Head**
1983 5½/14 H
Bronze, edition of 9

892 **Animal Turned Head**
1983 5⅛/13 L
Bronze, edition of 9

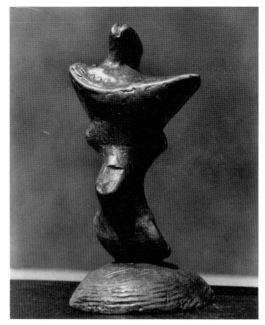

884

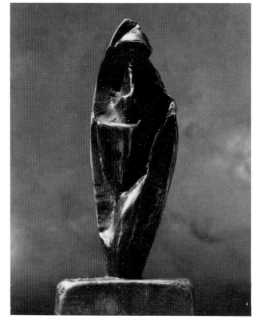

885

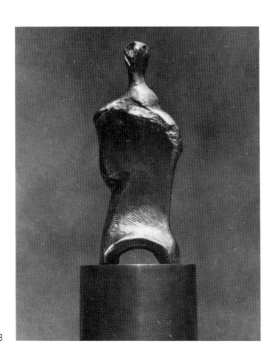

883

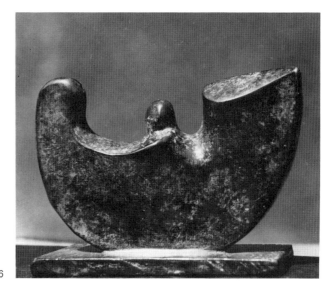

886

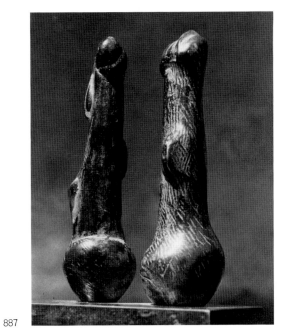

887

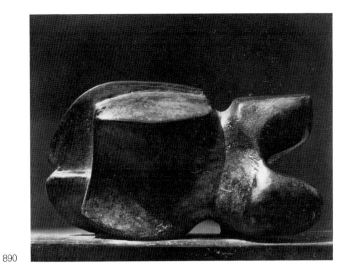

890

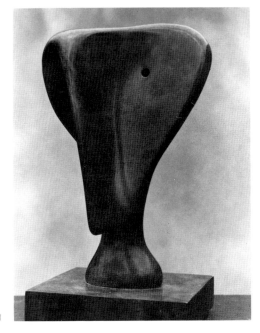

888

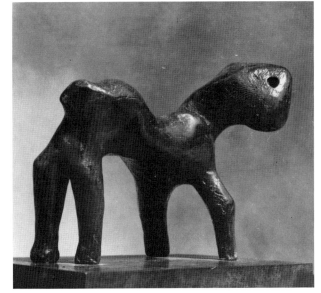

891

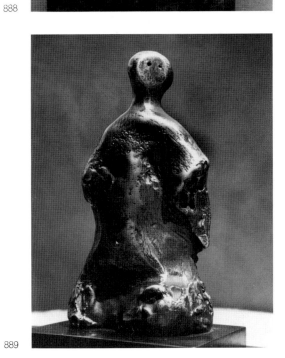

889

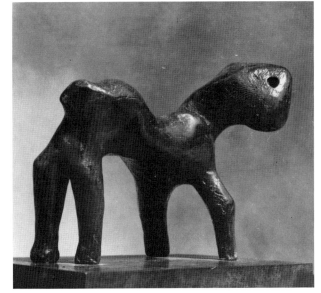

892

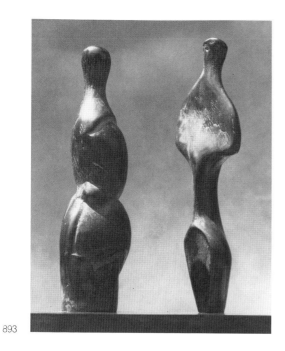

893

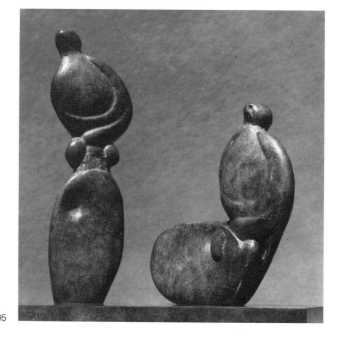

894

893 **Two Tall Forms**
1983 $6\frac{1}{8}$/15·5 H
Bronze, edition of 9

894 **Two Standing Women**
1983 $5\frac{3}{4}$/14·5 H
Bronze, edition of 9

895 **Seated and Standing Figures** (plates 112, 113)
1983 7/18 L
Bronze, edition of 9 including
Museum of Art, Dallas, Texas
Nelson-Atkins Museum of Art, Hall Family Foundation,
Kansas City, Missouri

896 **Standing Figure: Pointed Head**
1983 $8\frac{3}{4}$/22 H
Bronze, edition of 9

897 **Twins**
1983 $4\frac{1}{2}$/11·5 H
Bronze, edition of 9

898 **Half-Figure: Mother and Child** (plate 111)
1983 $4\frac{5}{8}$/11·5 H
Bronze, edition of 9 including
Yale Center for British Art, New Haven, Connecticut

899 **Small Mother and Child on Round Base** (plate 114)
1983 $2\frac{5}{8}$/6·5 H
Bronze, edition of 9

900 **Mother and Child: Skirt**
1983 4/10 H
Bronze, edition of 9

901 **Reclining Girl** (plate 115)
1983 5/12·5 L
Bronze, edition of 9

902 **Maquette for Reclining Figure: Circle** (plate 116)
1983 6/15 L
Bronze, edition of 9

895

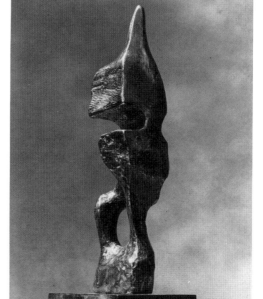

896

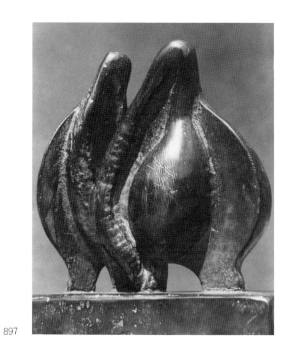

897

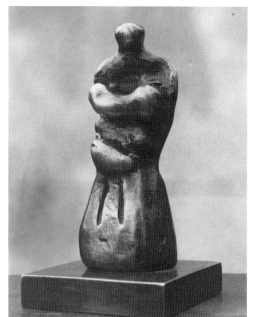

900

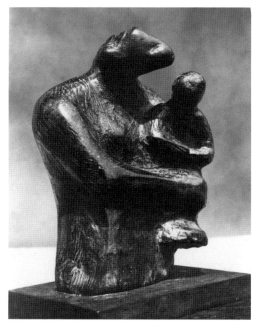

898

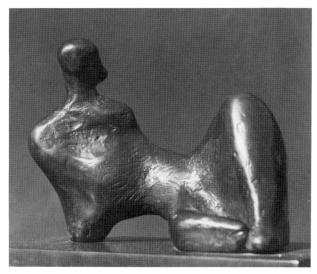

901

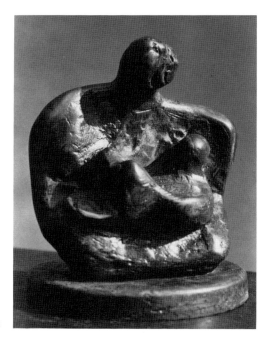

899

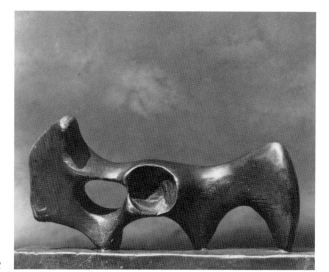

902

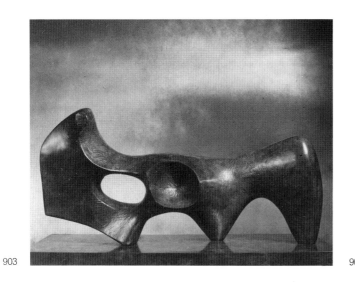

903

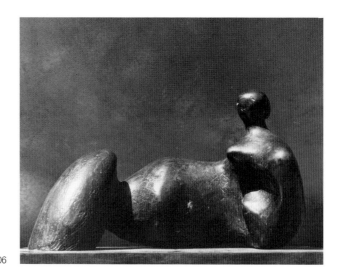

906

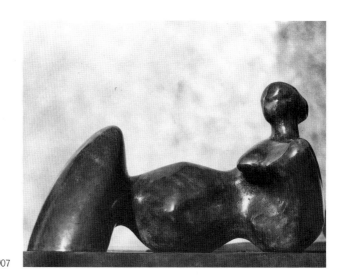

904

907

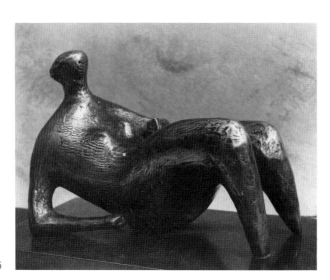

905

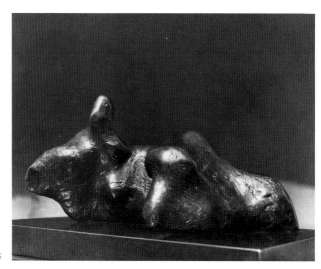

908

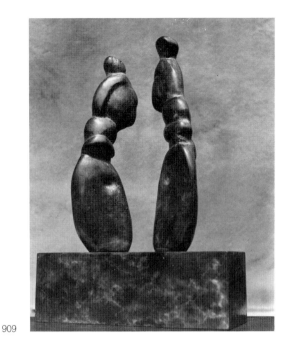

909

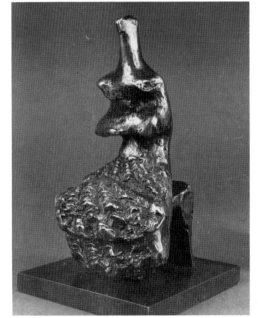

910

911

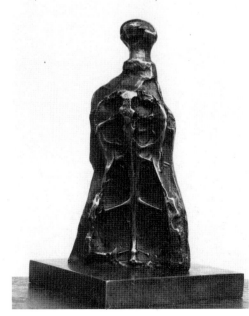

912

903 **Reclining Figure : Circle** (plates 117–119)
1983 35/89 L
Bronze, edition of 9

904 **Reclining Figure : Turned Head**
1983 8/20·5 L
Bronze, edition of 9

905 **Reclining Figure** (plates 120–123)
1983 7/18 L
Bronze, edition of 9

906 **Maquette for Reclining Figure : Umbilicus**
1983 8¾/22 L
Bronze, edition of 9 including
Nelson-Atkins Museum of Art, Hall Family Foundation,
Kansas City, Missouri

907 **Reclining Figure : Umbilicus** (plates 124, 125)
1984 37/94 L
Bronze, edition of 9

908 **Reclining Figure : Hollows**
1983 8/20·5 L
Bronze, edition of 9

909 **Two Standing Figures : Concretions** (plates 126, 127)
1983 8¼/21 H
Bronze, edition of 9

910 **Three-Quarter Girl**
1983 4/10 H
Bronze, edition of 9

911 **Seated Woman : Shell Skirt** (plates 128, 129)
cast 1984 7/18 H
Bronze, edition of 9

912 **Skeleton Figure**
cast 1984 5/12·5 H
Bronze, edition of 9 including
Museum of Art, Dallas, Texas

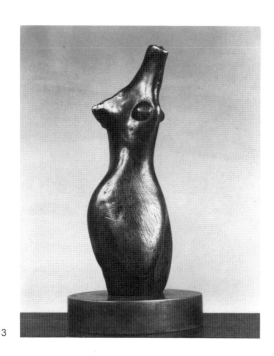

913

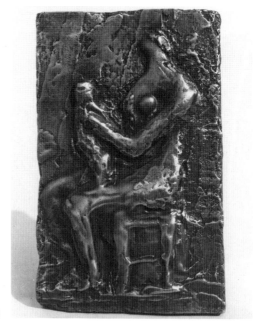

916

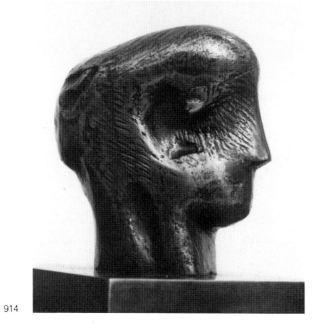

914

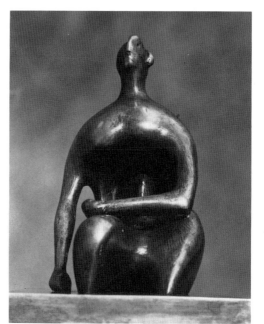

917

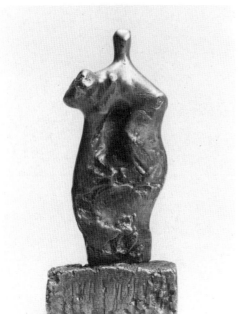

915

913 **Female Torso**
cast 1964 $6\frac{5}{8}$/17 H
Bronze, edition of 9

914 **Small Head**
cast 1984 3/7·5 H
Bronze, edition of 9

915 **Three-Quarter Figure : Hollow** (plates 130, 131)
cast 1984 $6\frac{3}{4}$/17 H
Bronze, edition of 9

916 **Small Mother and Child Relief**
cast 1984 4/10 H 6/15 W
Bronze, edition of 9

917 **Seated Figure : Thin Head** (plates 132–135)
cast 1984 $5\frac{3}{4}$/14·5 H
Bronze, edition of 9

918 **Head** (plates 136–139)
1984 $24\frac{1}{2}$/62 H
Bronze, edition of 9

919 **Three-Quarter Figure : Points**
cast 1985 $4\frac{3}{4}$/12 H
Bronze, edition of 9

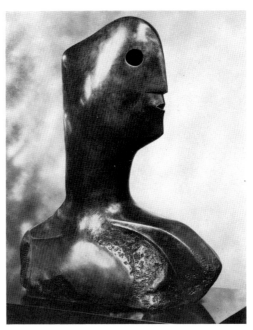

918

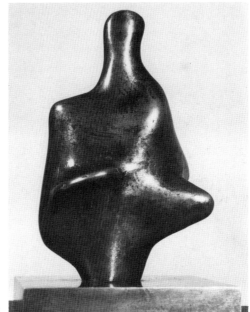

919

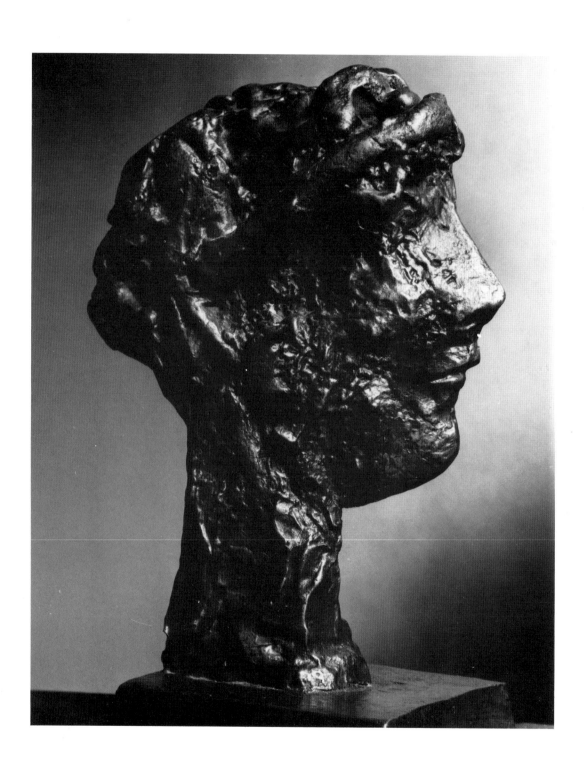

1 **Head: Profile** (522c) 8¾/22 H c. 1964

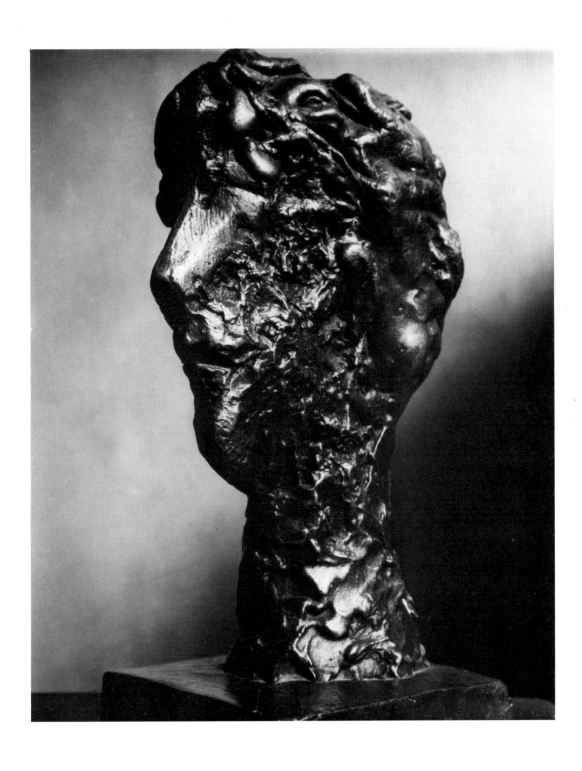

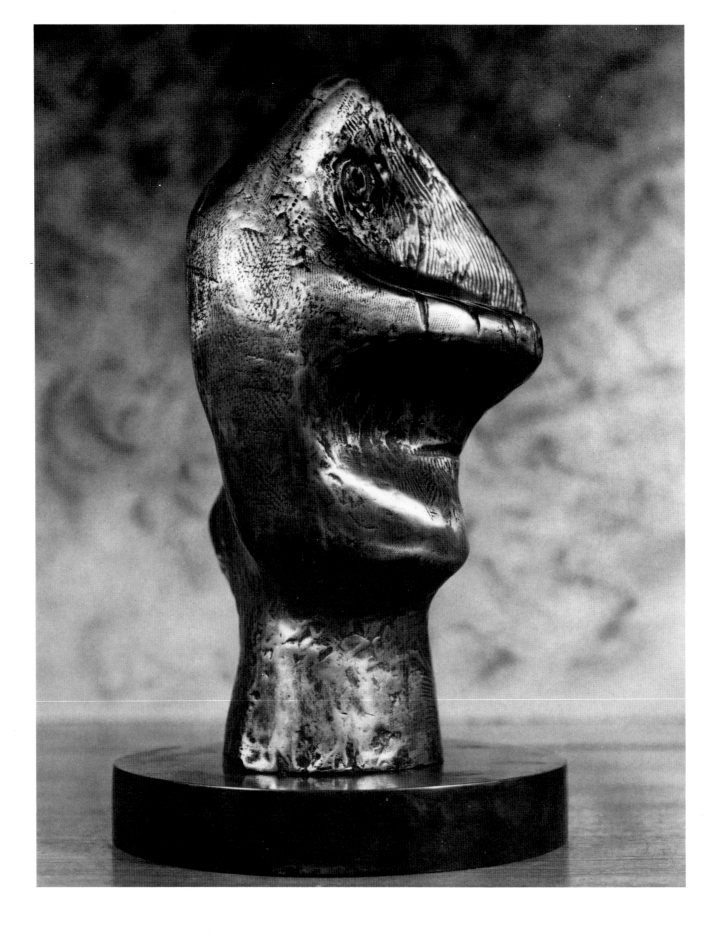

3 Head (522d) 12¼/31 H c. 1964 cast 1982

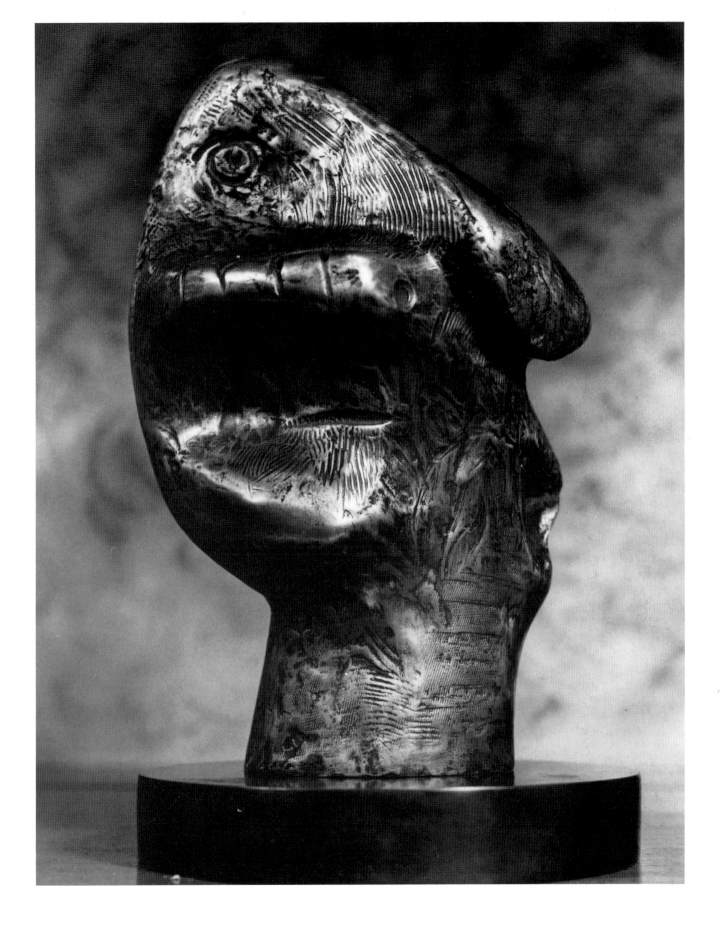

4 Another view of **Head**

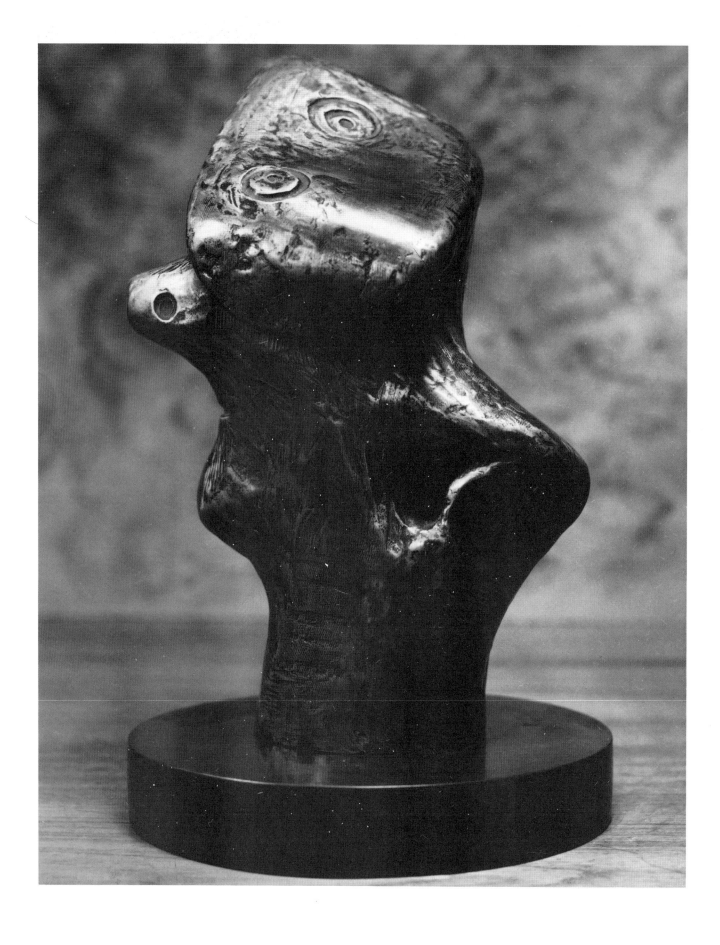

5 Another view of **Head**

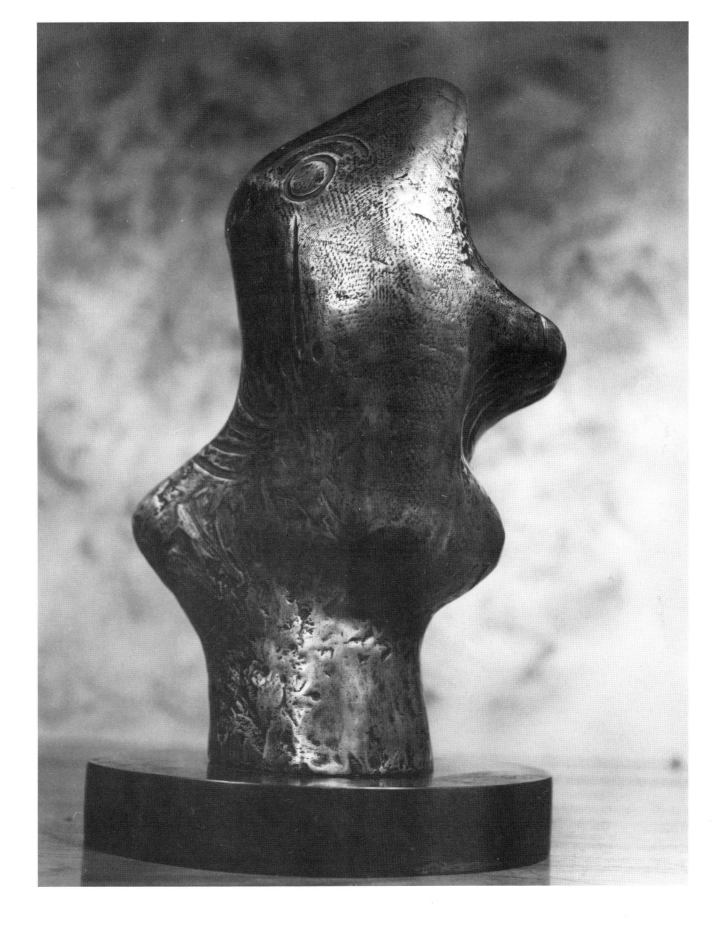

6 Another view of **Head**

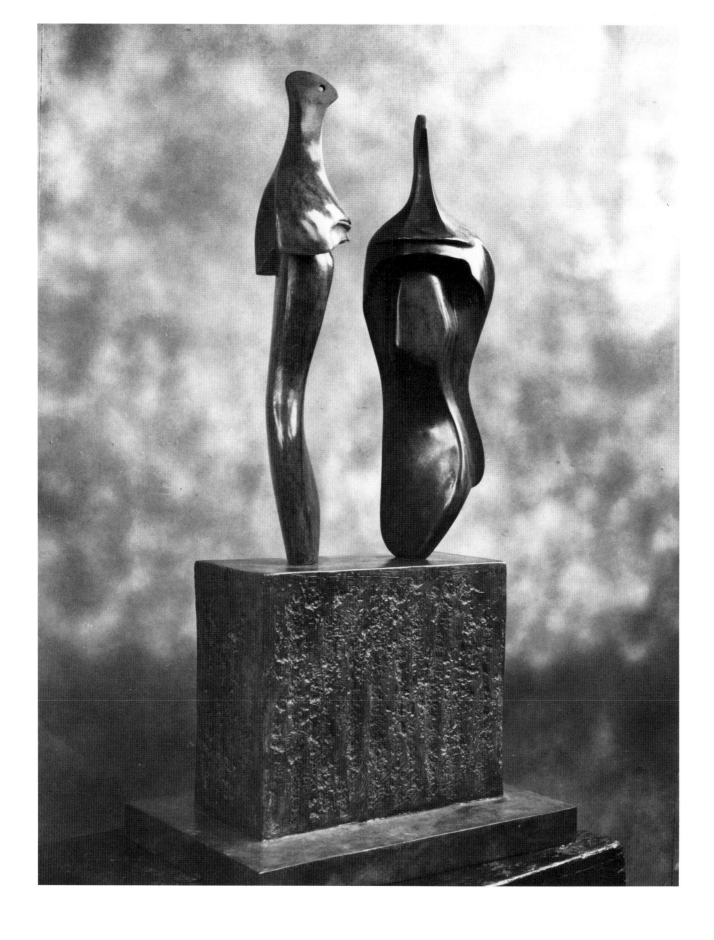

7 **Two Three-Quarter Figures on Base** (539b) 40/101·5 H cast 1984

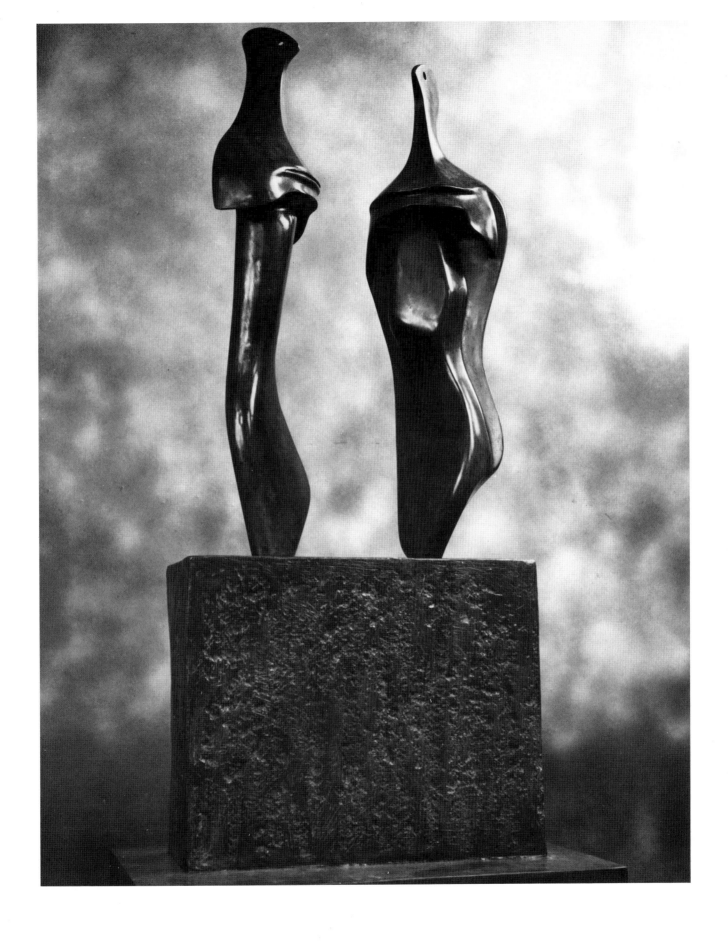

8 Another view of **Two Three-Quarter Figures on Base**

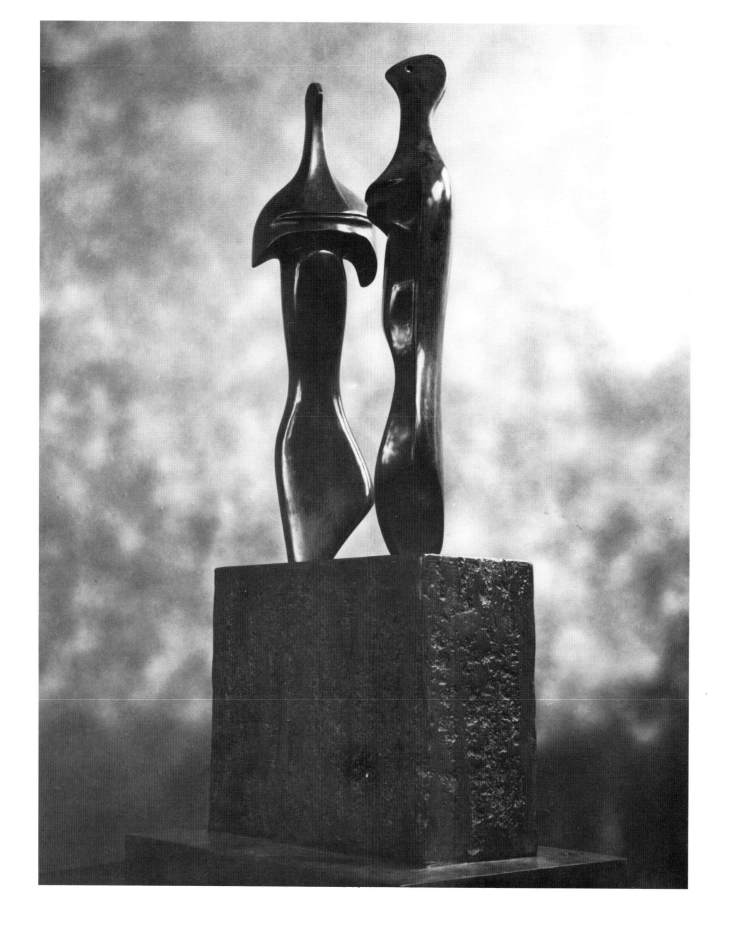

9 Another view of **Two Three-Quarter Figures on Base**

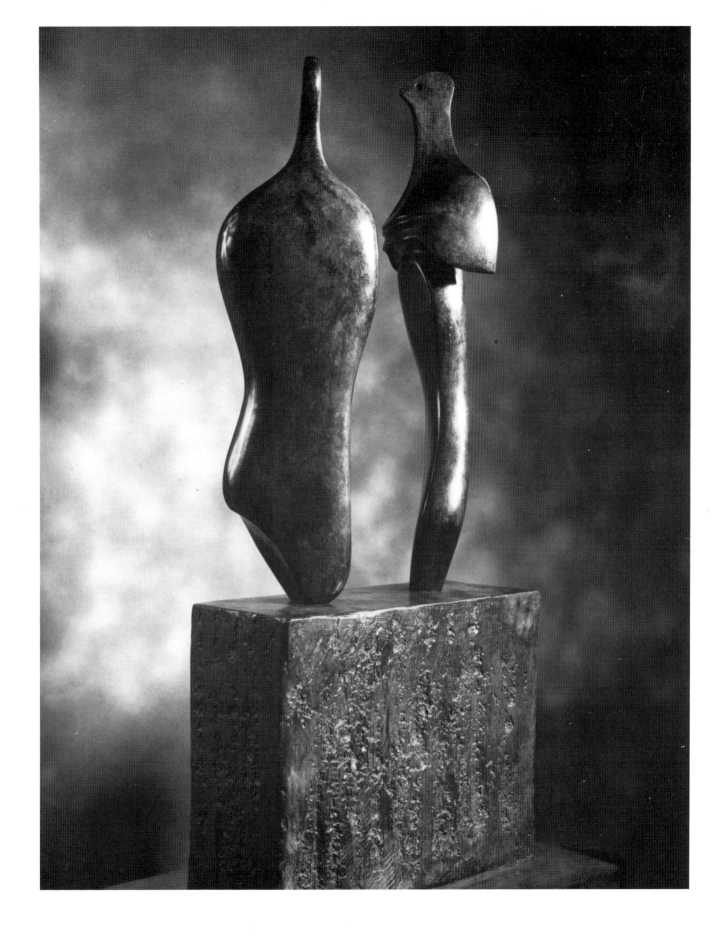

10 Another view of **Two Three-Quarter Figures on Base**

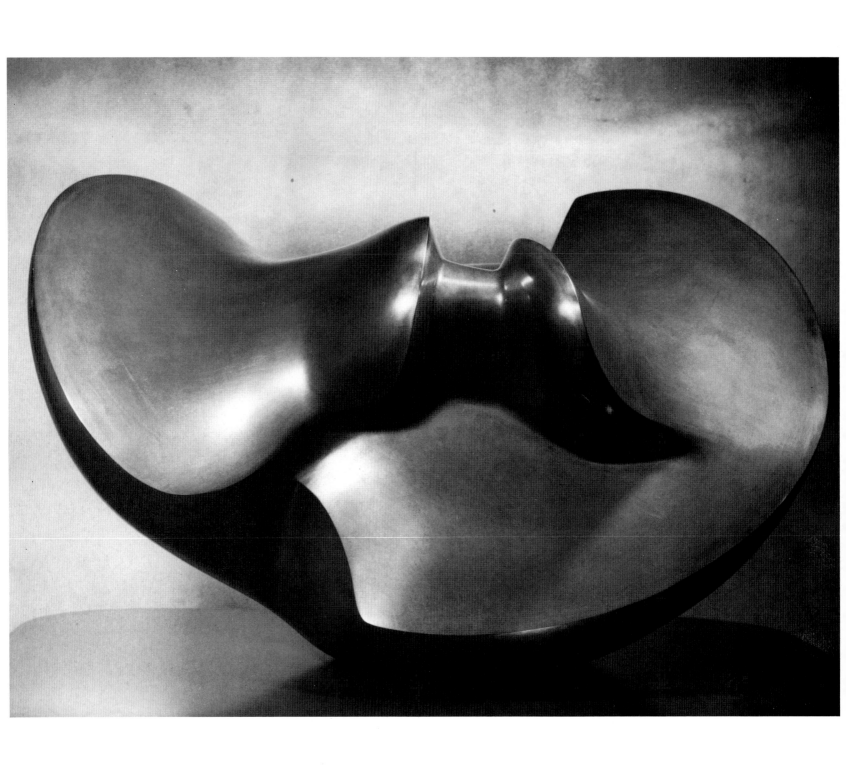

11 **Working Model for Divided Oval: Butterfly** (571a) 36/91·5 L 1967 cast 1982

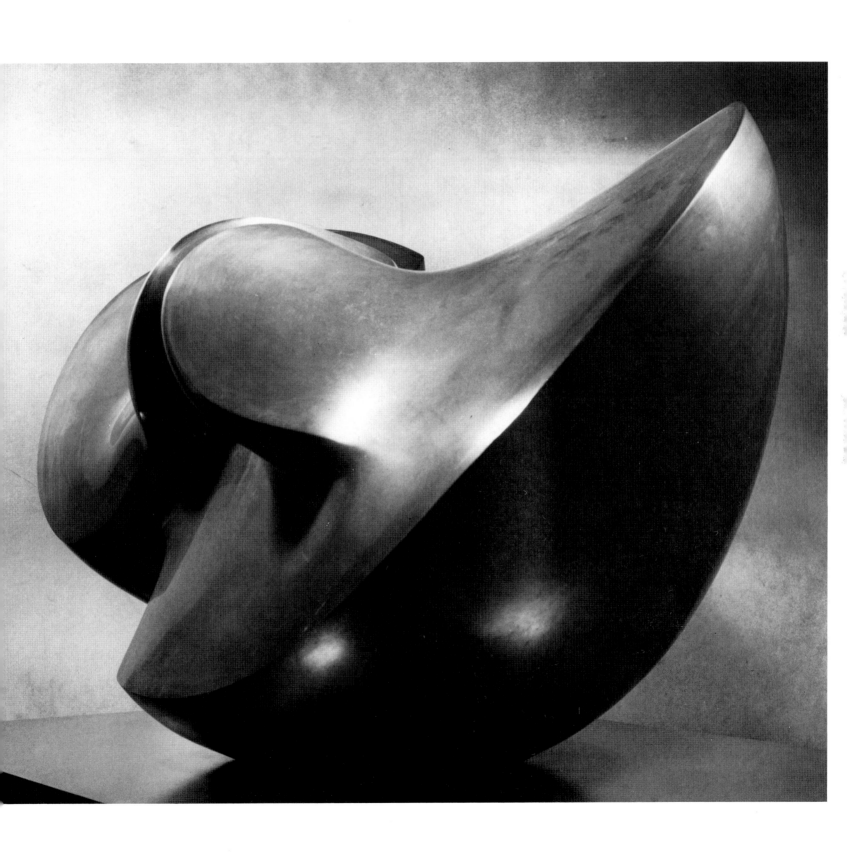

2 Another view of **Working Model for Divided Oval : Butterfly**

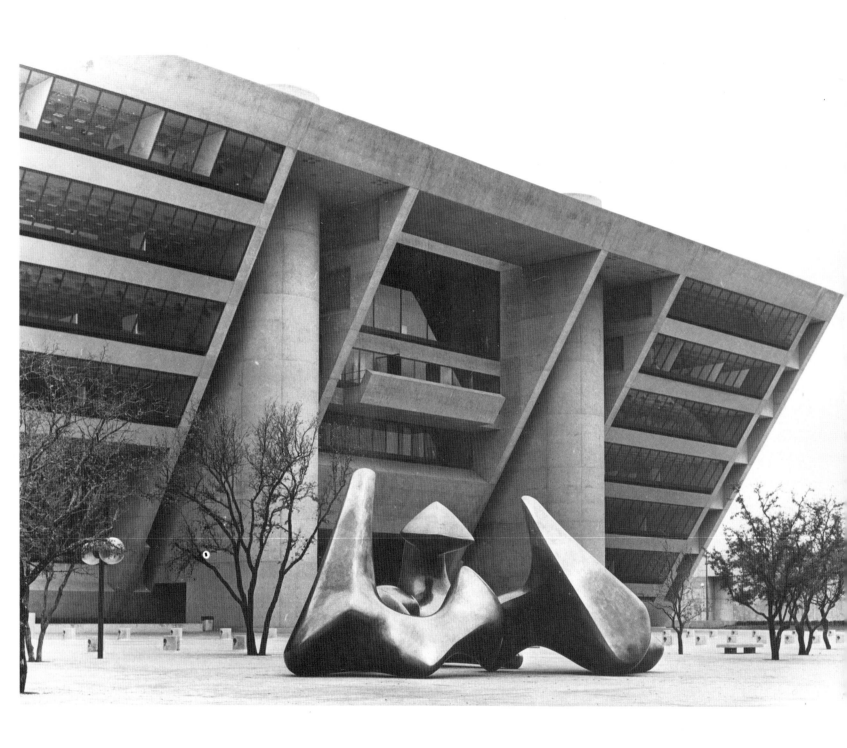

13 **Three Forms Vertebrae** (580a) 40ft/1219 L 1978/9

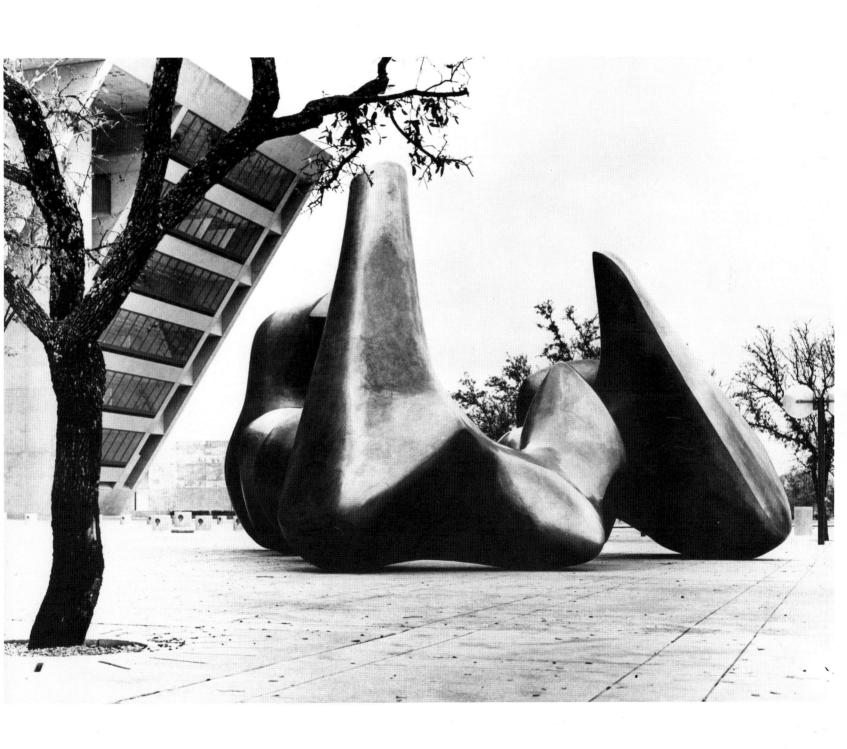

14 Another view of **Three Forms Vertebrae**

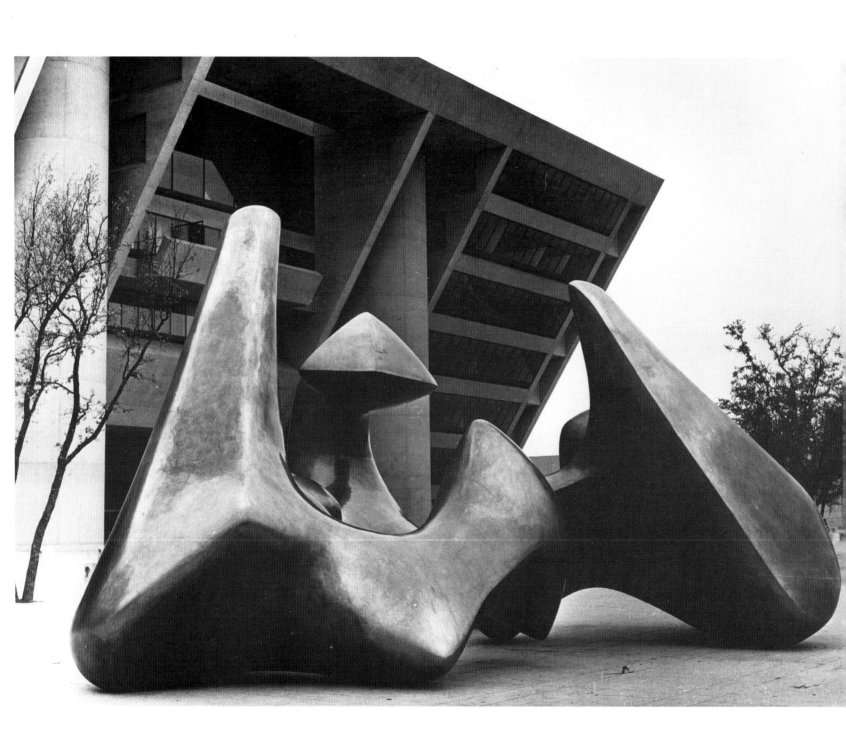

15 Another view of **Three Forms Vertebrae**

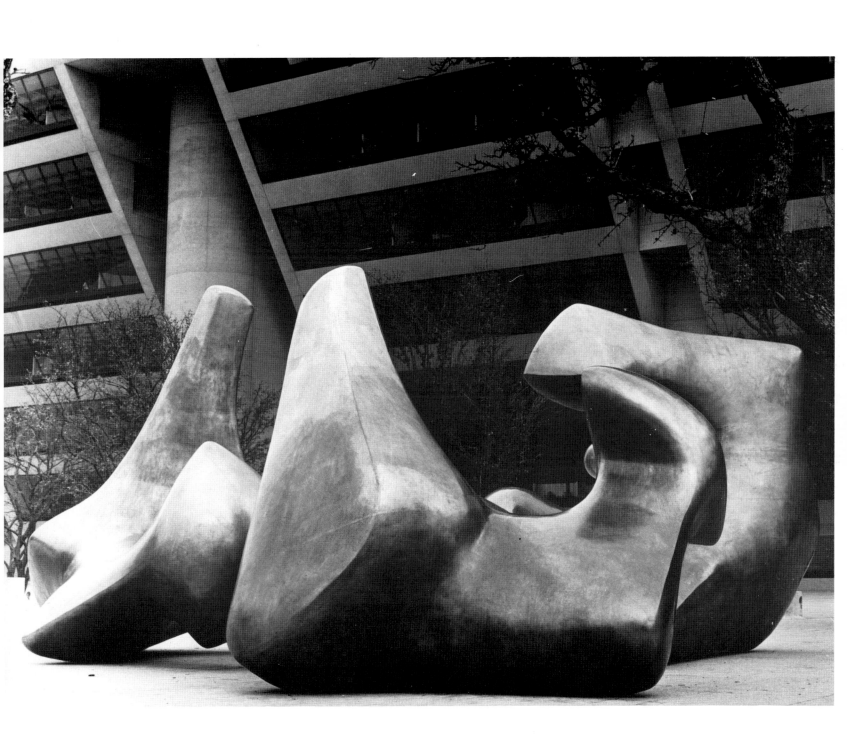

16 Another view of **Three Forms Vertebrae**

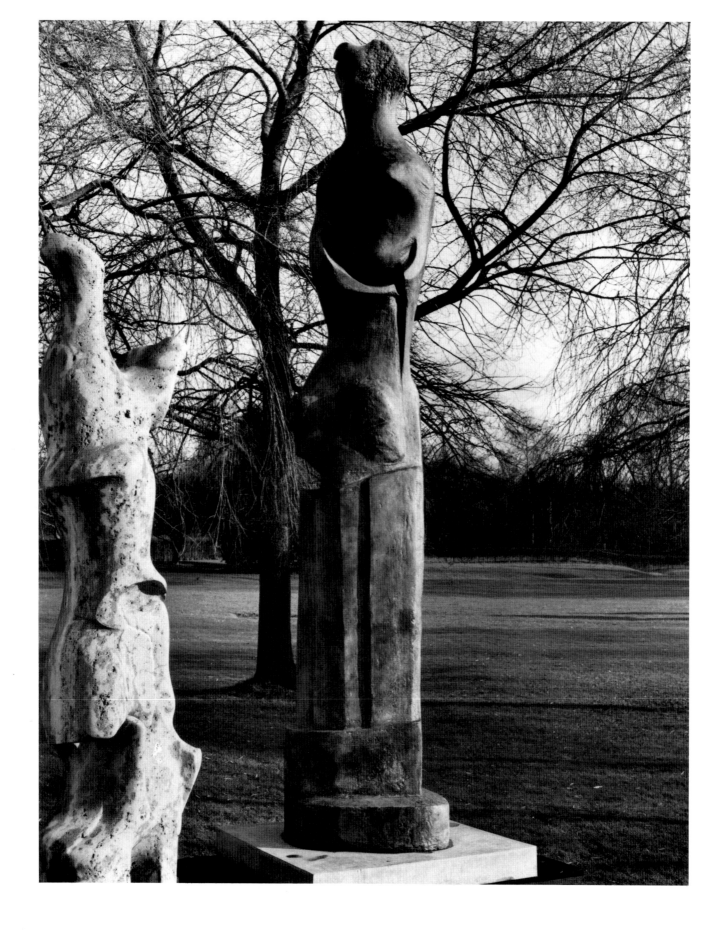

17 (above) **Upright Motive No. 9** (586a) 11ft/335·5 H 1979

18 (opposite) Another view of **Upright Motive No. 9**

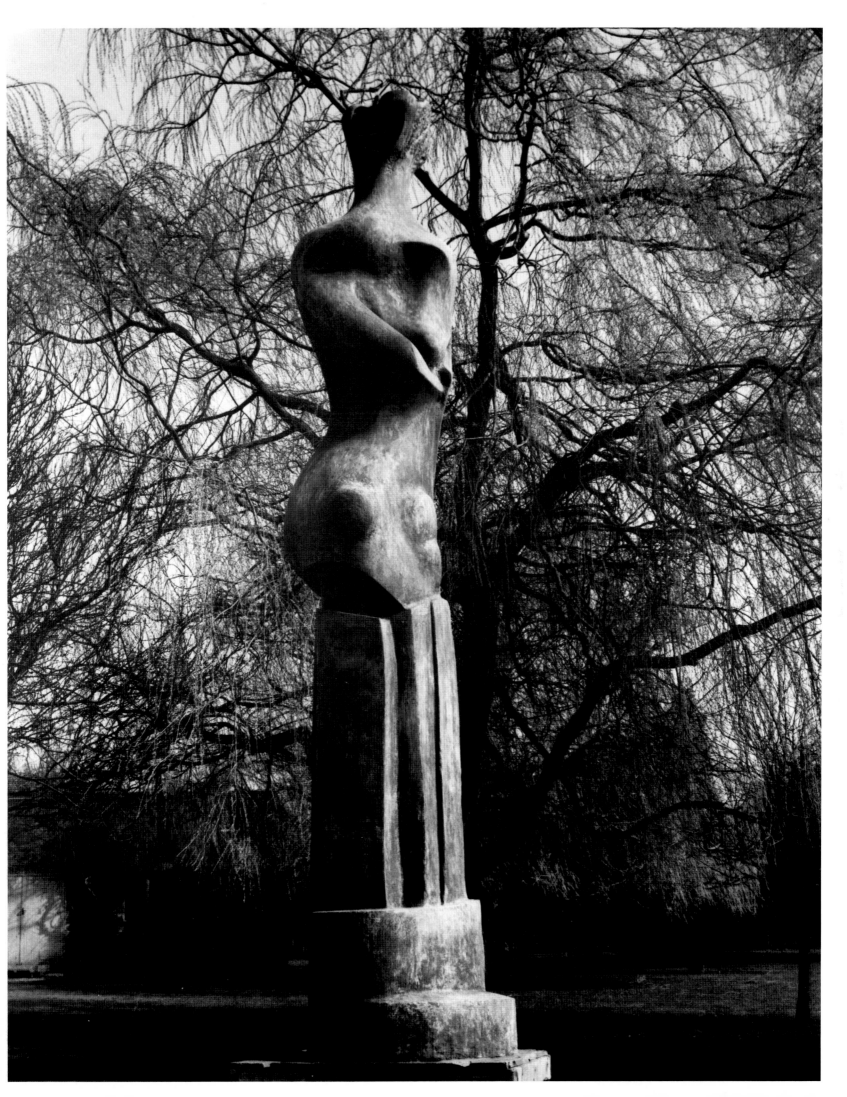

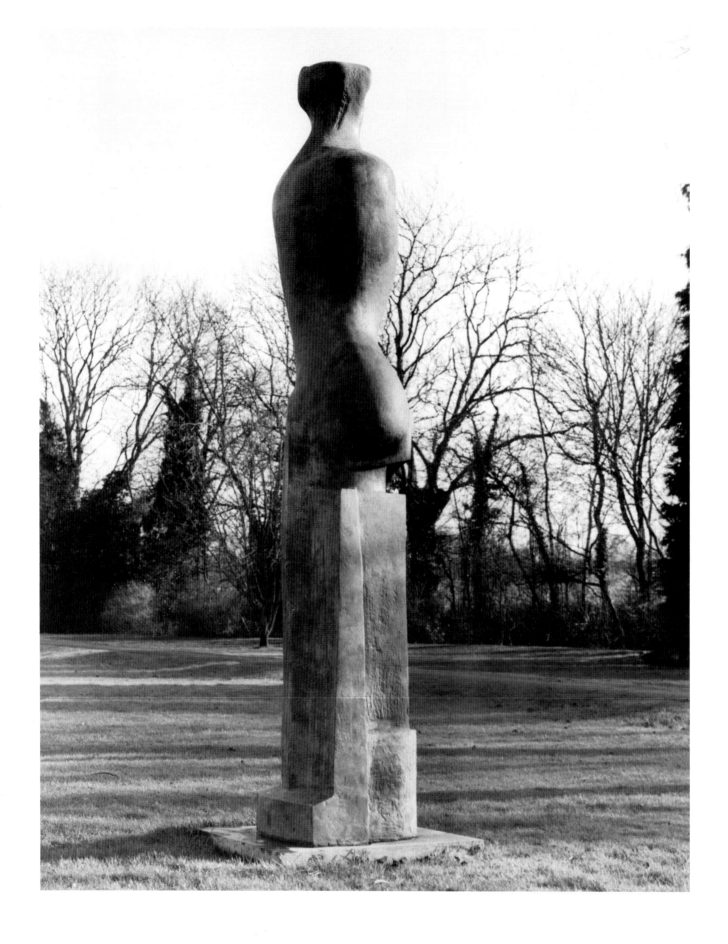

19 (above) Another view of **Upright Motive No. 9**

20 (opposite) Another view of **Upright Motive No. 9**

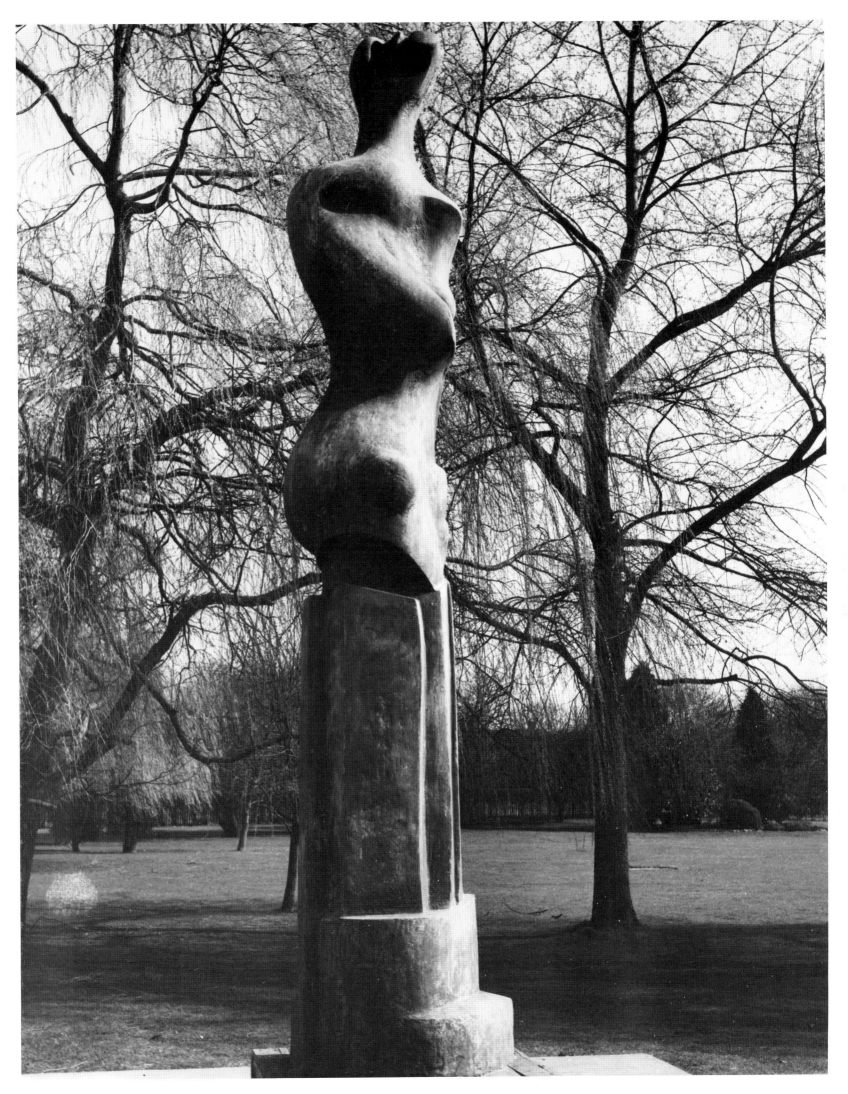

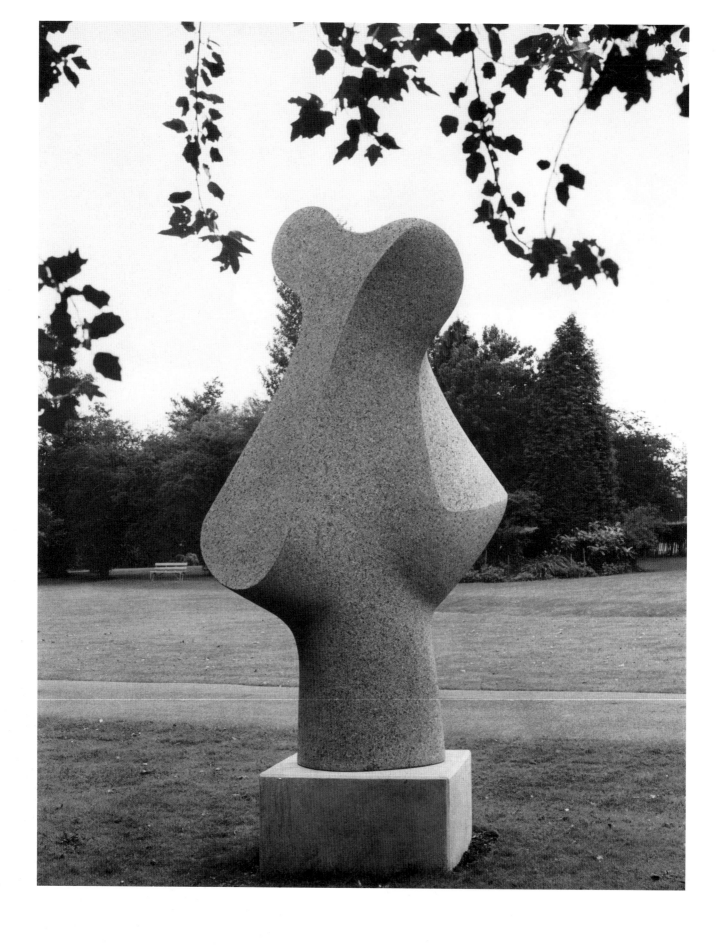

21 (above) **Stone Form** (652b) 8ft 10in/269 H carved 1984

22 (opposite) Another view of **Stone Form**

On following pages:

23 Another view of **Stone Form**

24 Another view of **Stone Form**

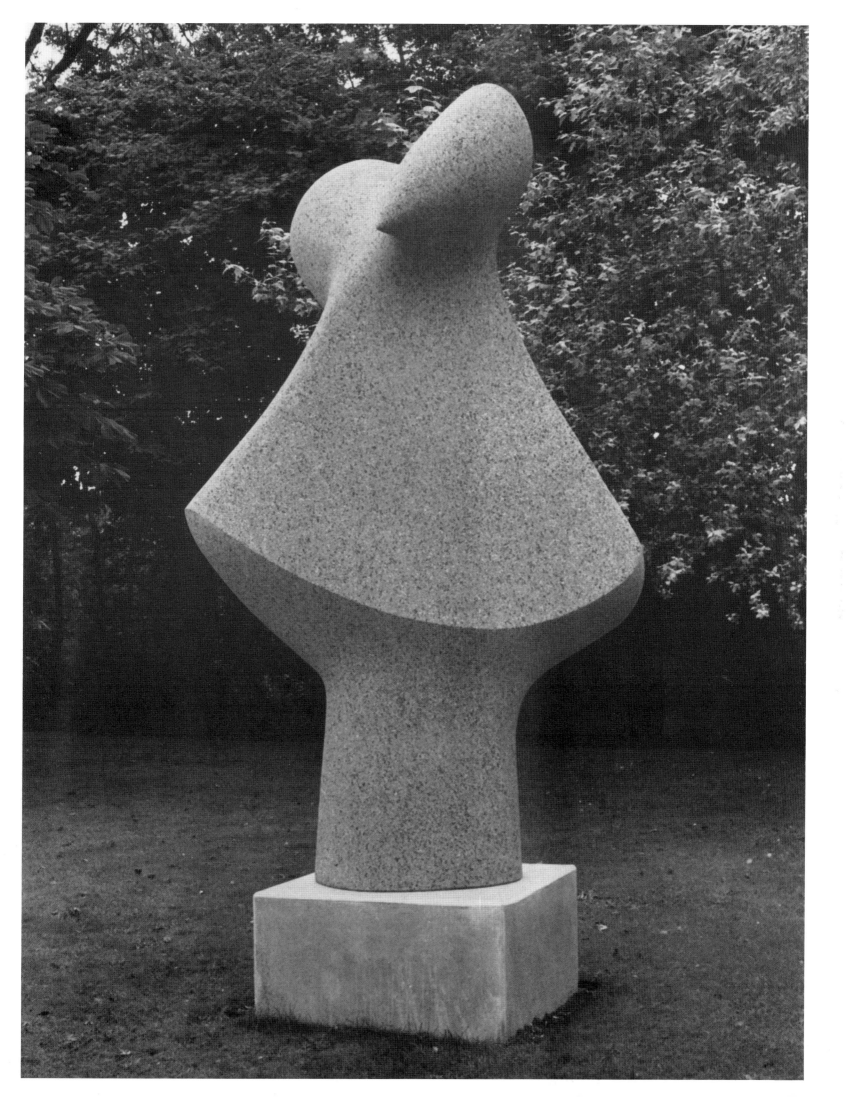

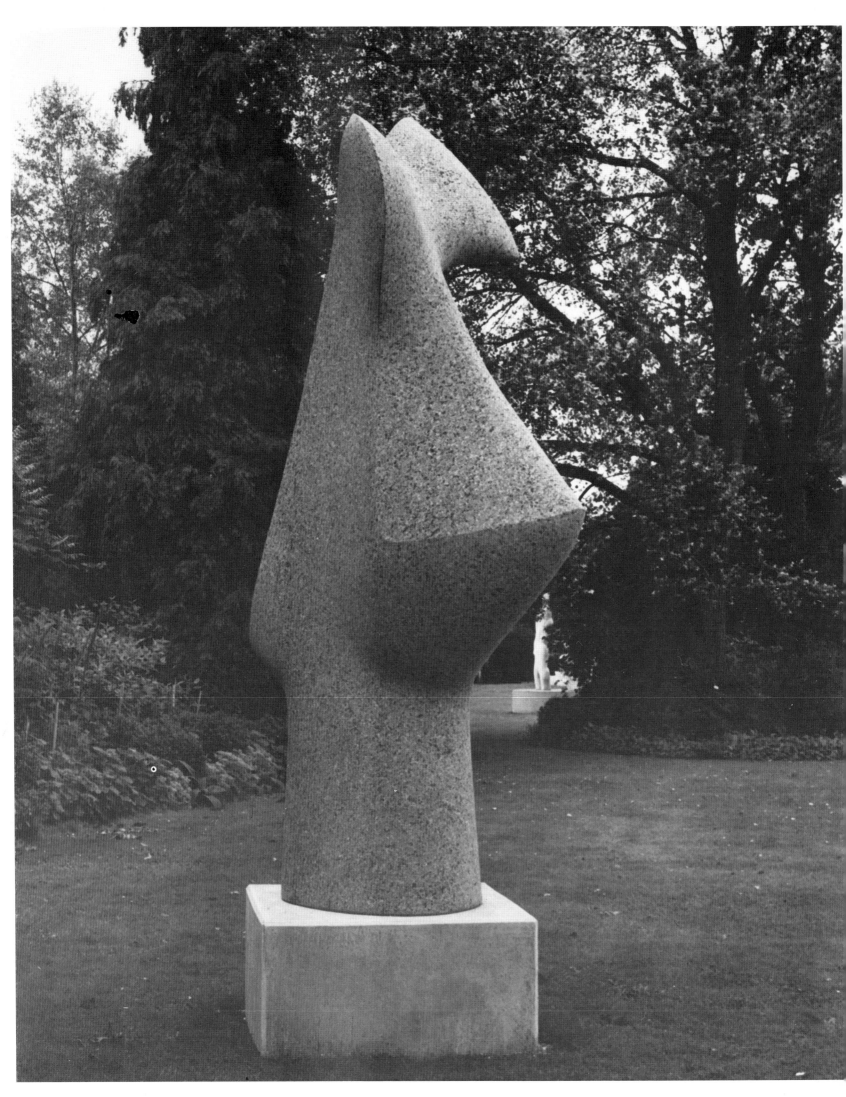

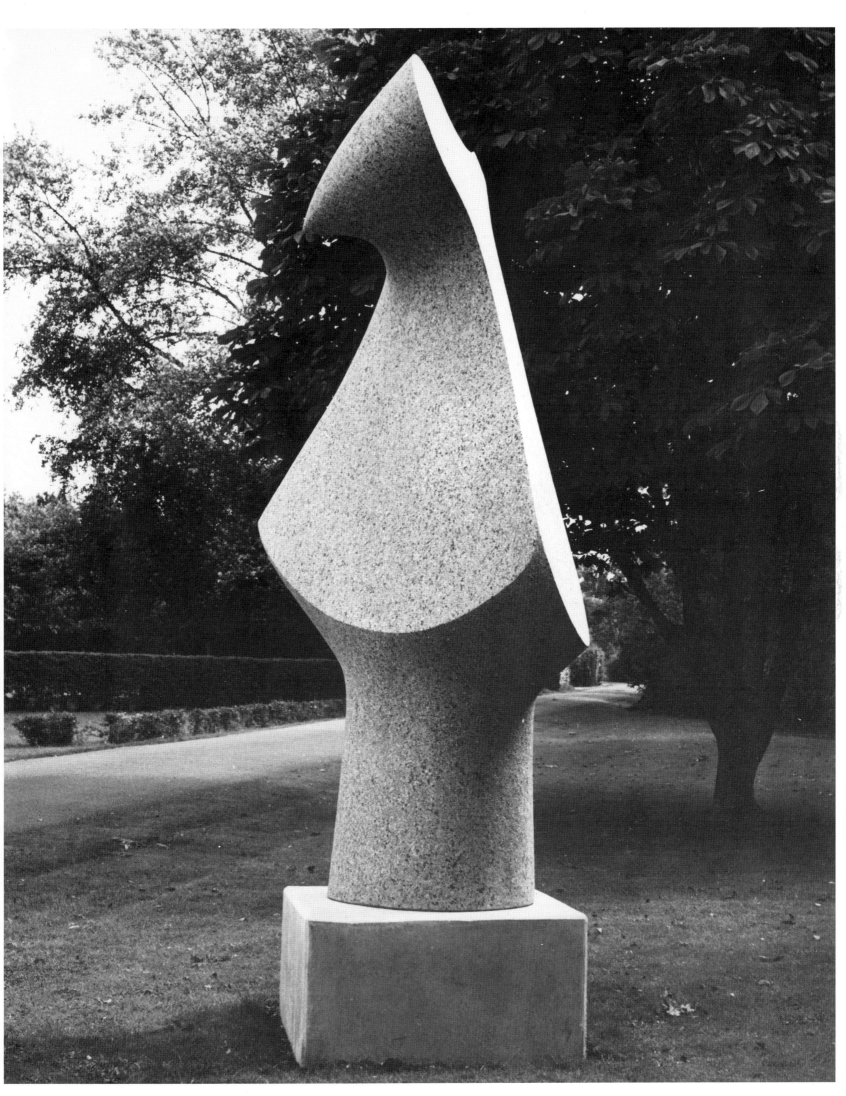

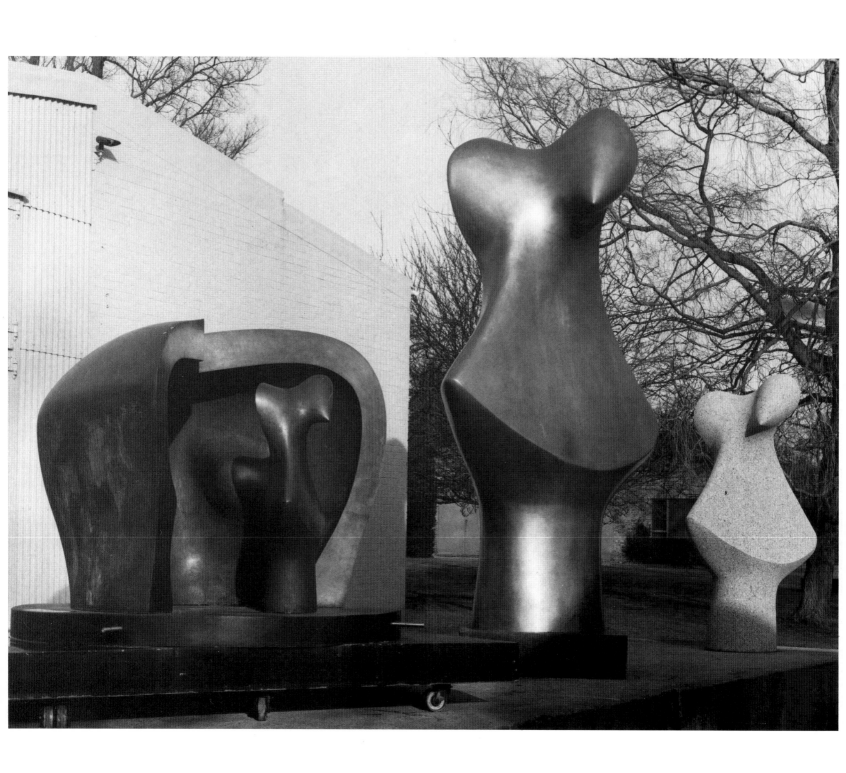

25 Another view of **Stone Form** including views of **Figure in a Shelter** (652a) and **Bronze Form** (652d)

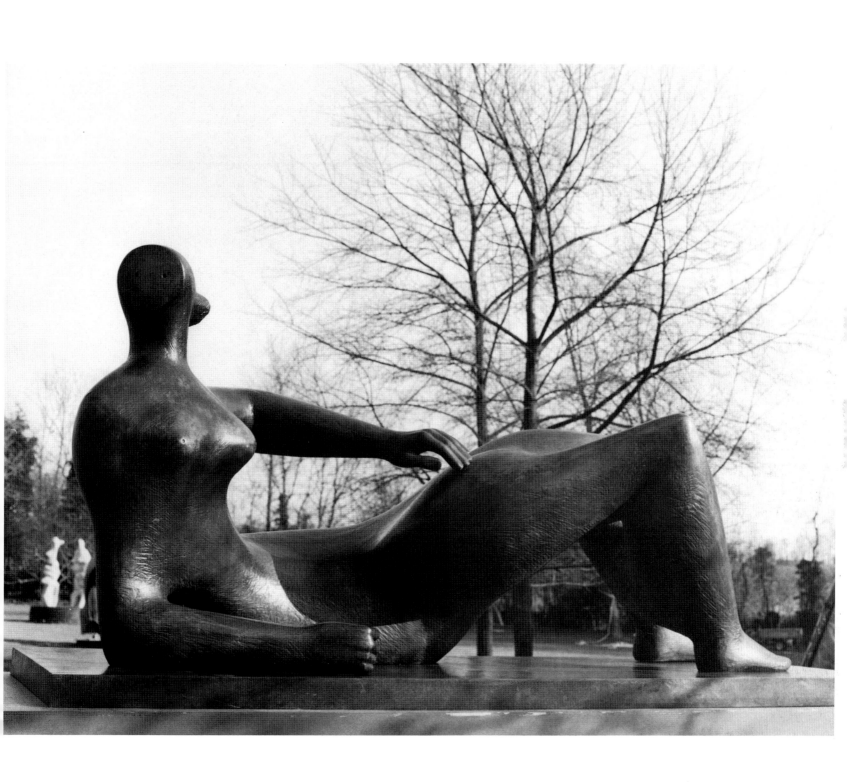

26 **Reclining Figure** (677a) 93/236 L 1982

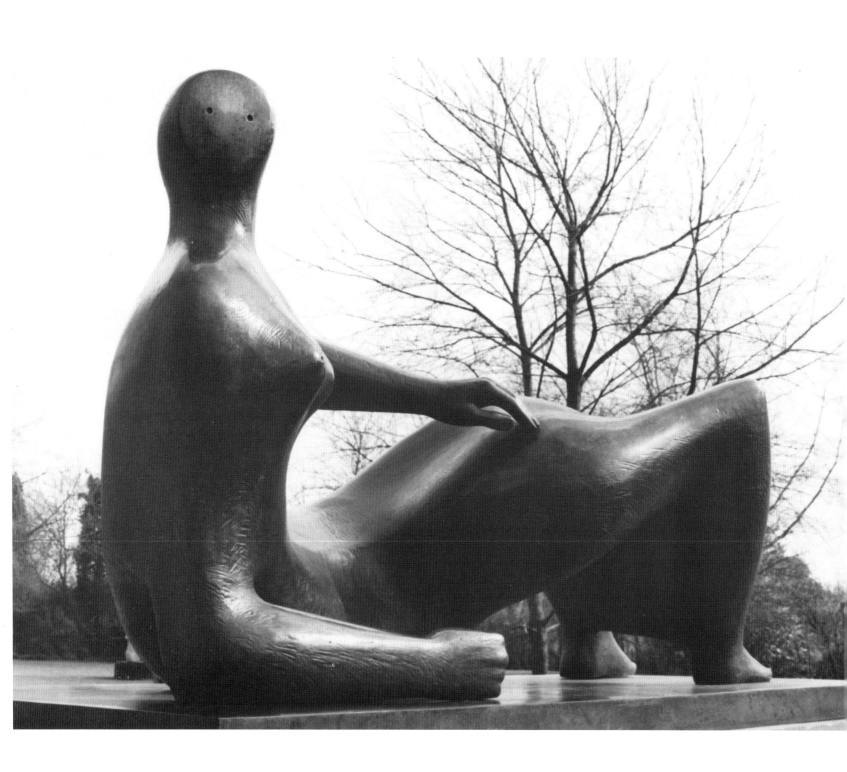

27 Another view of **Reclining Figure**

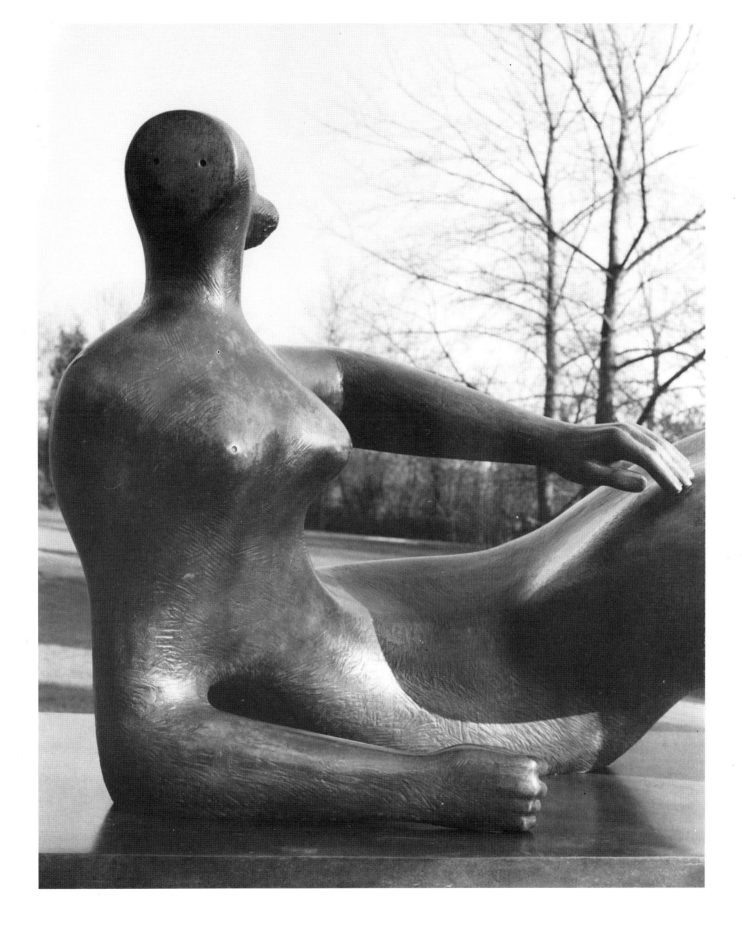

28 Detail of **Reclining Figure**

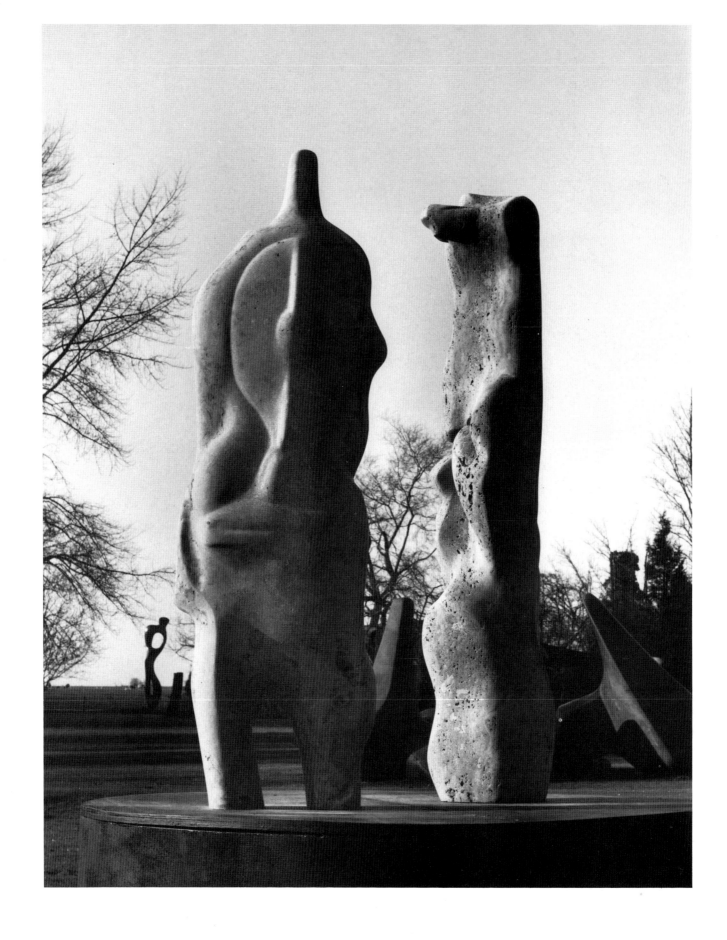

29 (above) **Two Standing Figures** (715a) 8ft 1in/246·5 H 1981

30 (opposite) Another view of **Two Standing Figures**

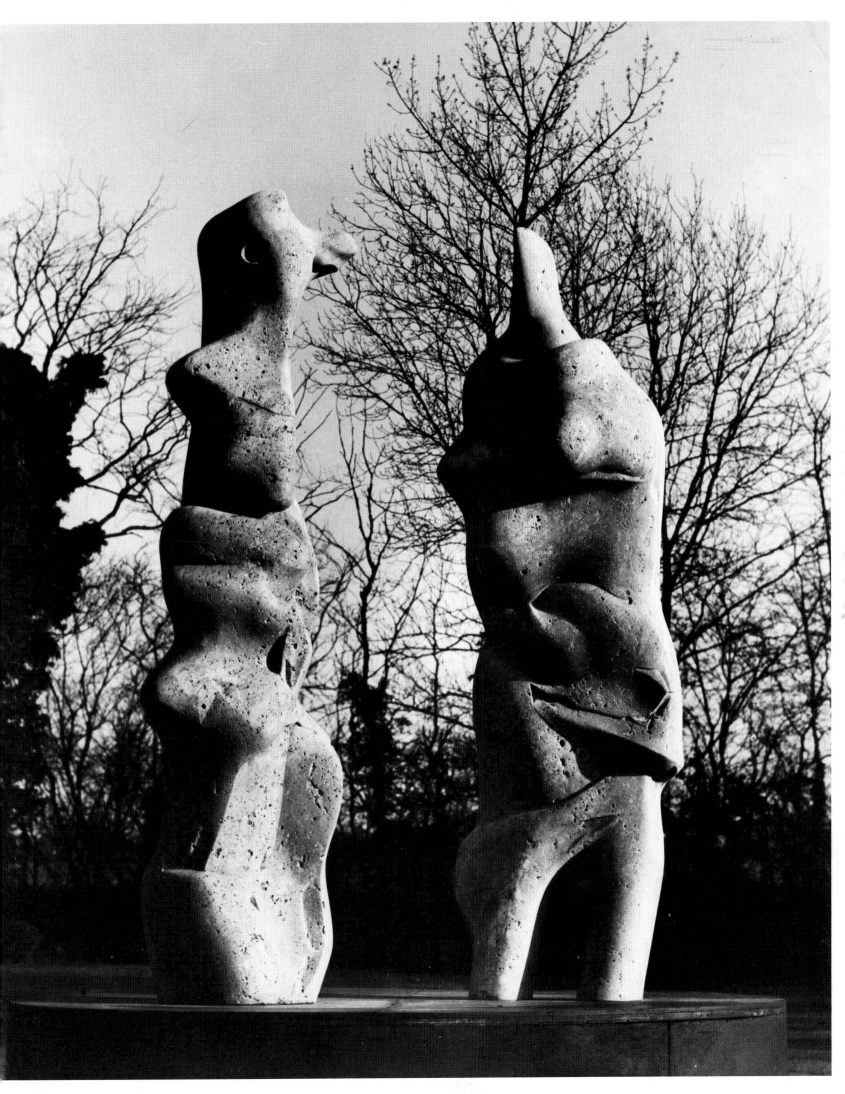

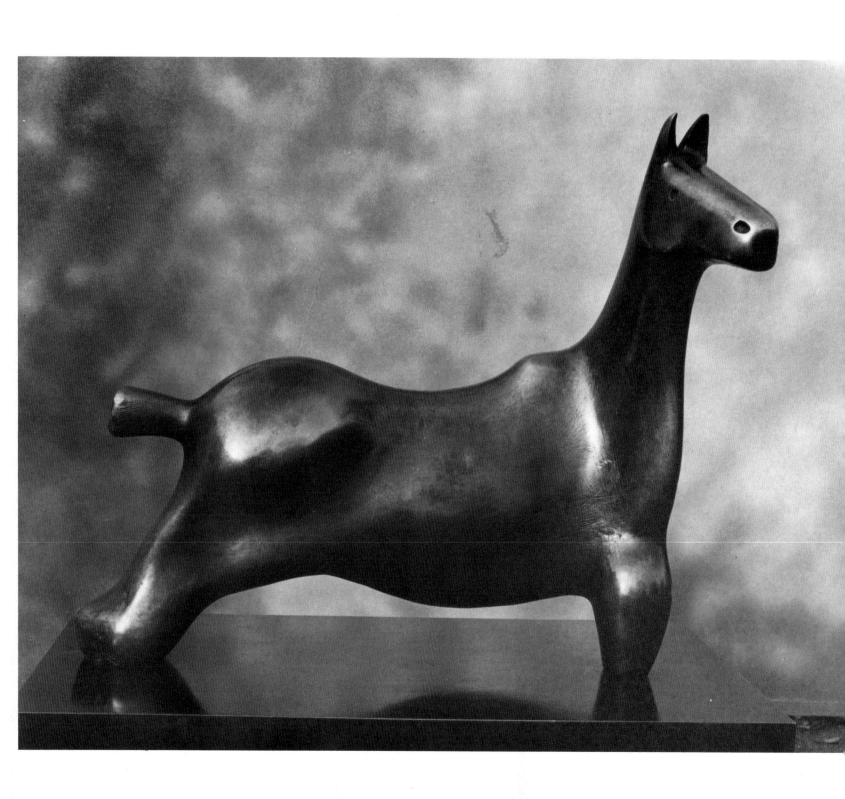

31 **Horse** (740a) 27/68·5 L cast 1984

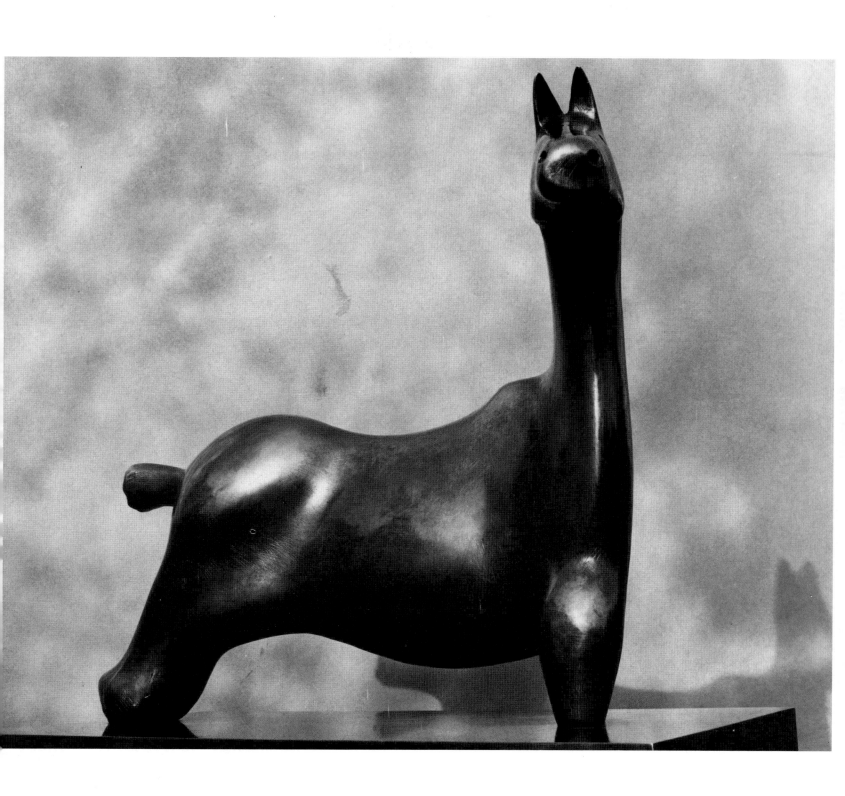

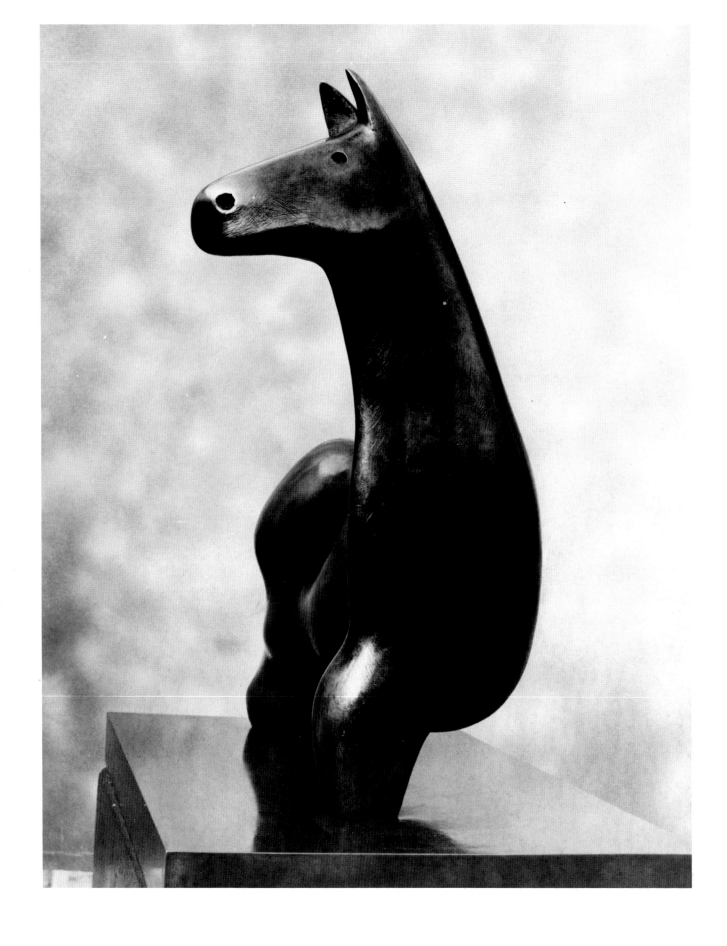

33 Another view of **Horse**

PLATES

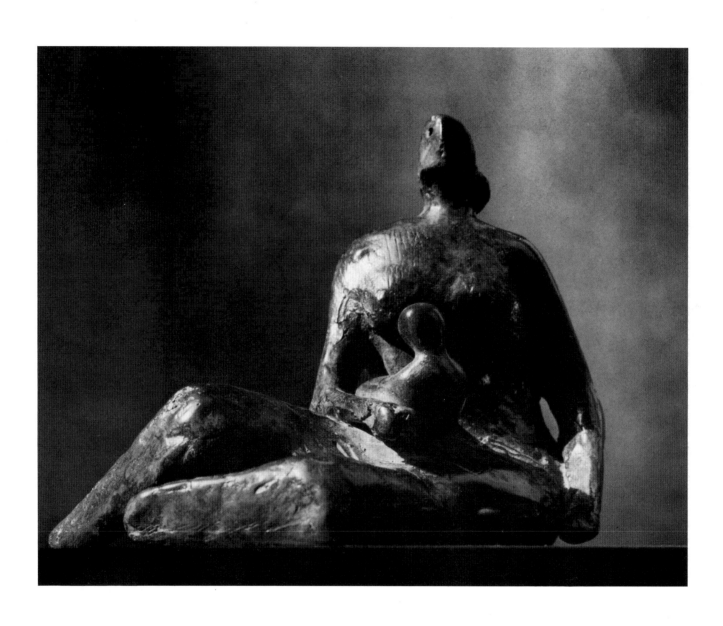

34 **Draped Seated Mother and Child on Ground** (783) 8/20·5 L 1980

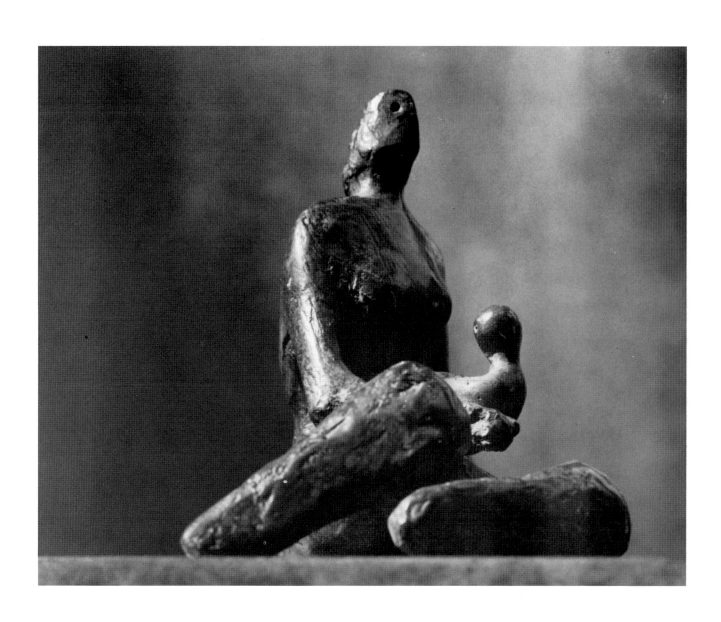

35 Another view of **Draped Seated Mother and Child on Ground**

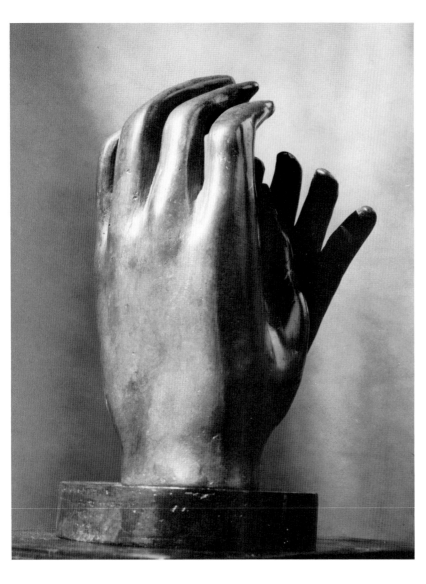 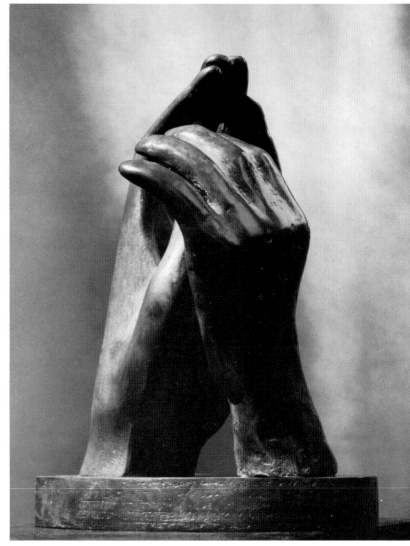

36 Two views of **Mother and Child : Hands** (785) 7¾/19·5 H 1980

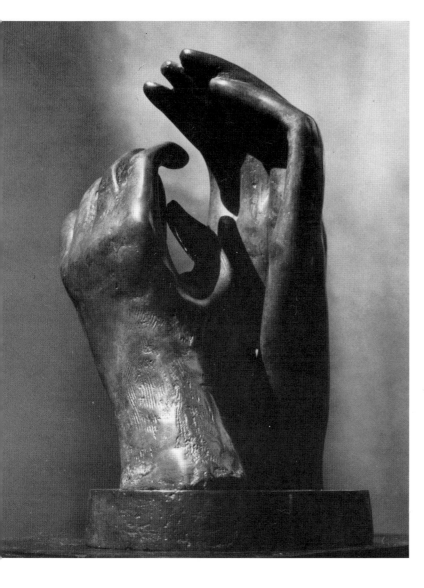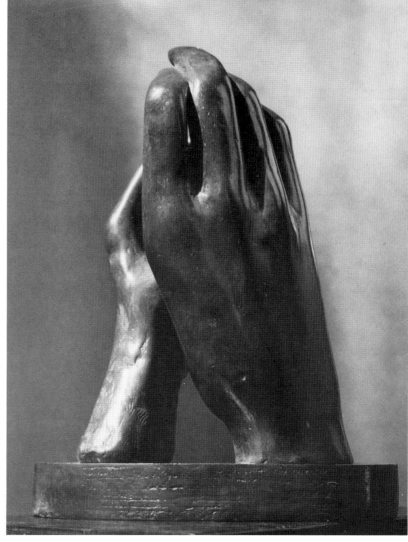

37 Two more views of **Mother and Child : Hands**

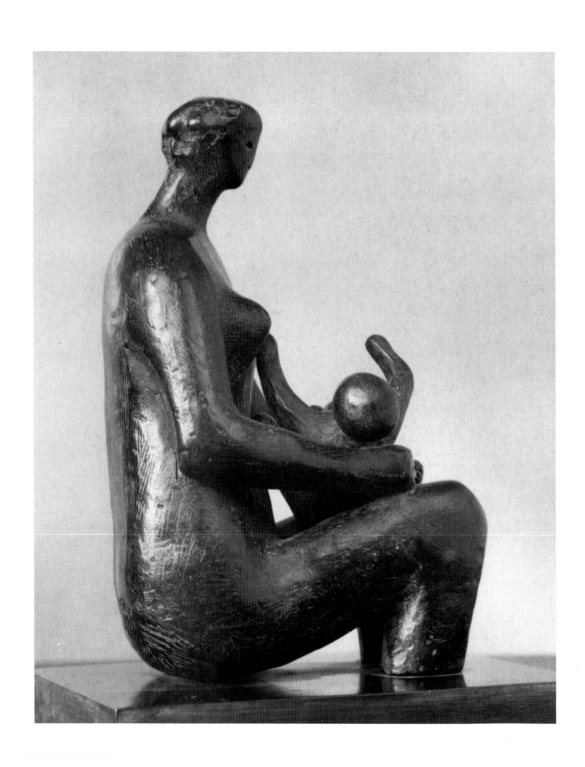

38 Mother and Child : Round Form (789) 7½/19 H 1980

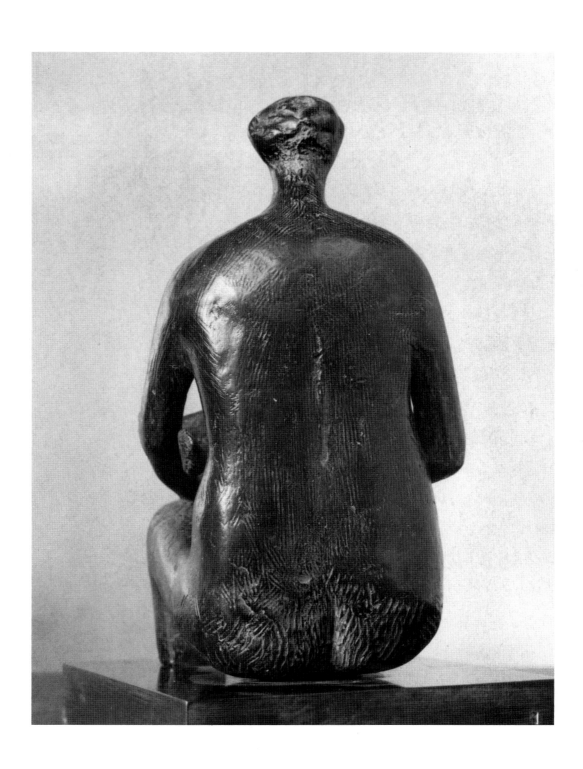

39 Another view of **Mother and Child: Round Form**

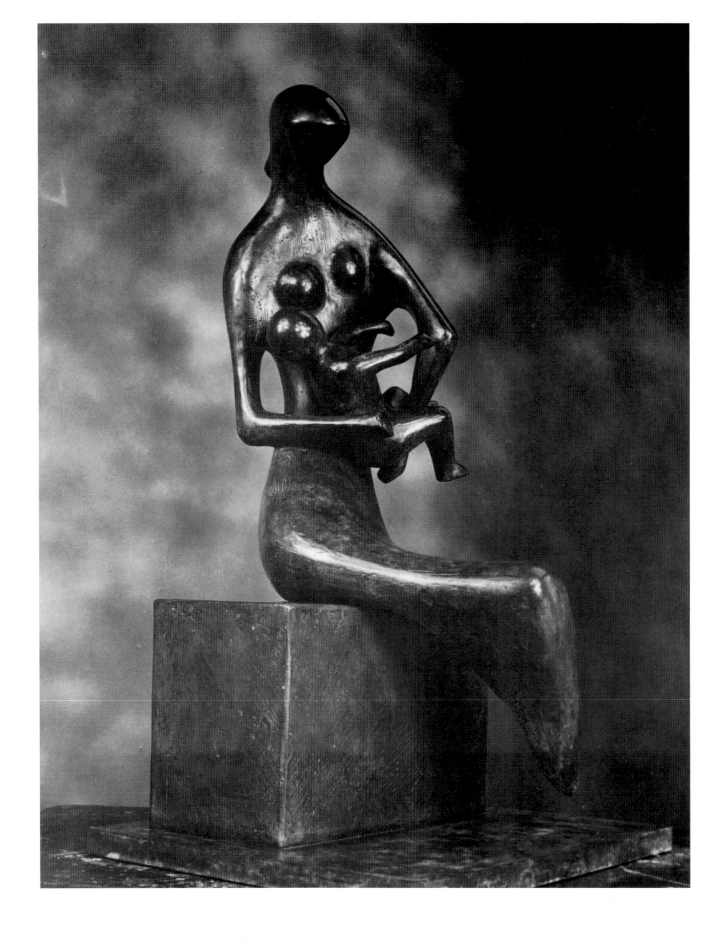

40 **Mother and Child Curved** (792) 23/58·5 H 1983

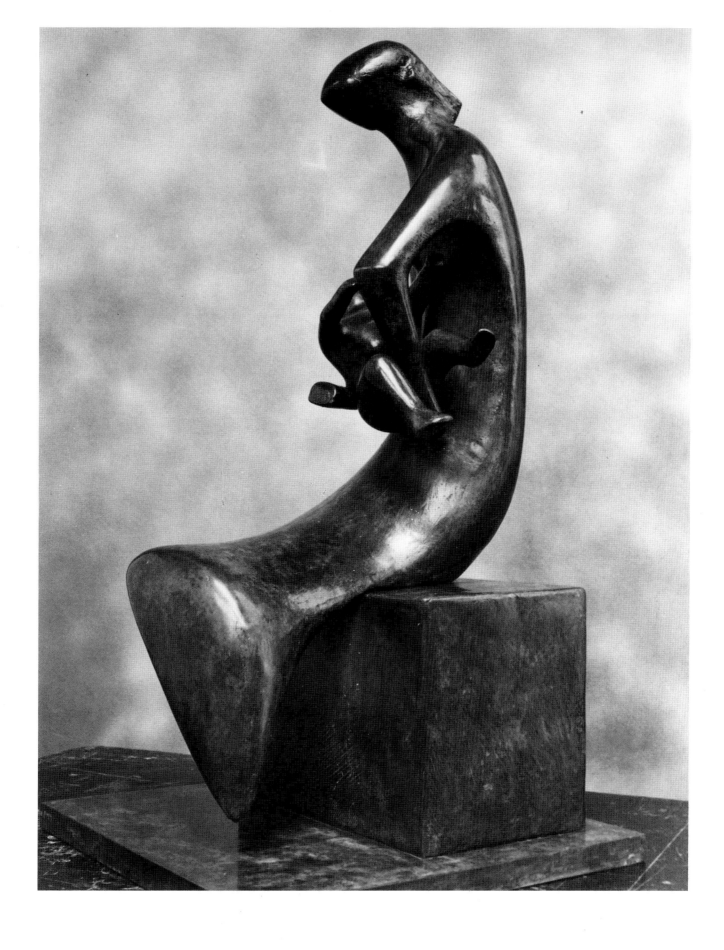

1 Another view of **Mother and Child Curved**

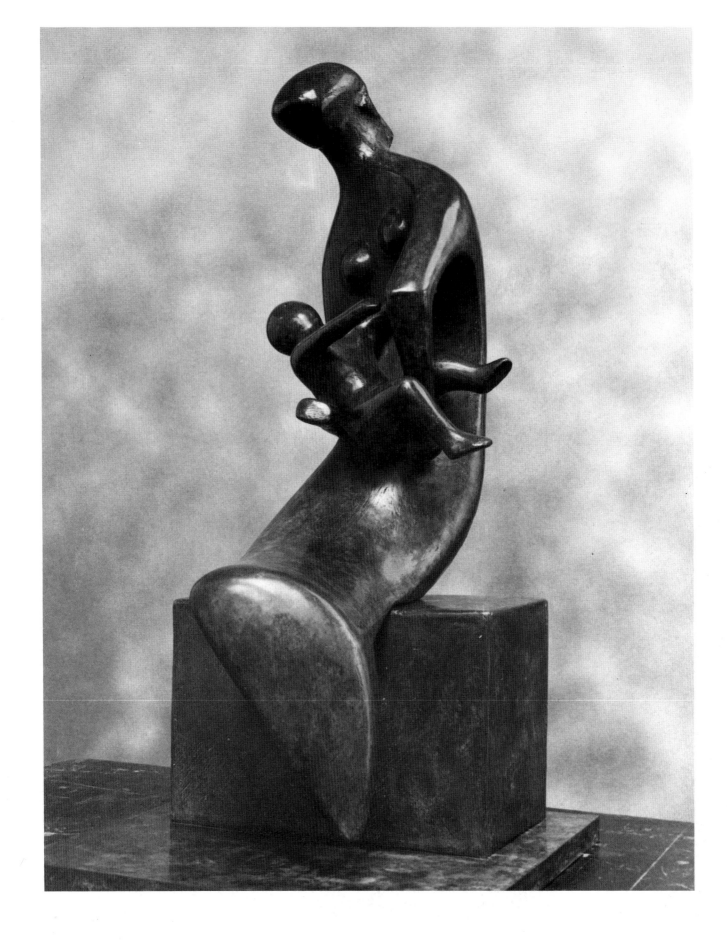

42 (above) Another view of **Mother and Child Curved**

43 (opposite) Detail of **Mother and Child Curved**

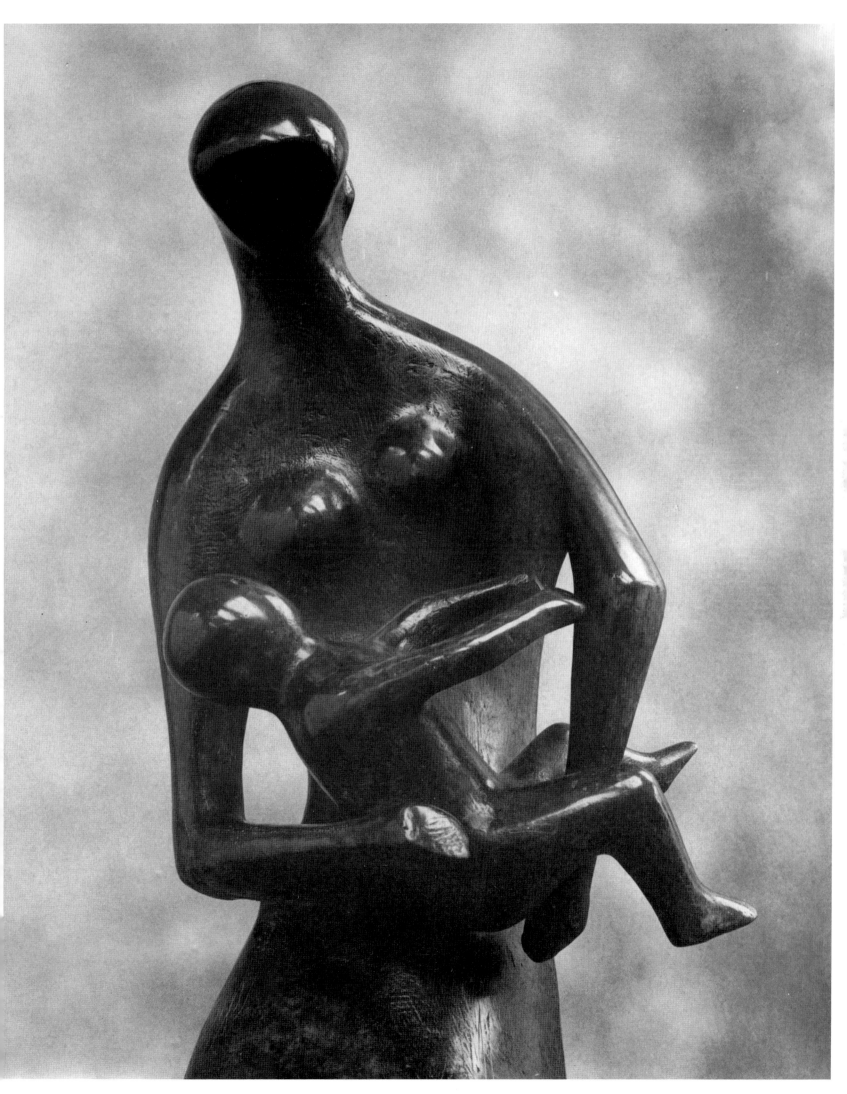

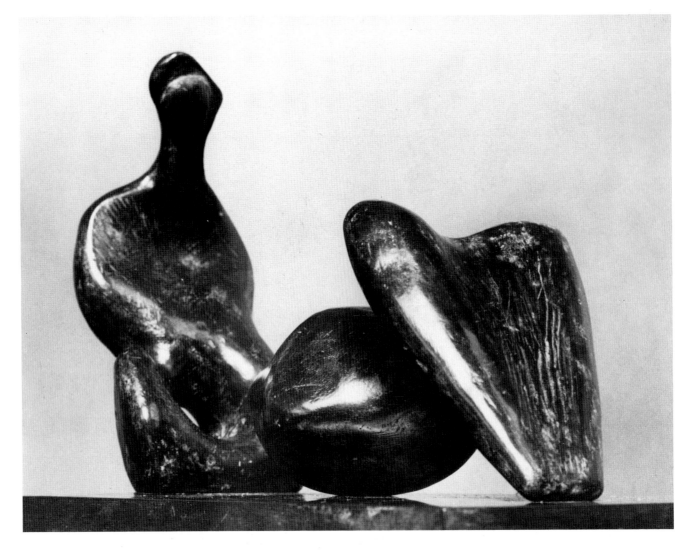

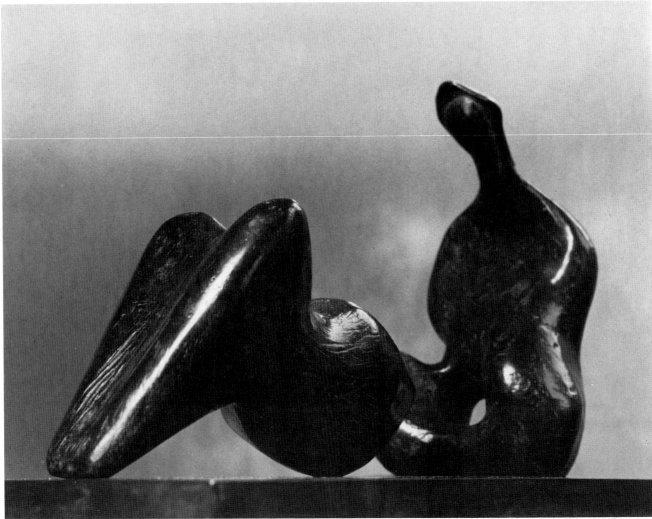

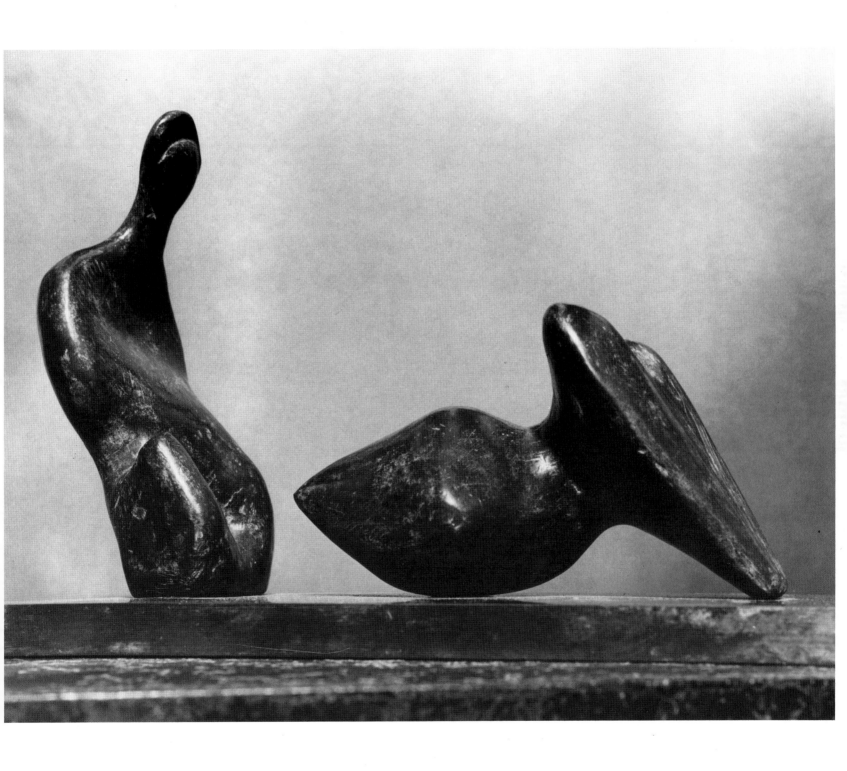

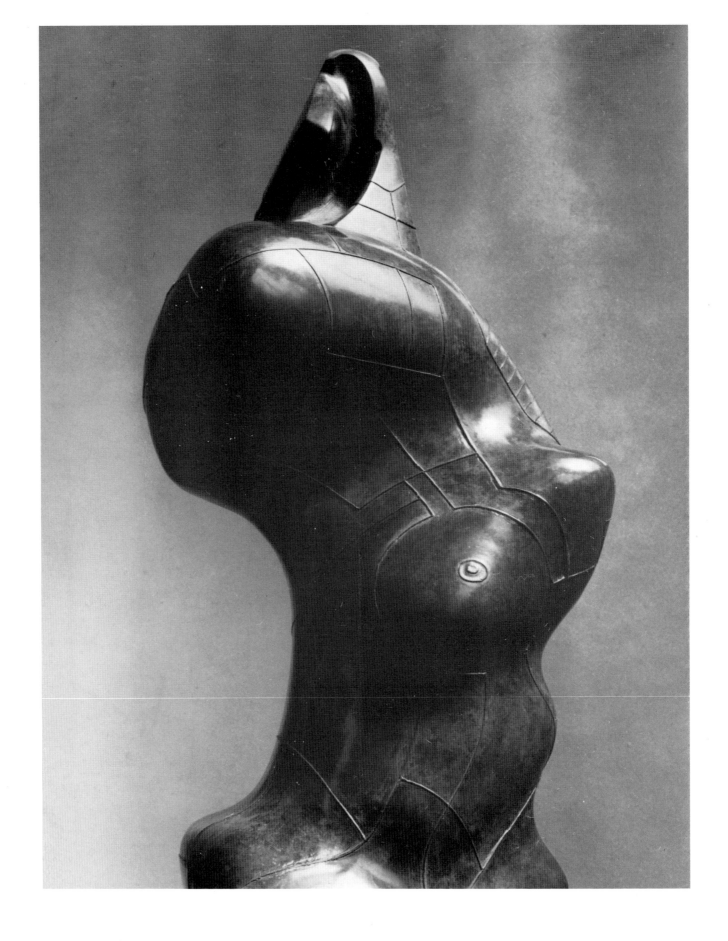

46 (above) **Three-Quarter Figure: Lines** (797) 33/84 H 1980

47 (opposite) Another view of **Three-Quarter Figure: Lines**

On following pages:

48 and 49 Two more views of **Three-Quarter Figure: Lines**

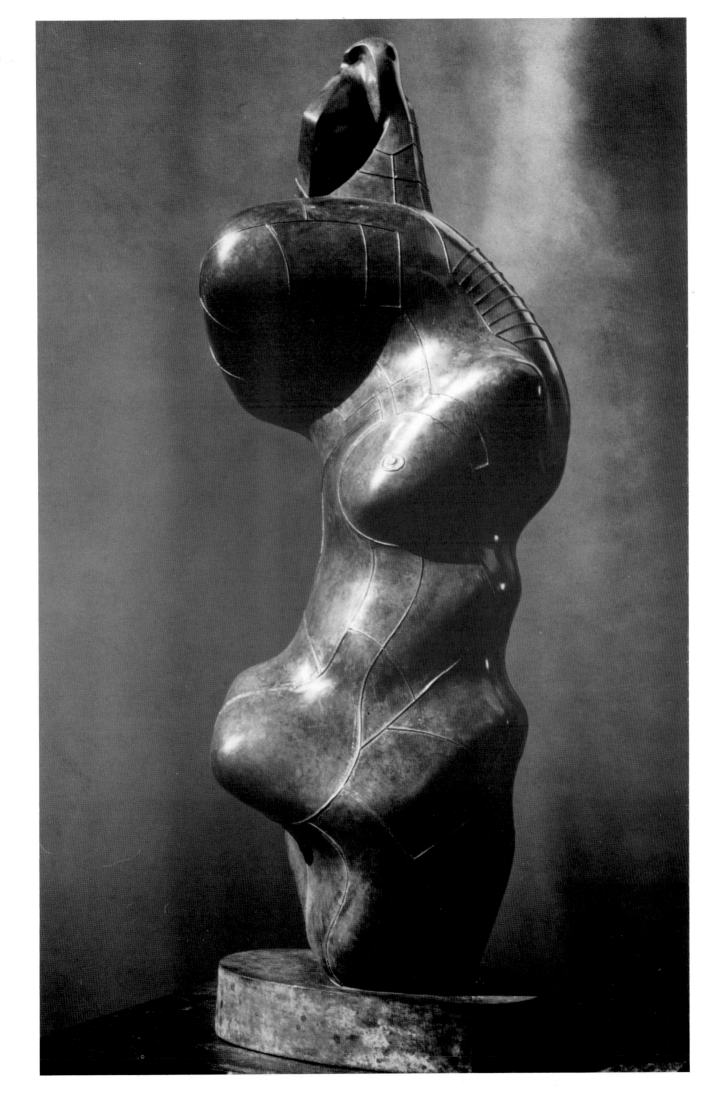

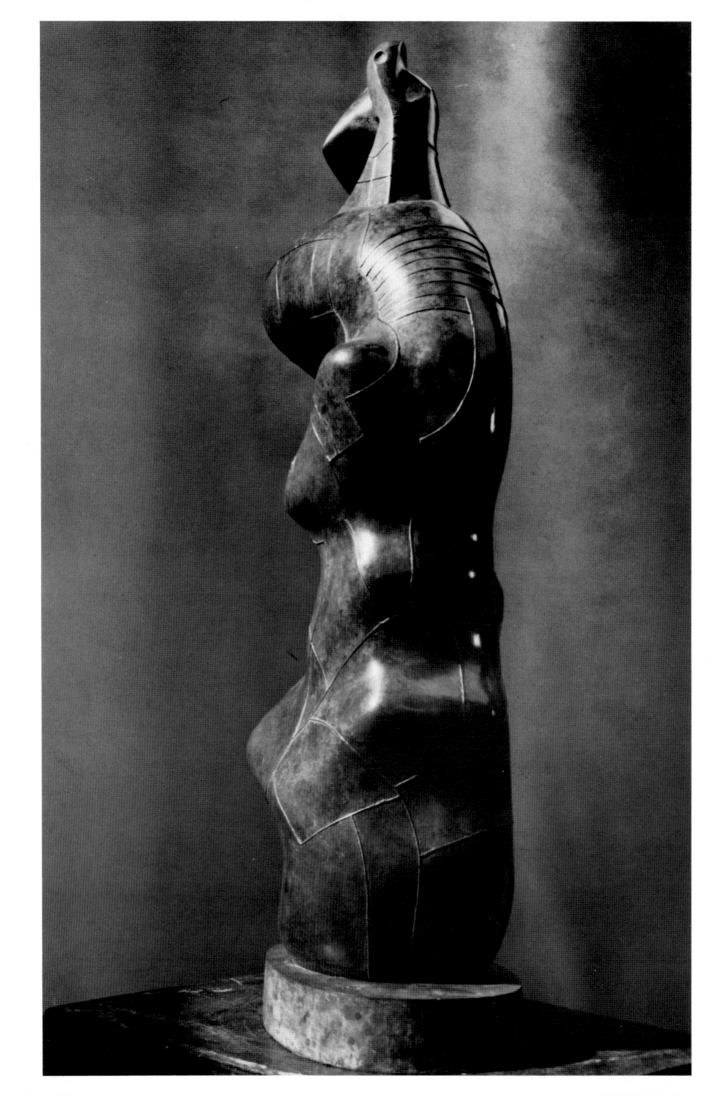

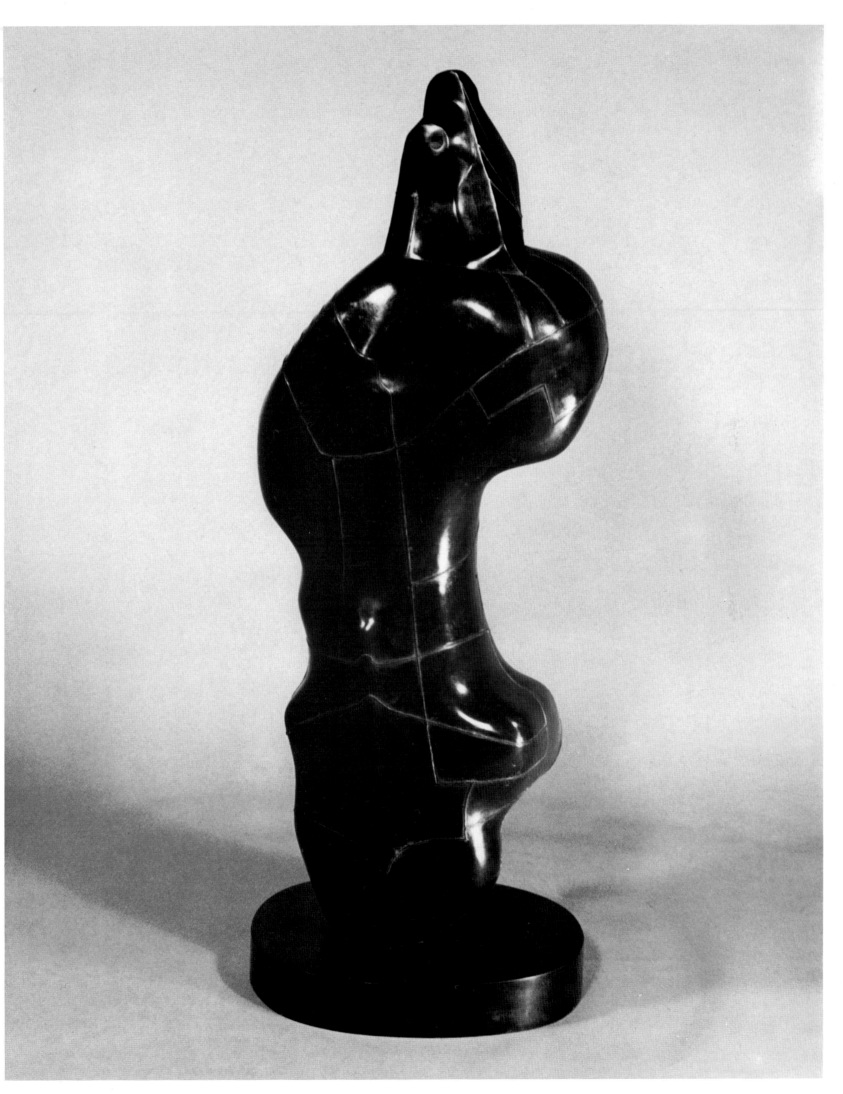

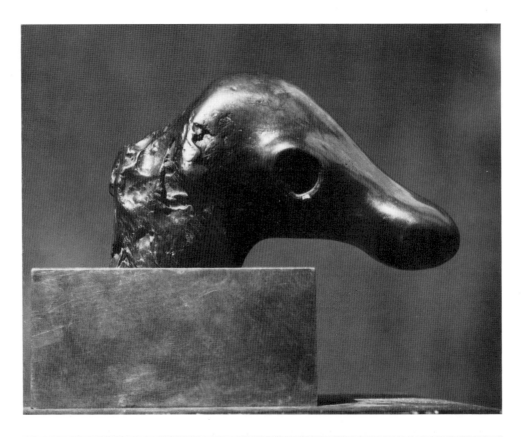

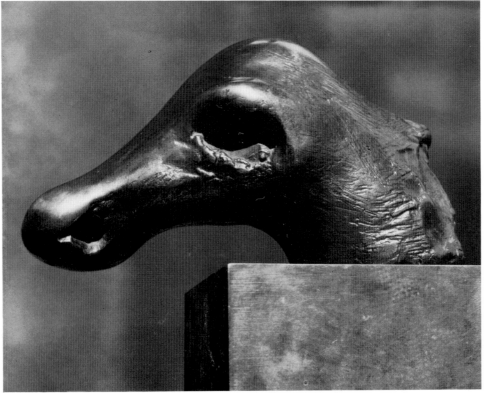

50 (above) Two views of **Dog's Head** (800) 4¾/12 L 1980

51 (opposite) Two views of **Horse's Head** (801) 7¾/20 L 1980

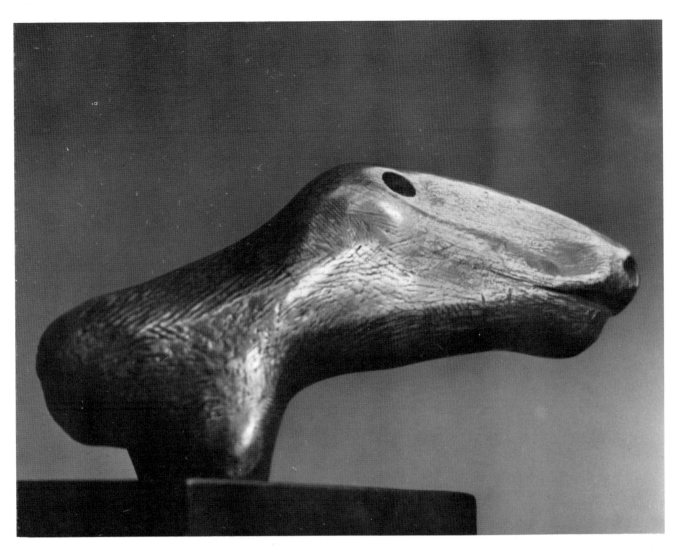
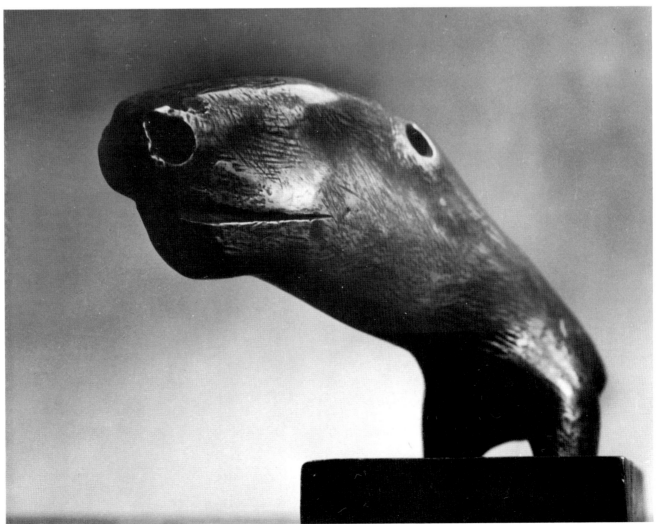

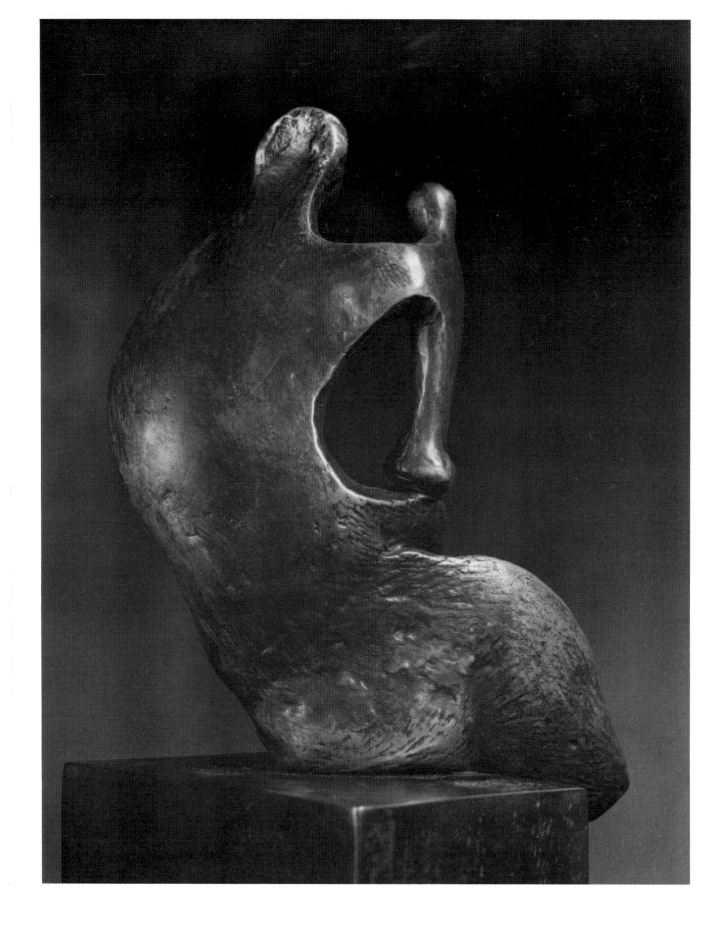

52 Seated Mother and Child: Thin (804) 9½/24 H 1980

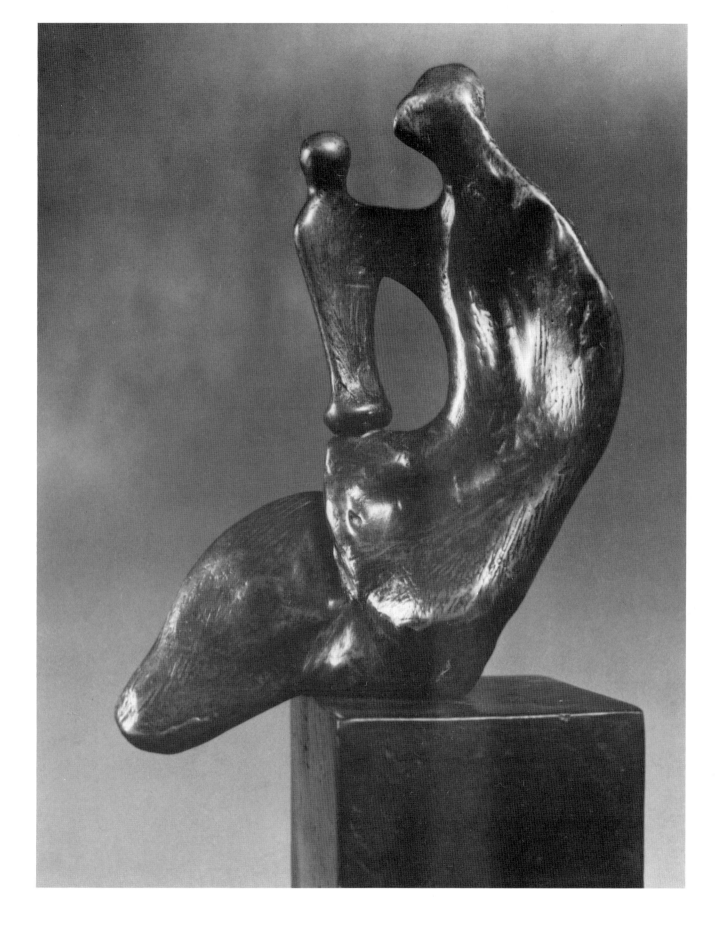

3 Another view of **Seated Mother and Child : Thin**

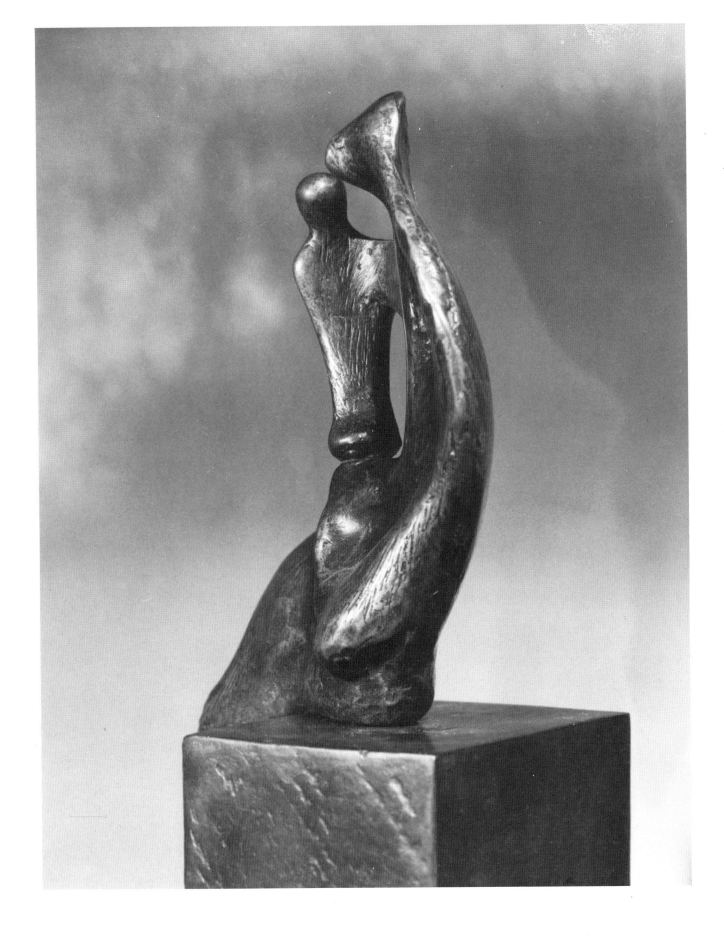

54 Another view of **Seated Mother and Child : Thin**

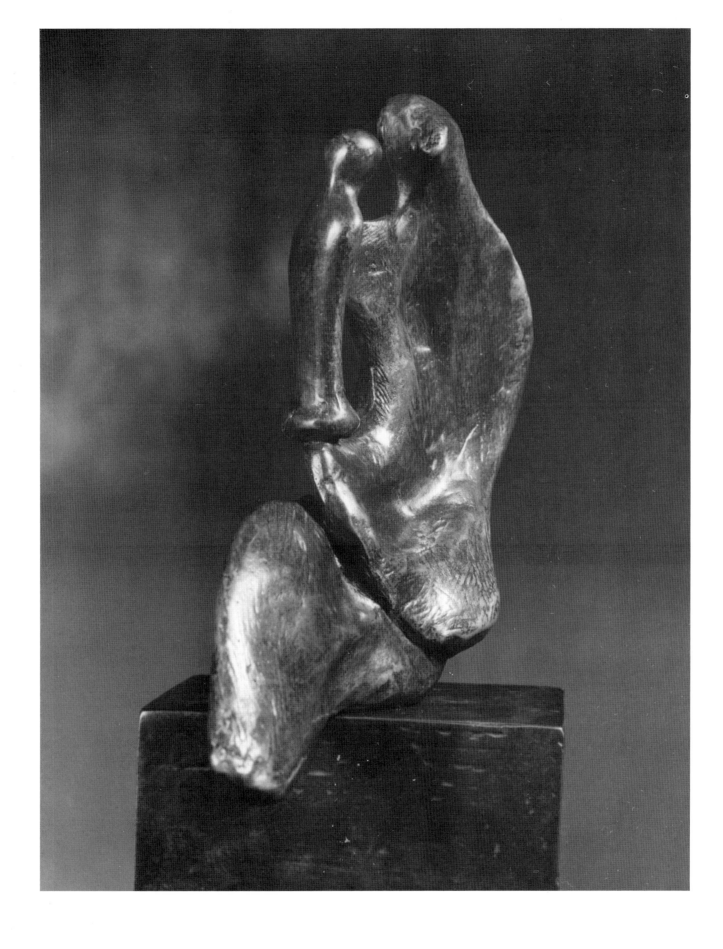

55 Another view of **Seated Mother and Child : Thin**

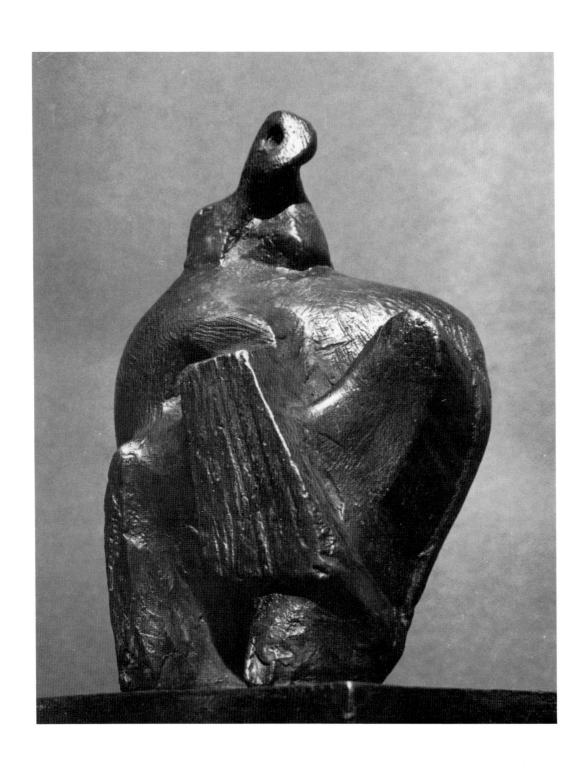

56 **Three-Quarter Figure: Wedge** (806) 6¾/17 H 1980

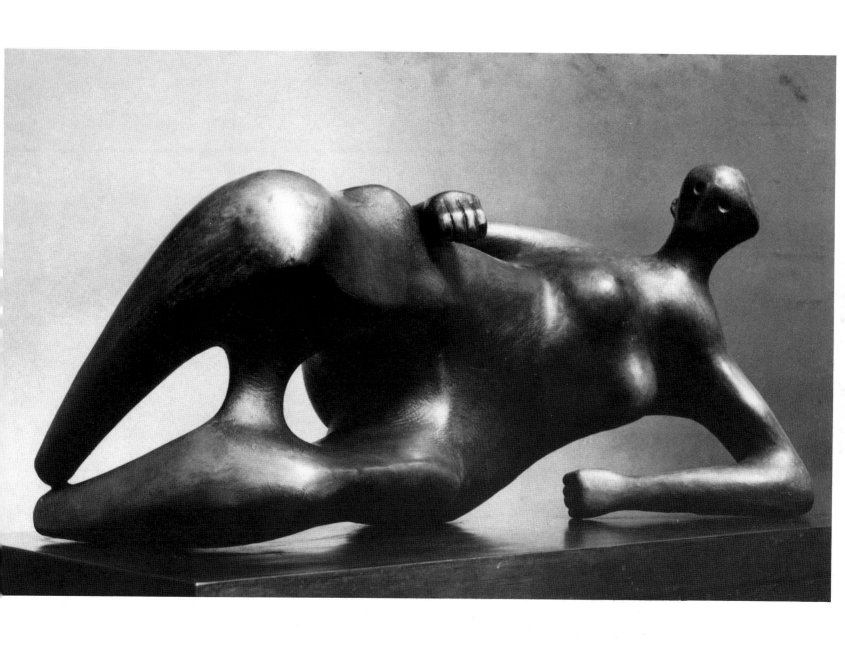

7 Working Model for Reclining Woman : Elbow (809) 34/86·5 L 1981

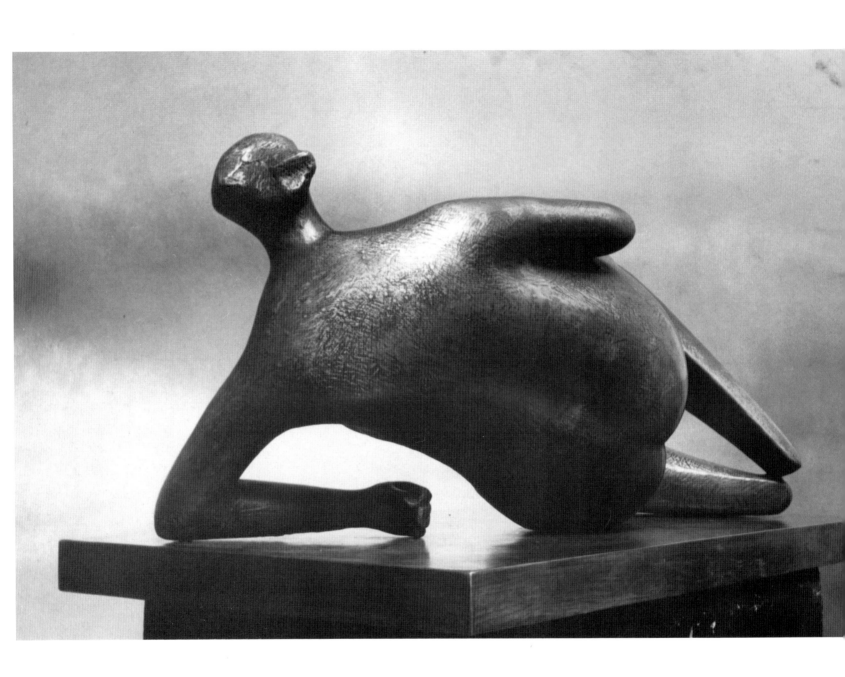

58 Another view of **Working Model for Reclining Woman : Elbow**

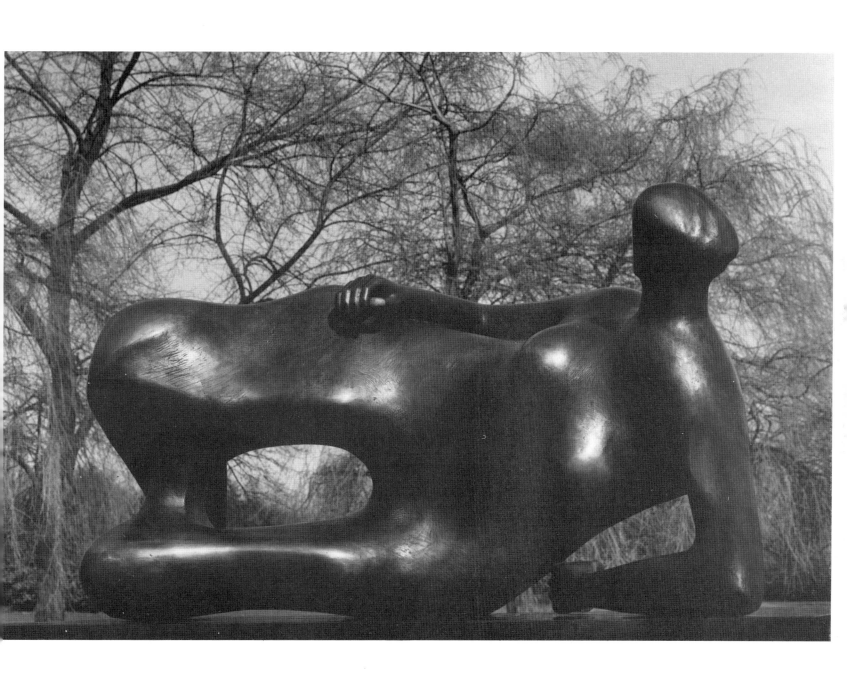

69 **Reclining Woman: Elbow** (810) 87/221 L 1981

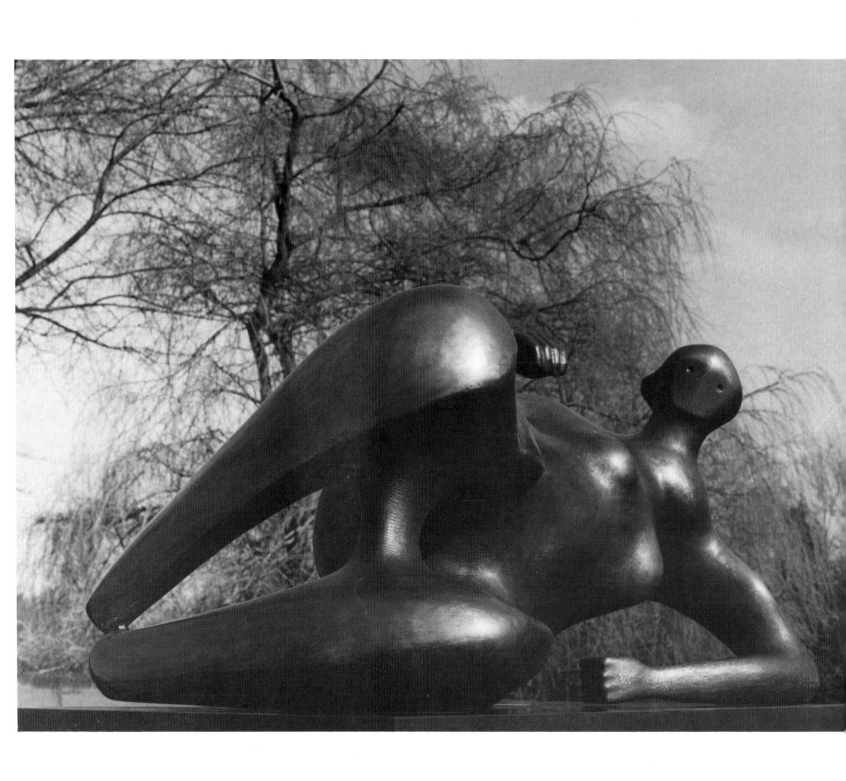

60 Another view of **Reclining Woman : Elbow**

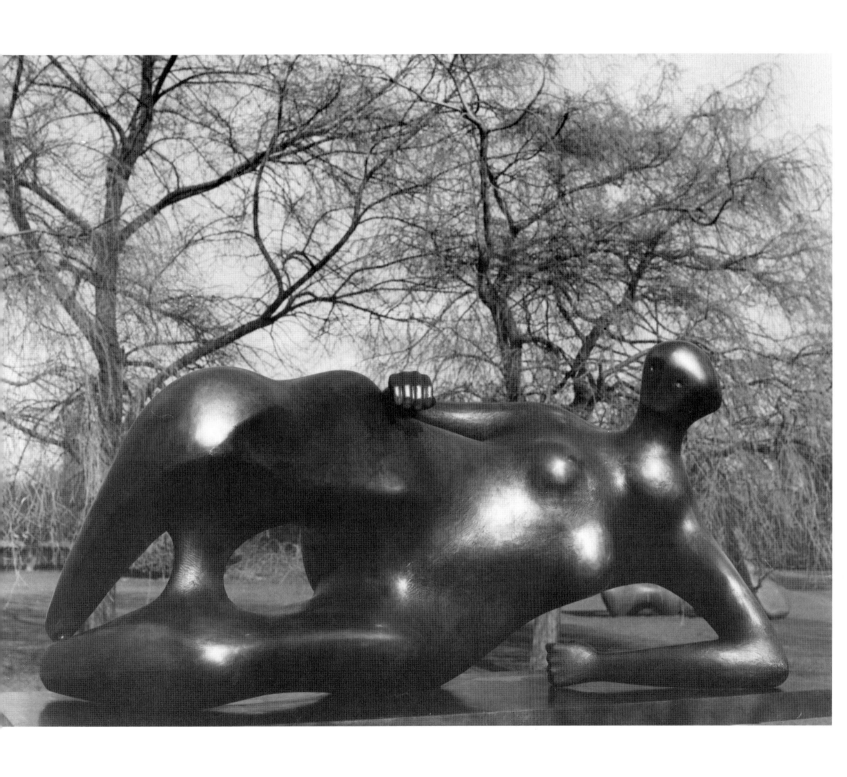

61 Another view of **Reclining Woman : Elbow**

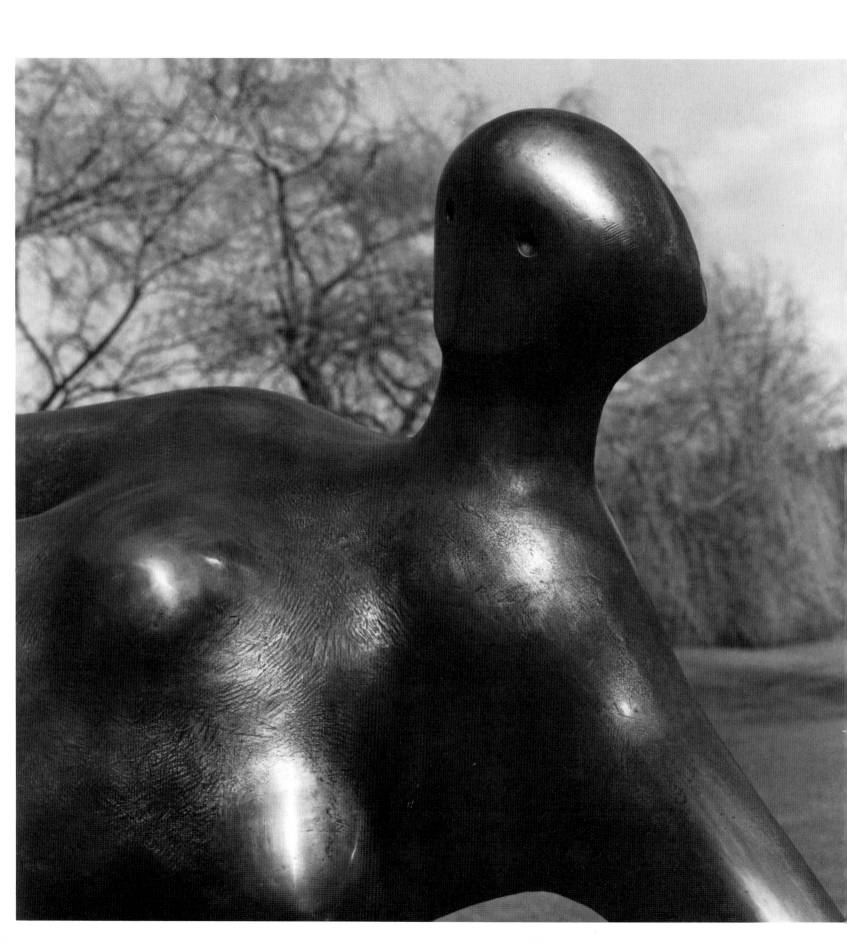

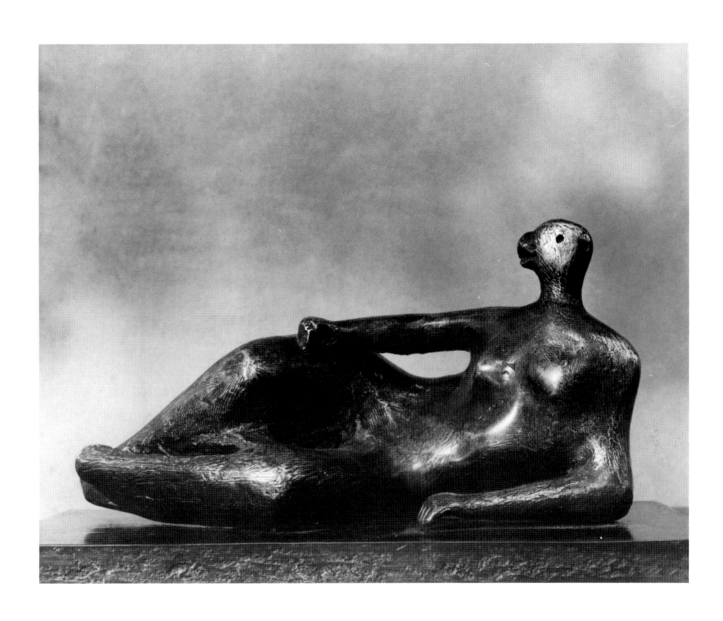

63 **Reclining Woman No. 2** (811) 11½/29 L 1980

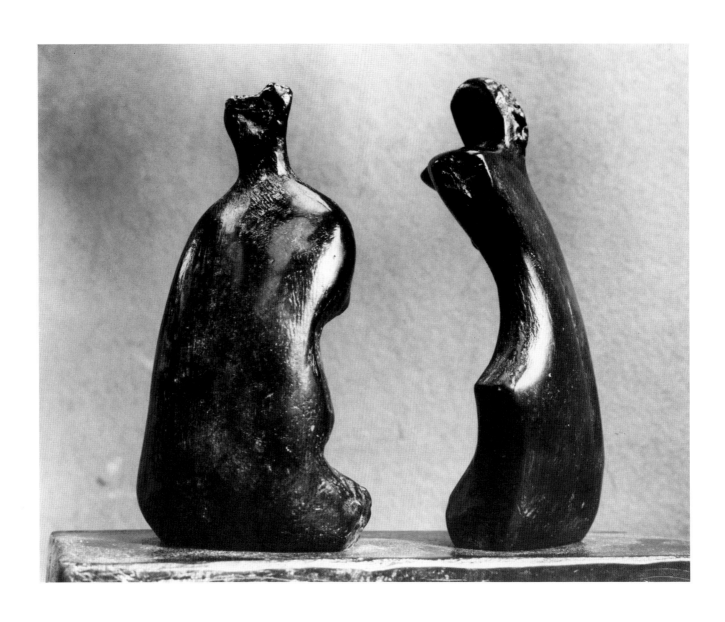

64 **Two Torsos** (814) 8/20·5 L 1981

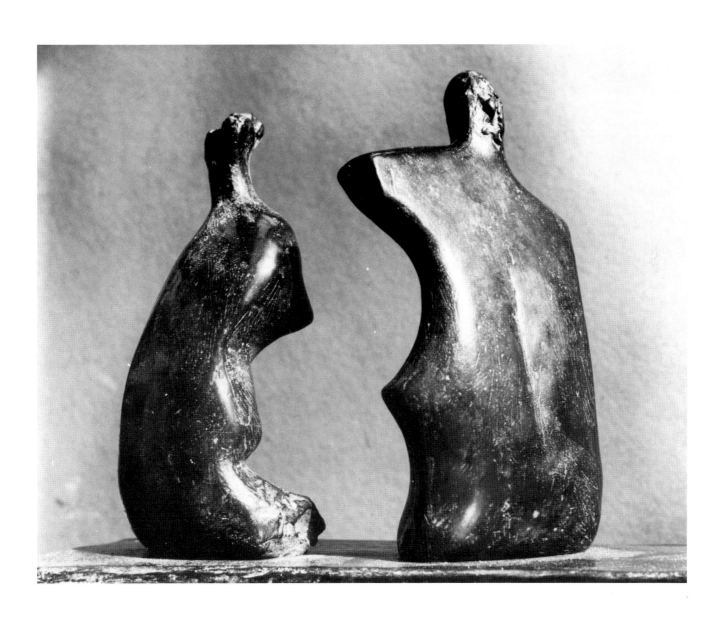

65 Another view of **Two Torsos**

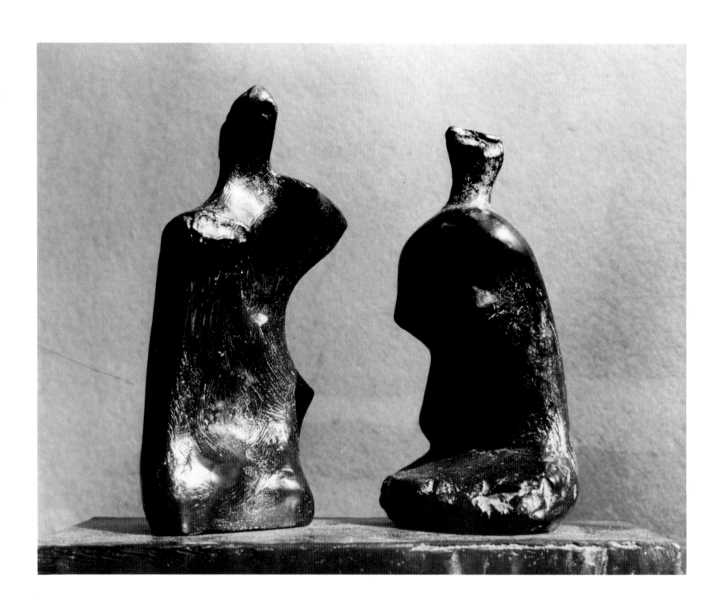

66 Another view of **Two Torsos**

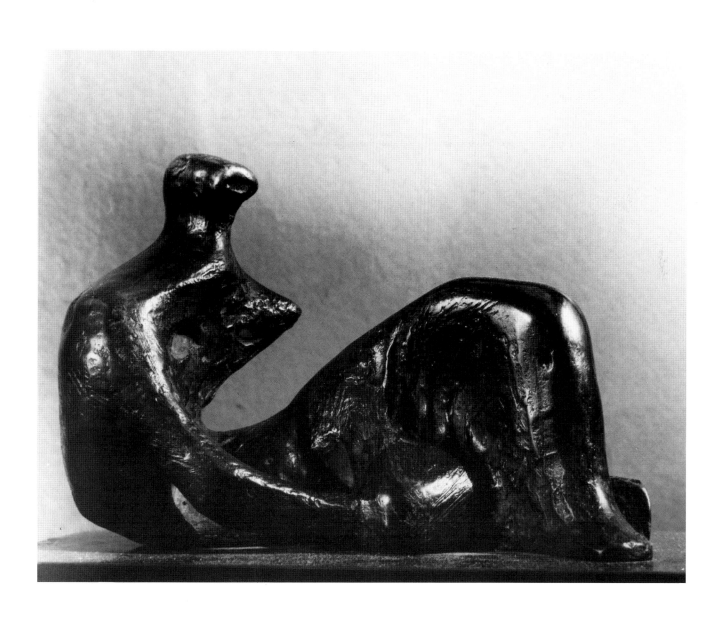

67 **Draped Reclining Figure: Knee** (815) 7½/19 L 1981

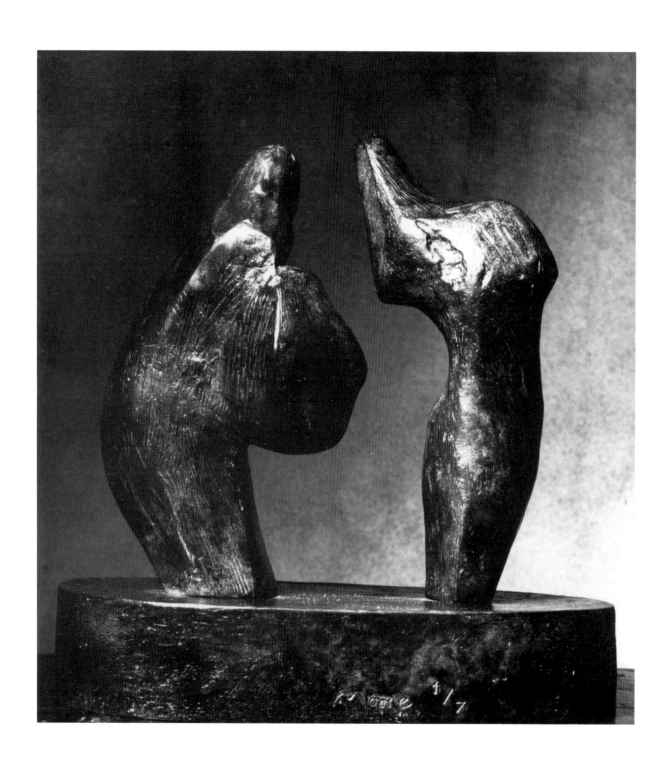

68 **Family Group: Two Piece** (817) 6/15 L 1981

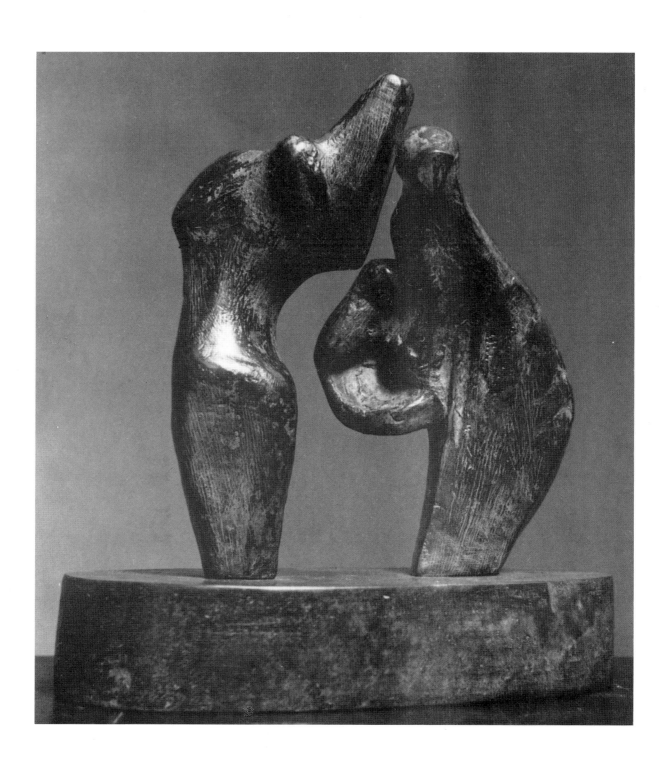

69 Another view of **Family Group: Two Piece**

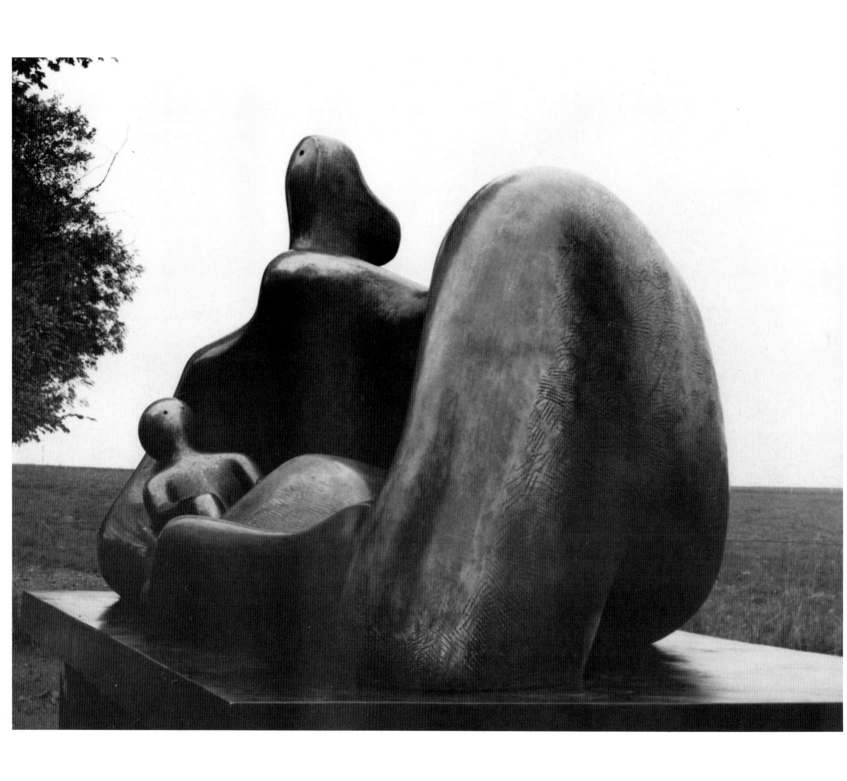

70 **Draped Reclining Mother and Baby** (822) 8ft 8½in/265·5 L 1983

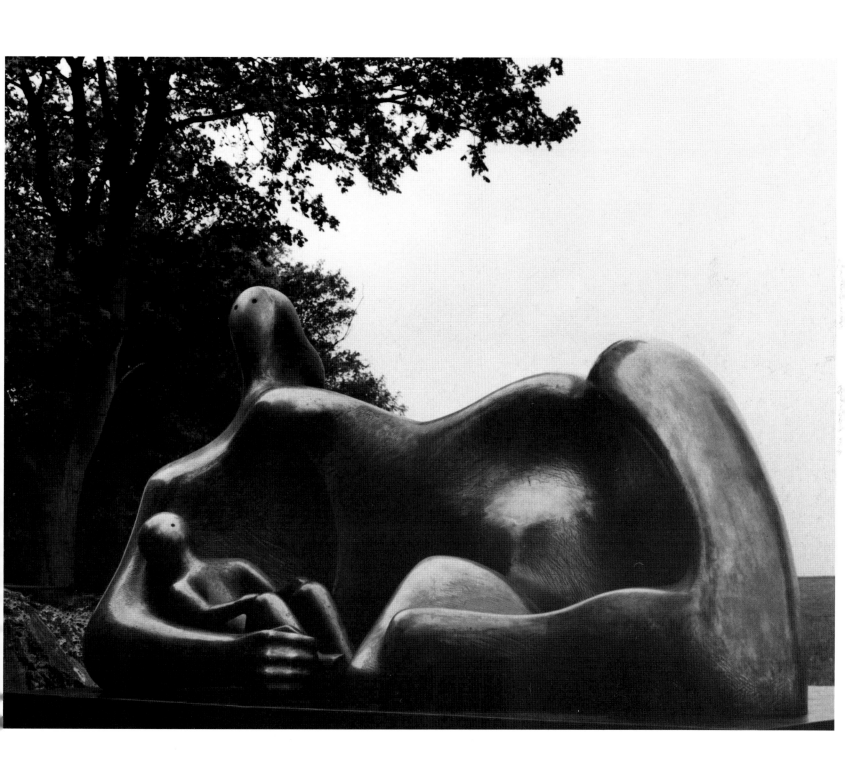

71 Another view of **Draped Reclining Mother and Baby**

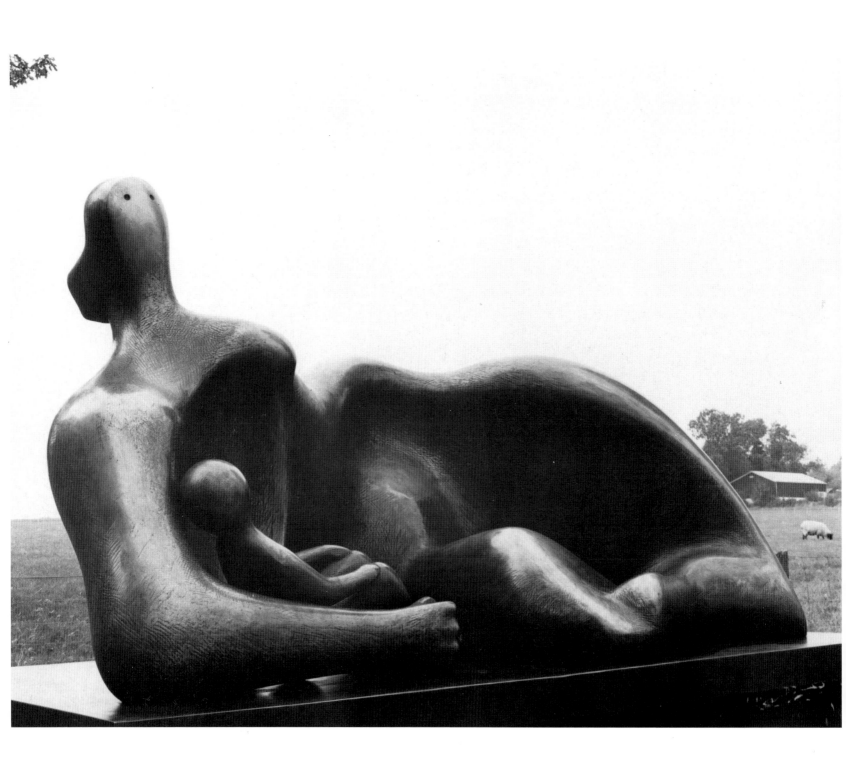

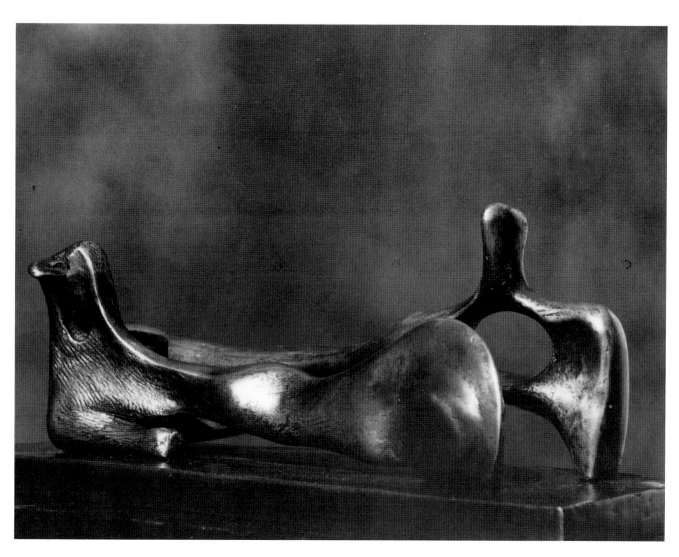

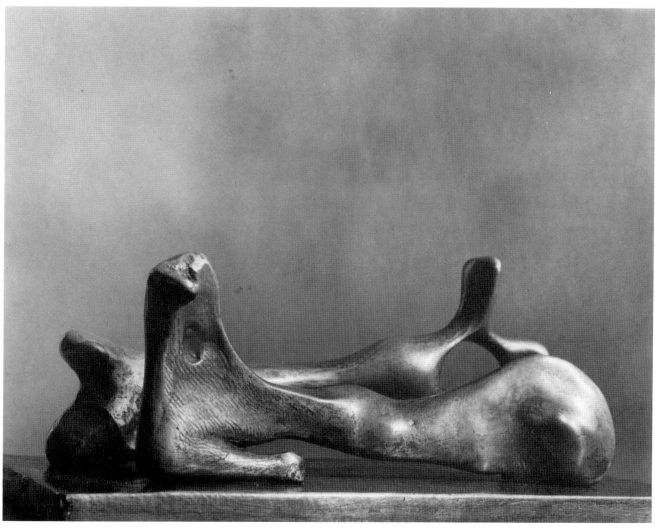

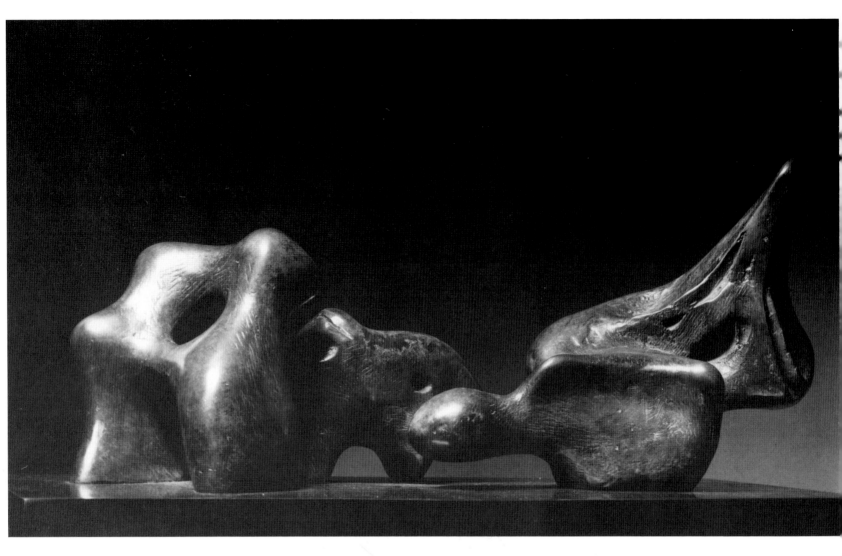

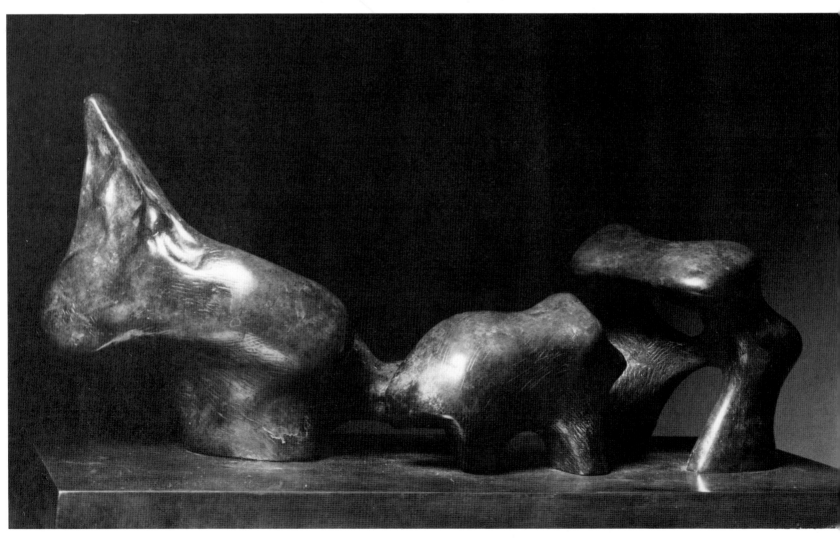

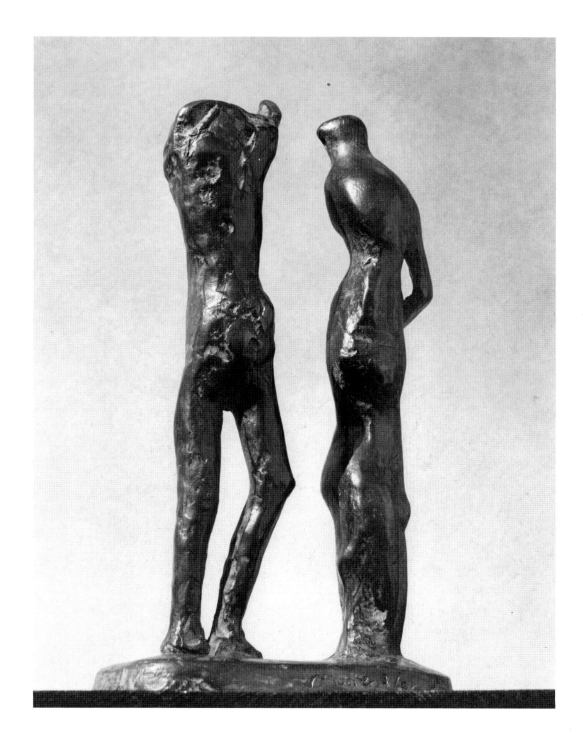

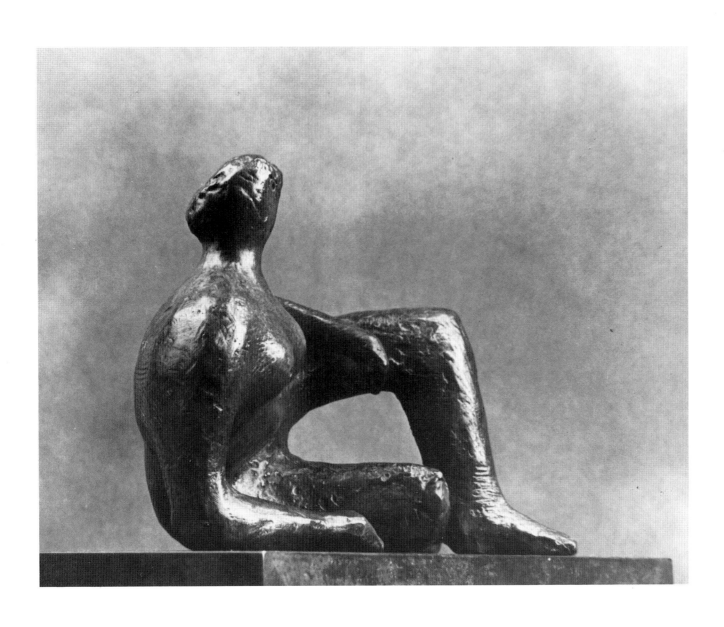

76 **Reclining Figure : Right Angles** (830) 7⅞/20 L 1981

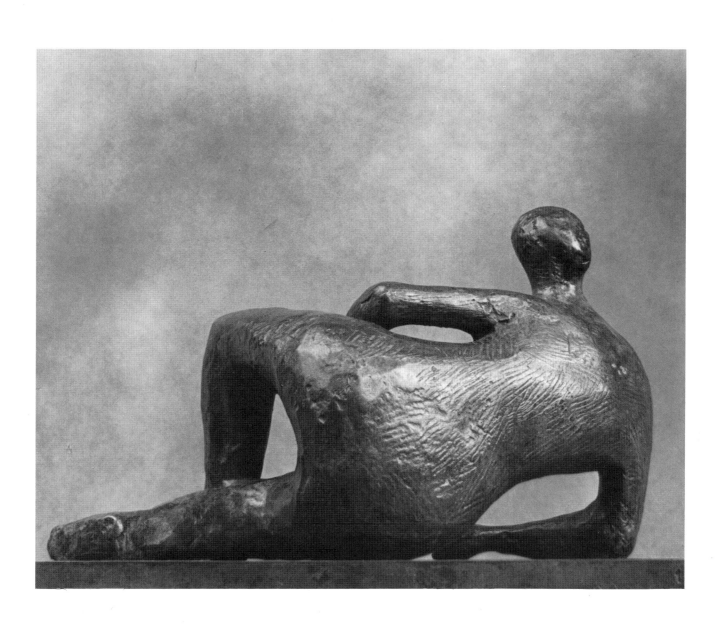

77 Another view of **Reclining Figure: Right Angles**

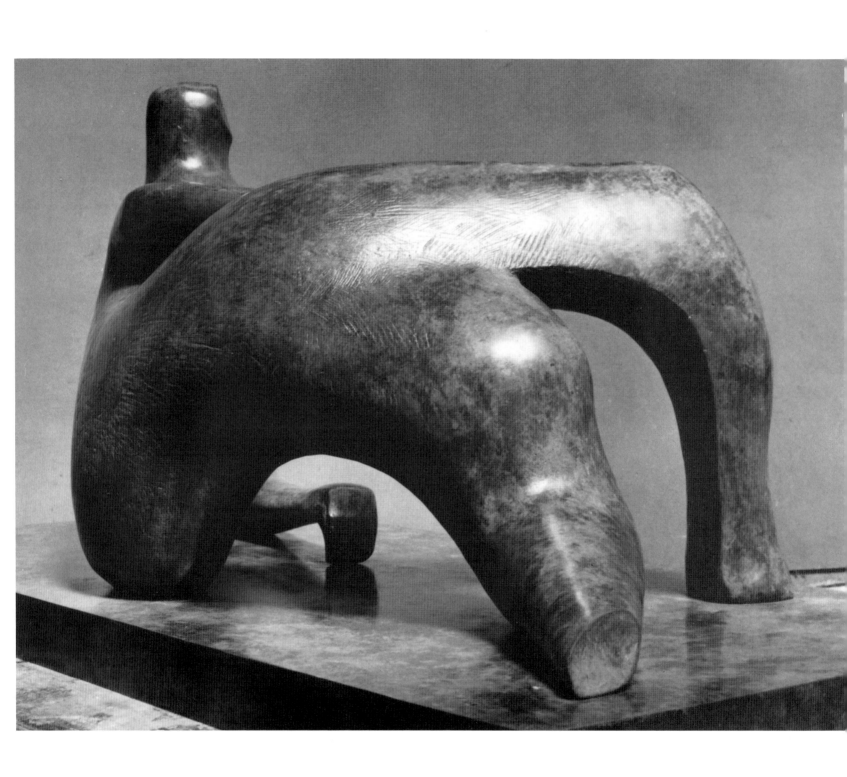

78 **Reclining Figure: Open Pose** (832) 36/91·5 L 1982

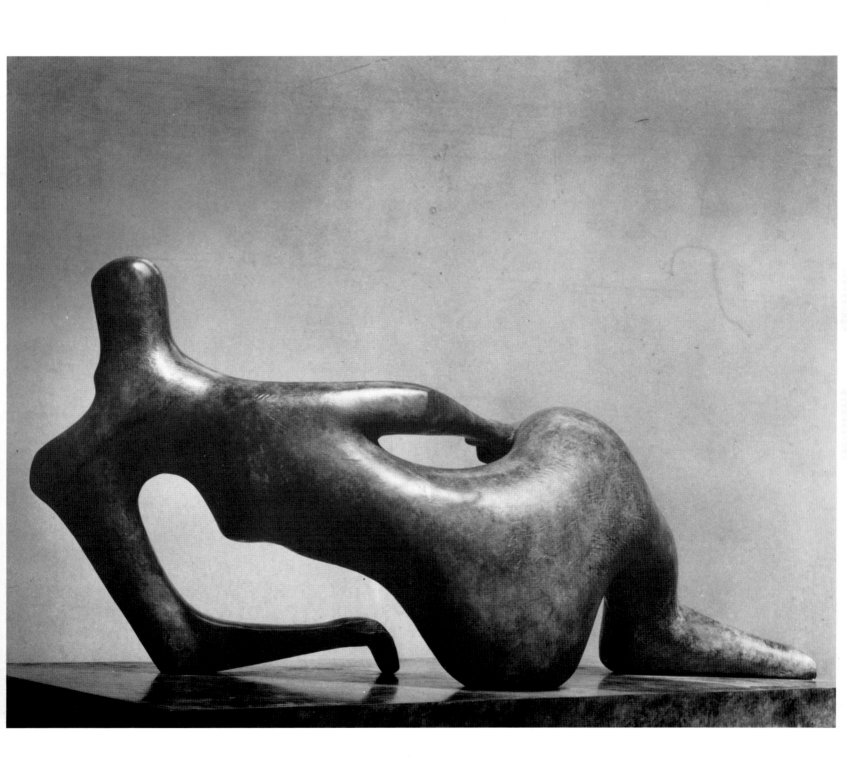

79 Another view of **Reclining Figure: Open Pose**

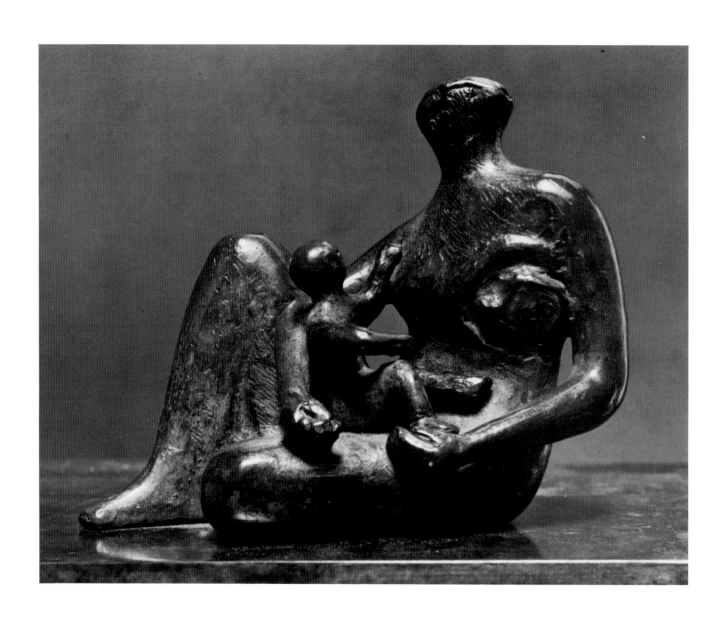

80 **Semi-Seated Mother and Child** (835) 7¾/19·5 L 1981

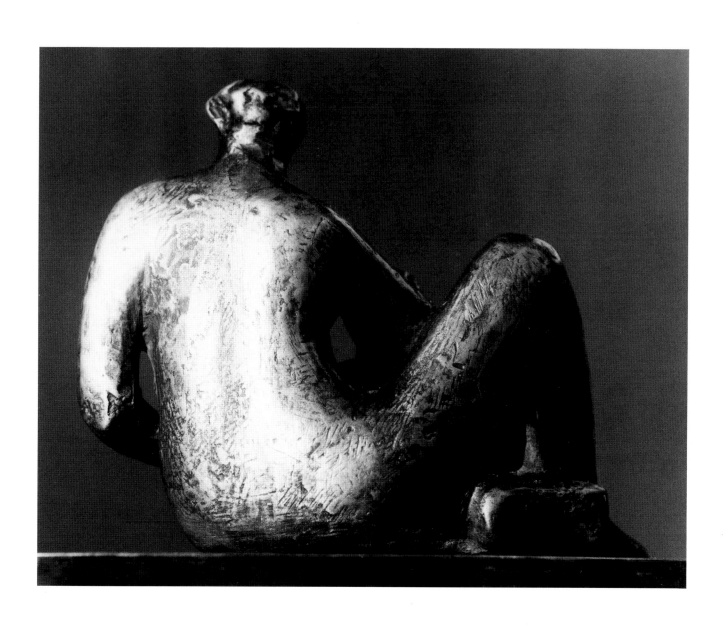

1 Another view of **Semi-Seated Mother and Child**

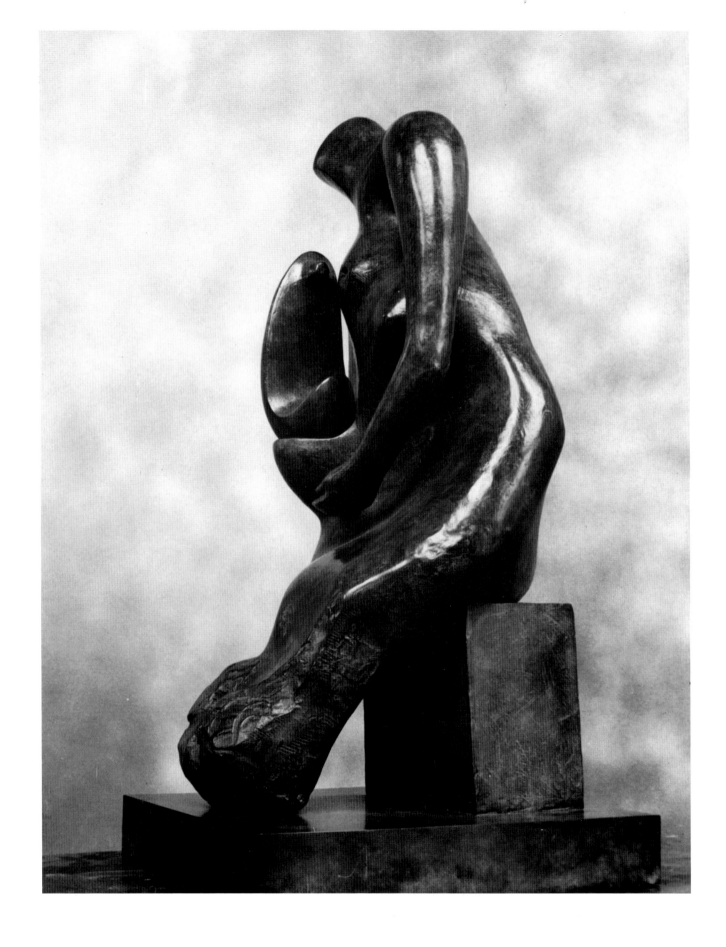

82 (above) **Working Model for Mother and Child: Block Seat** (837) 27/68·5 H 1983

83 (opposite) Another view of **Working Model for Mother and Child: Block Seat**

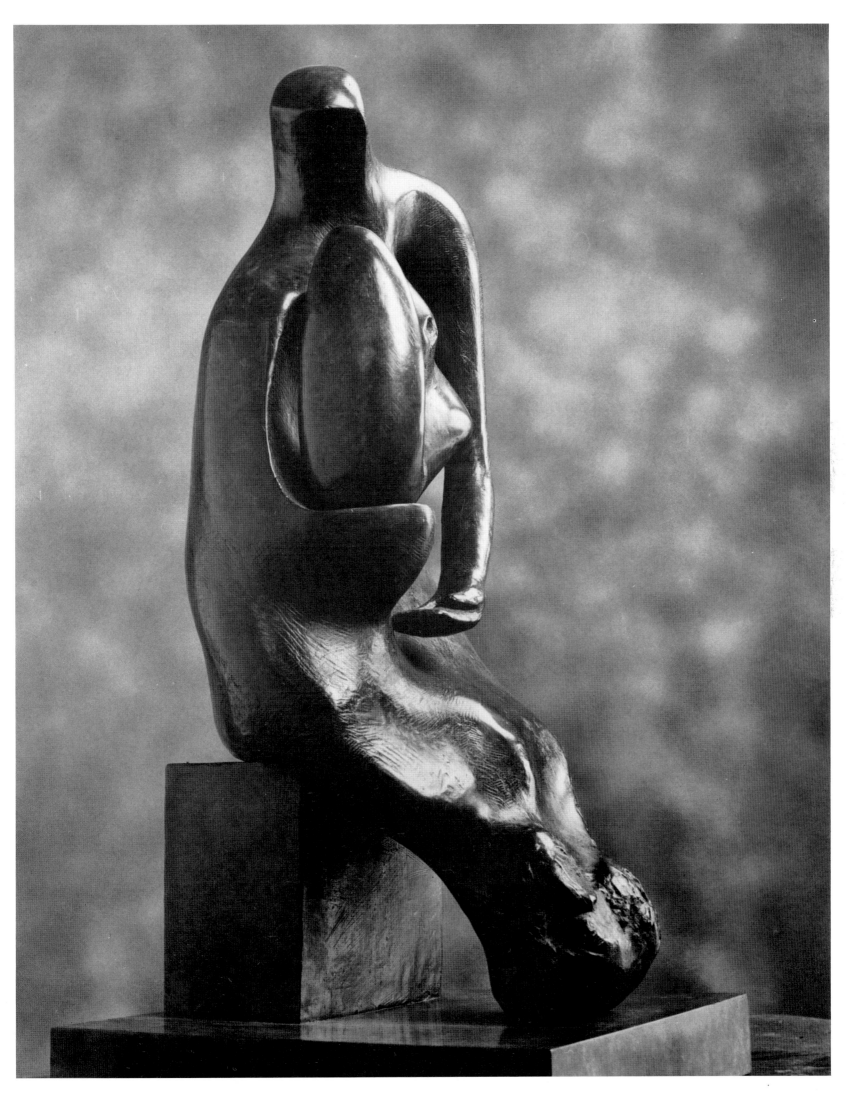

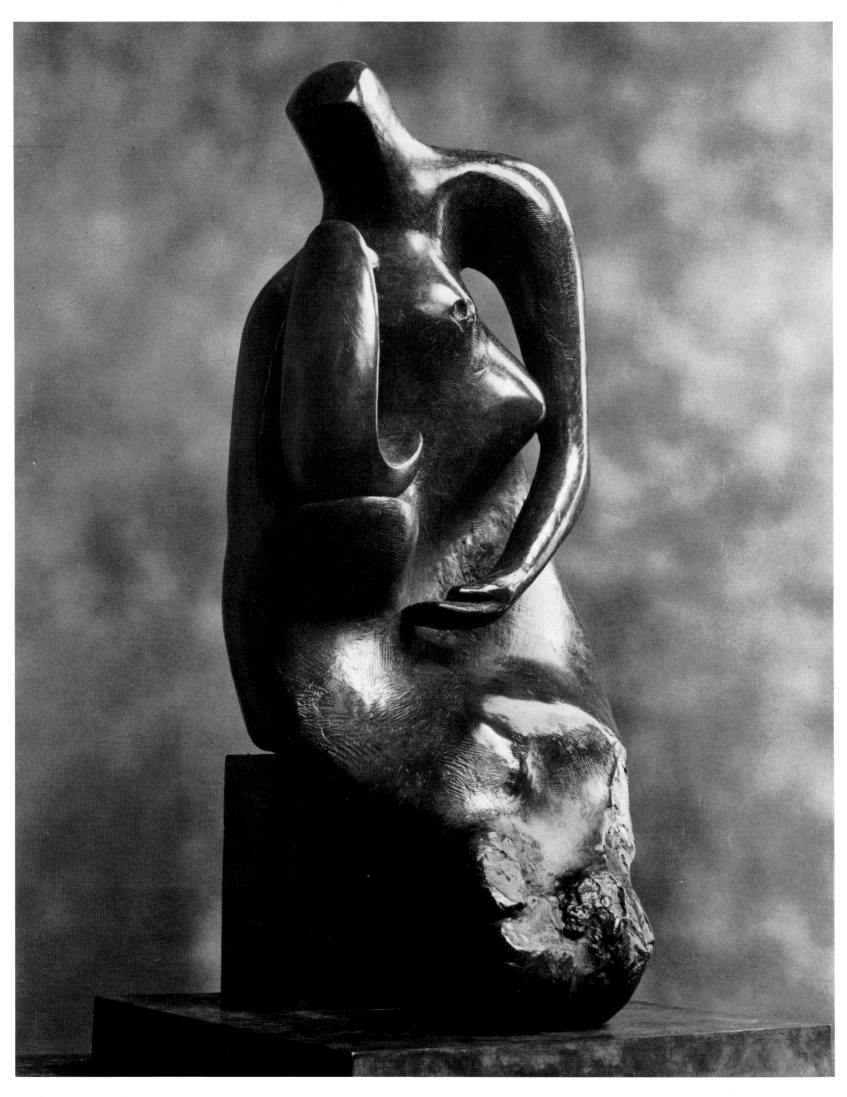

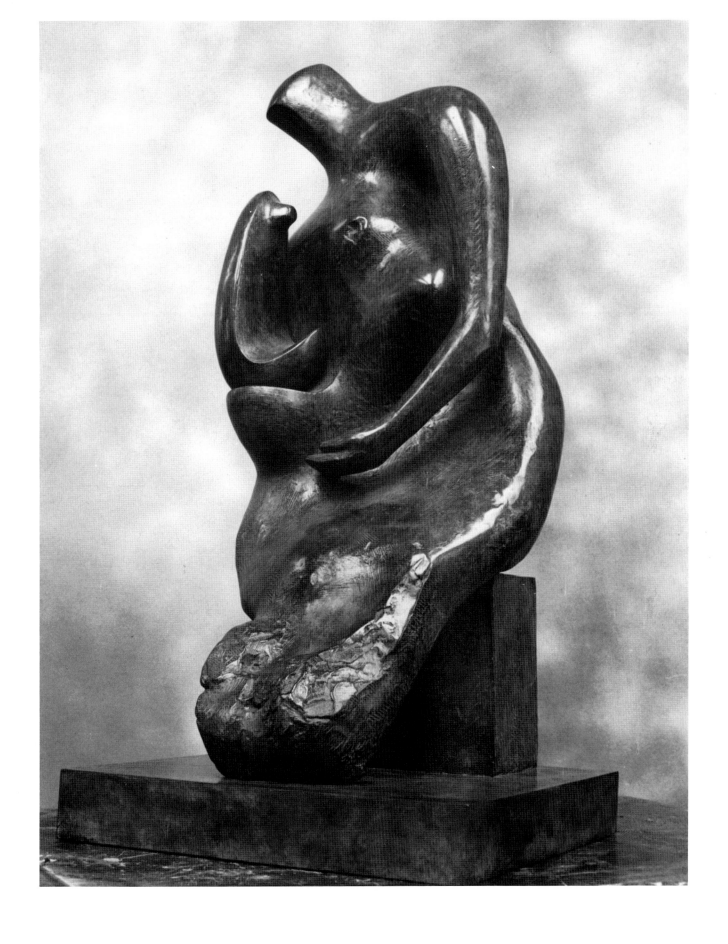

84 (opposite) Another view of **Working Model for Mother and Child : Block Seat**

85 (above) Another view of **Working Model for Mother and Child : Block Seat**

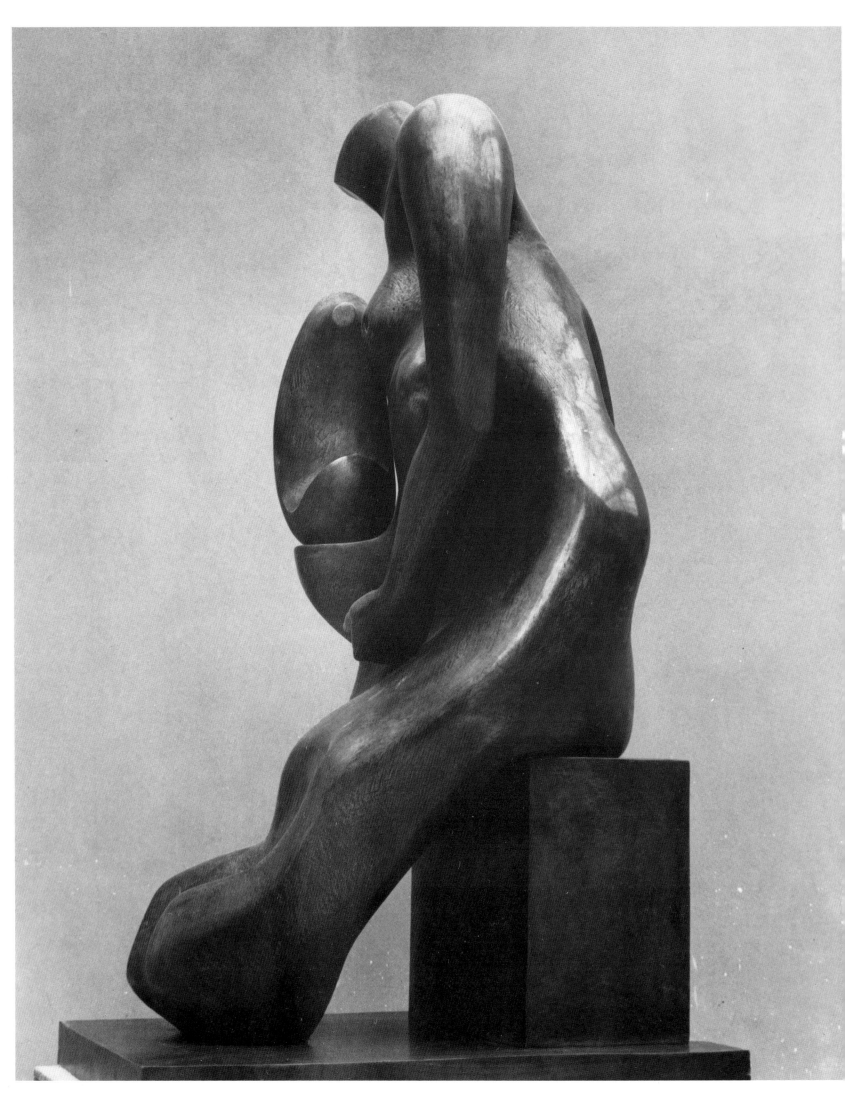

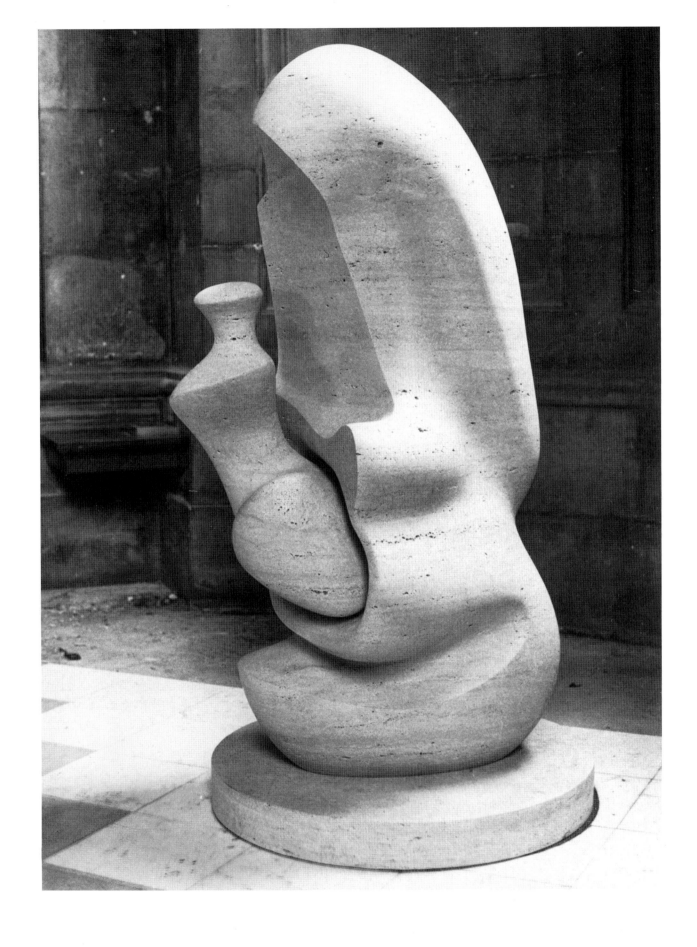

86 (opposite) **Mother and Child: Block Seat** (838) 96/244 H 1983/4

On following pages:

87 (above) **Mother and Child: Hood** (851) 6ft/183 H 1983

88 and 89 Two more views of **Mother and Child: Hood**

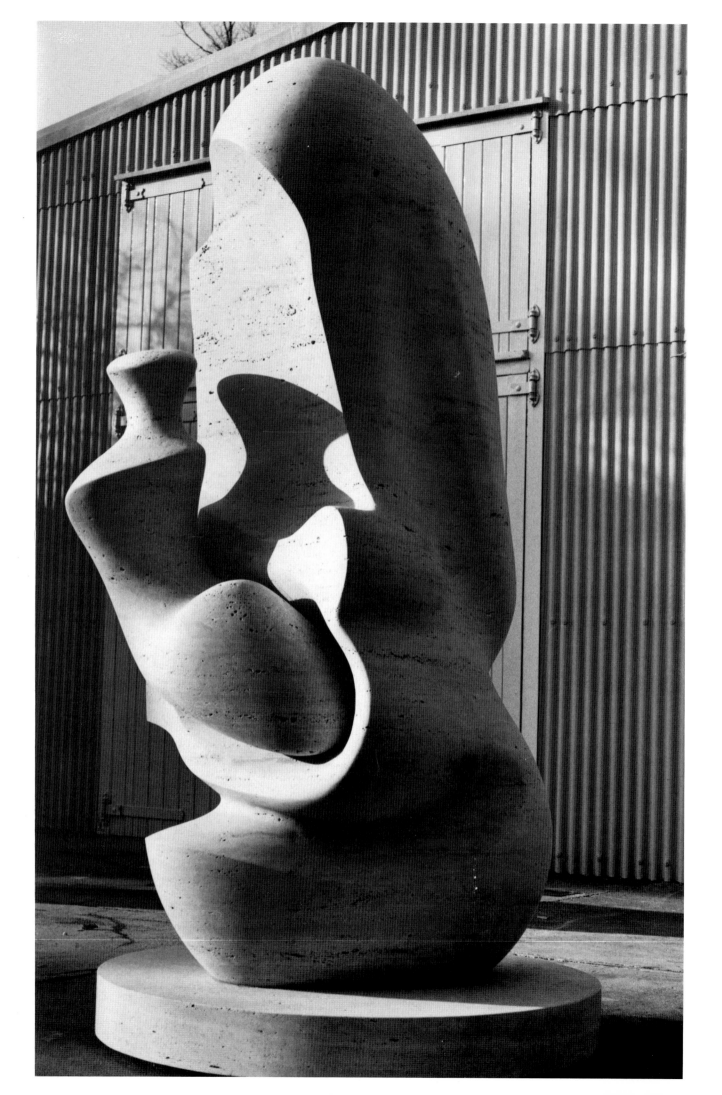

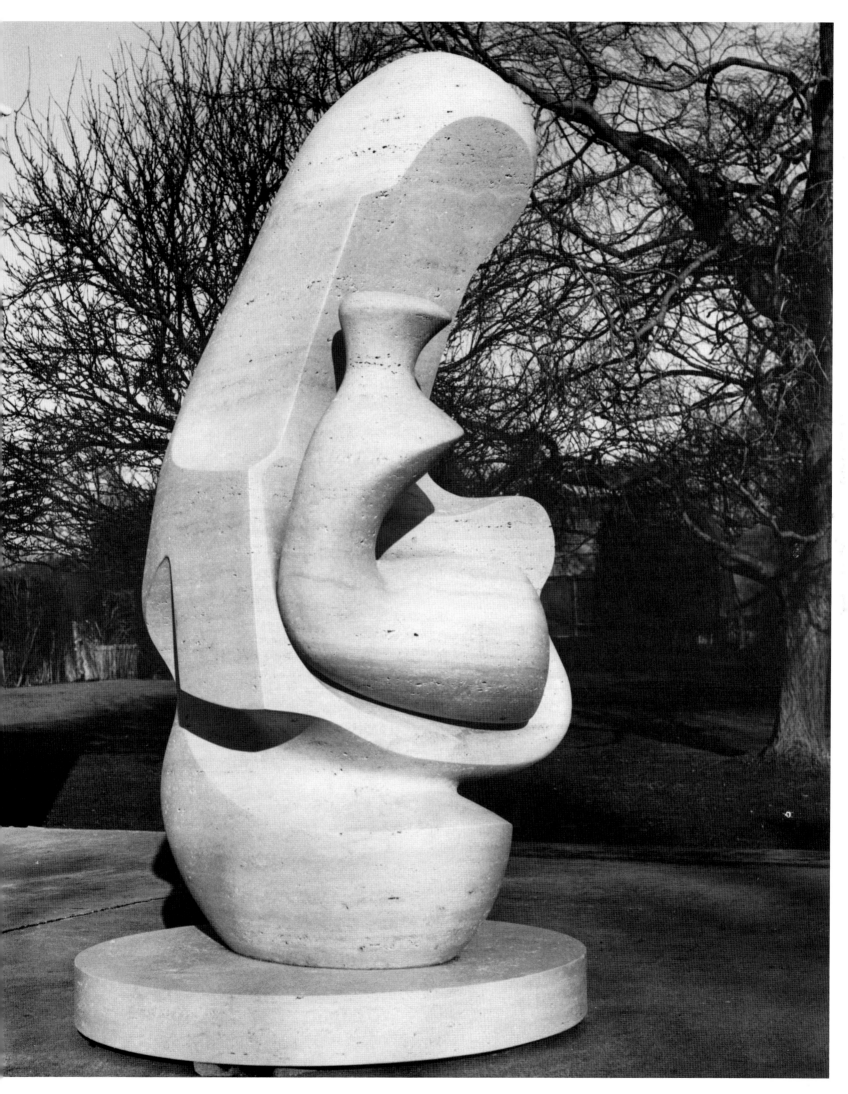

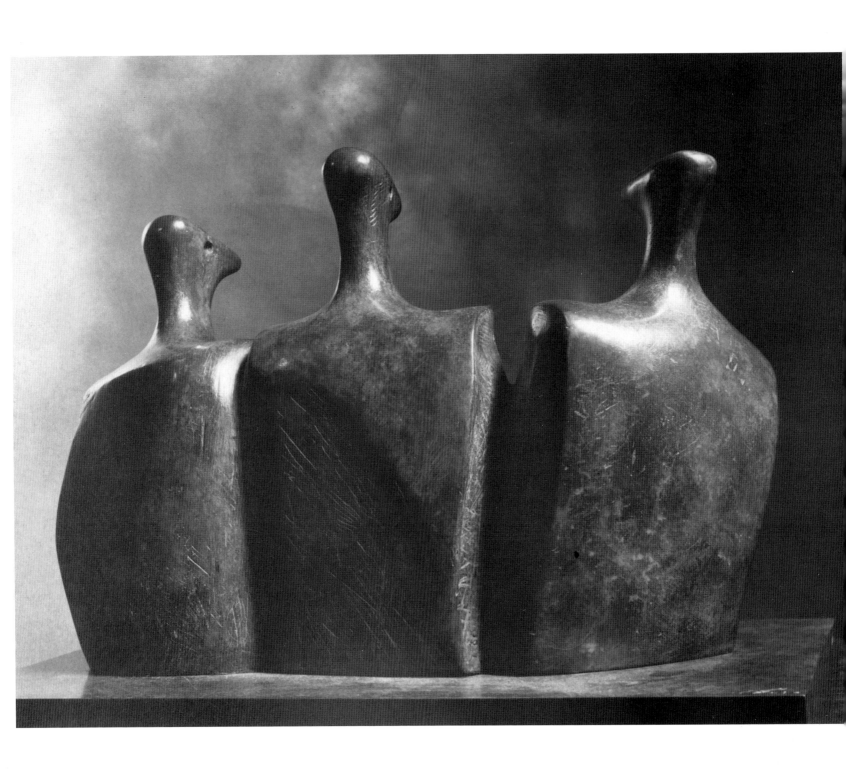

90 **Three Figures** (853) 14¼/36 L 1982

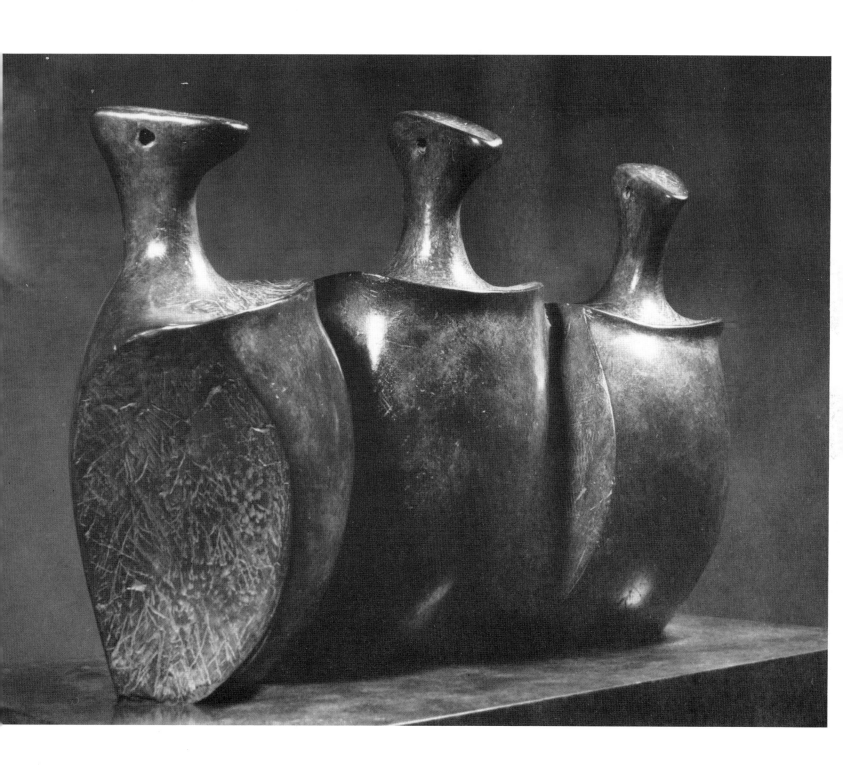

41 Another view of **Three Figures**

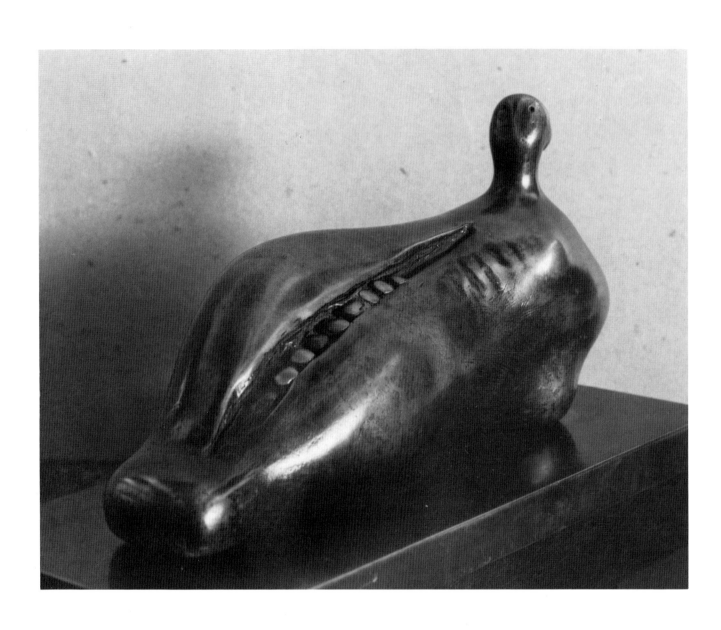

92 **Reclining Figure: Pea Pod** (854) 8½/21·5 L 1982

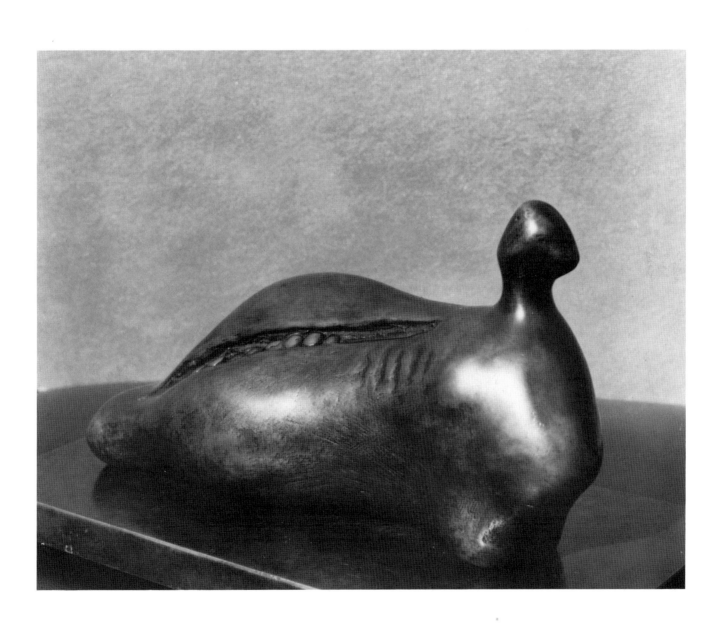

93 Another view of **Reclining Figure: Pea Pod**

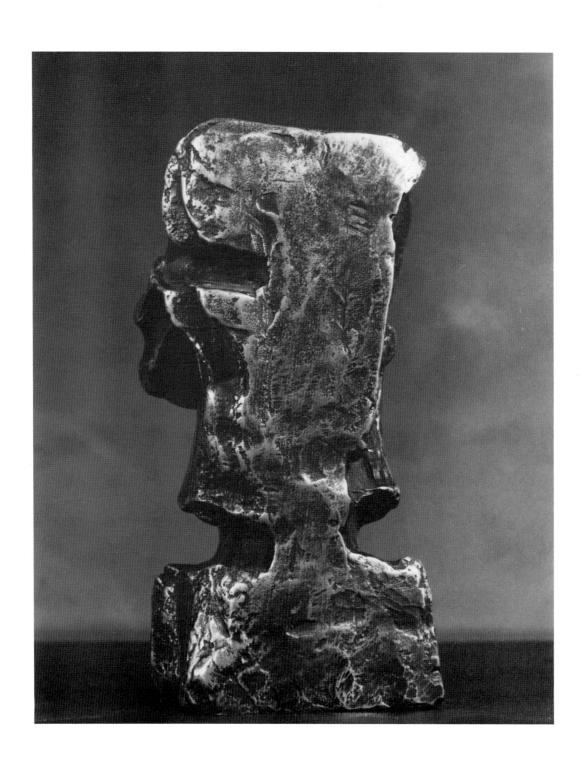

94 **Rock Form** (861) 6/15 H 1982

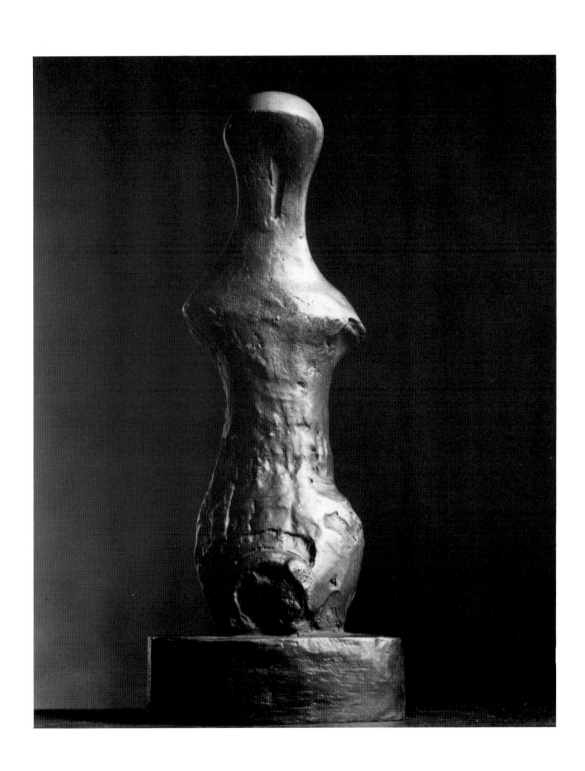

95 **Half-Figure: Round Head** (862) 6¹/₁₆ H 1982

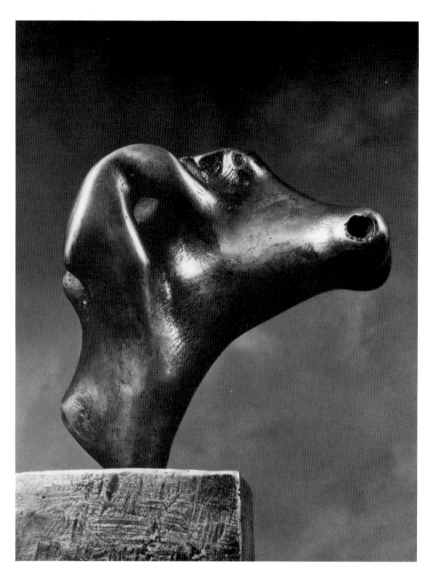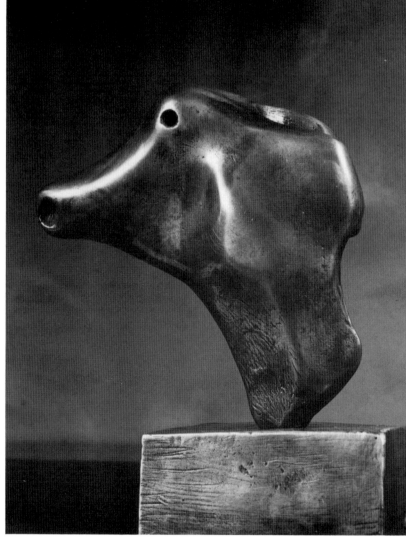

96 (above) Two views of **Head of Horse** (867) 5½/14 H 1982

97 (opposite) **Mother with Child on Lap** (870) 31/78·5 H cast 1985

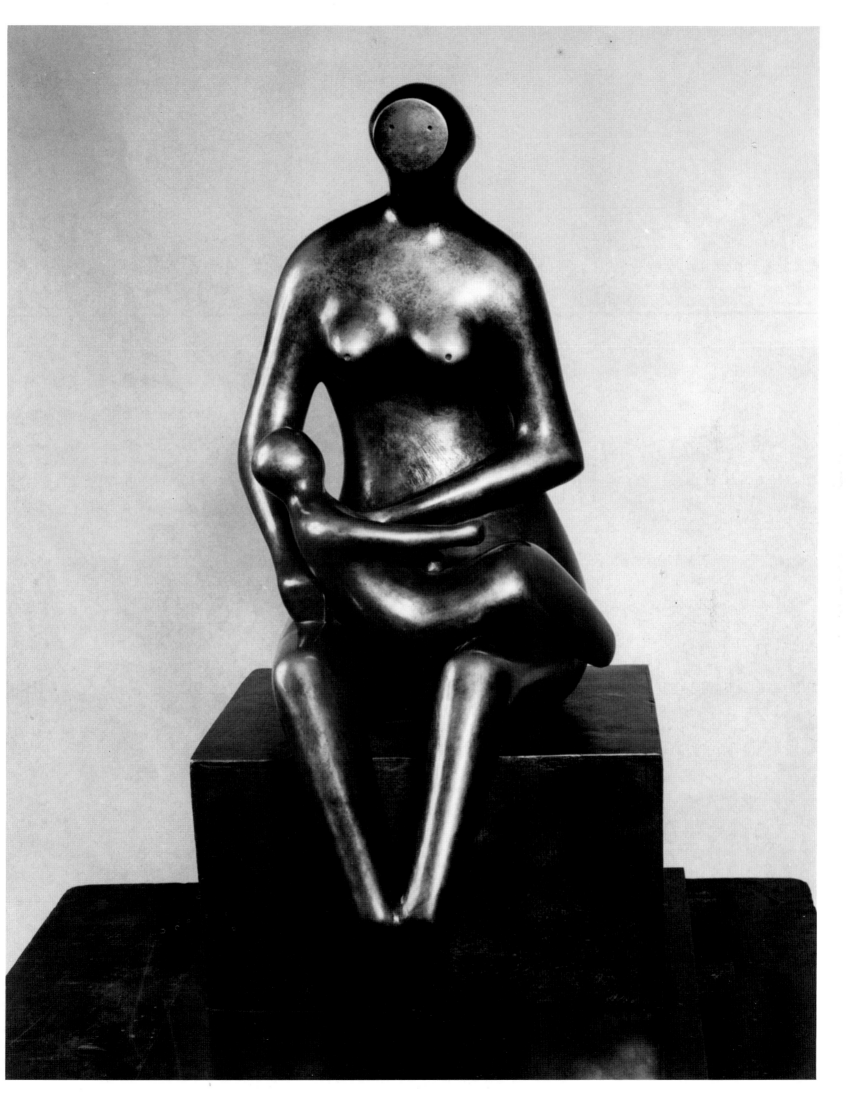

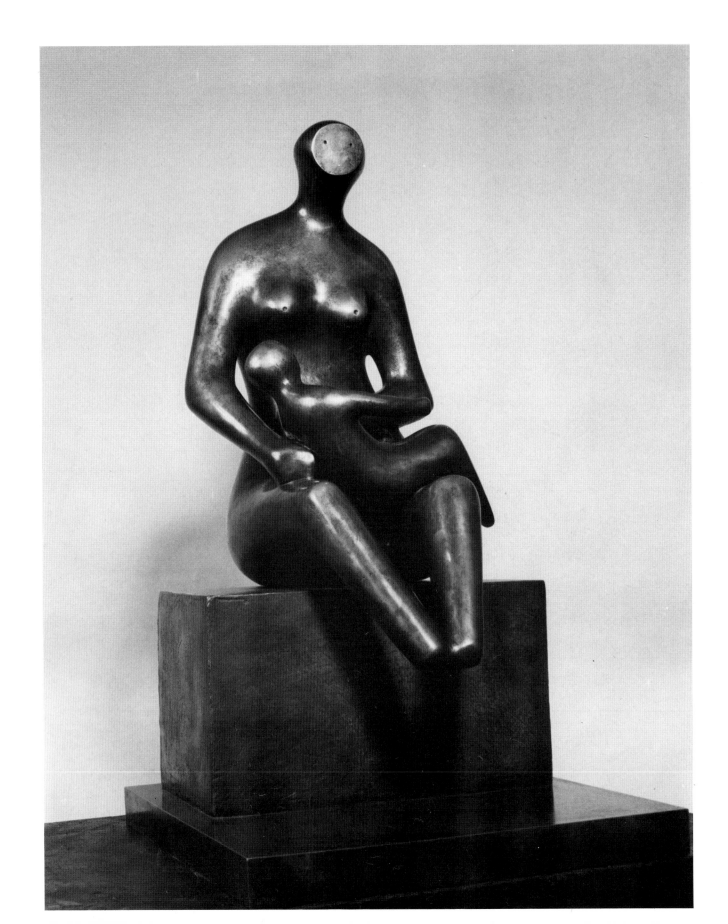

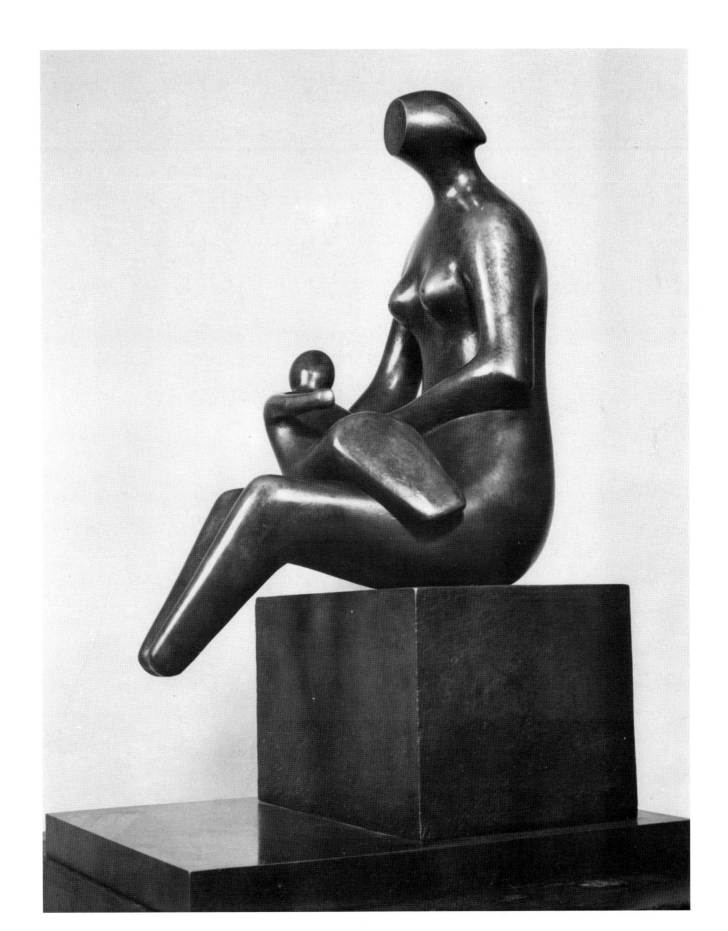

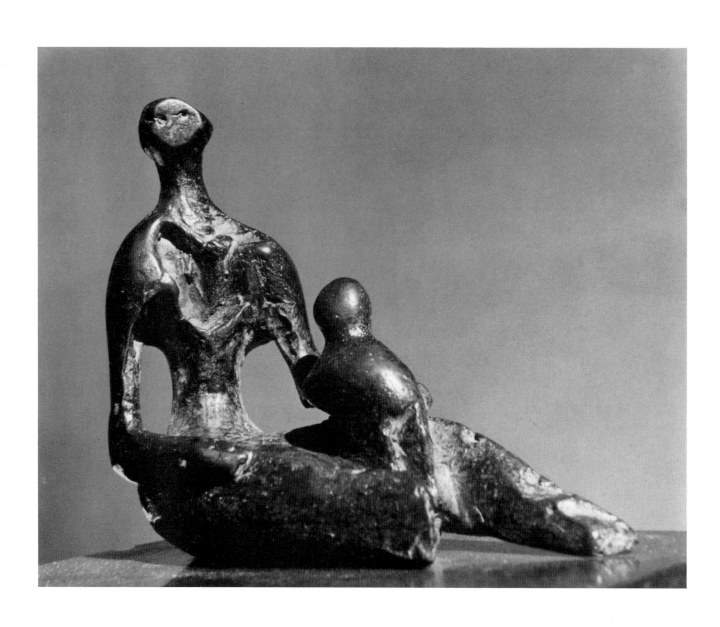

100 **Small Mother and Child** (871) 5/12·5 L 1982

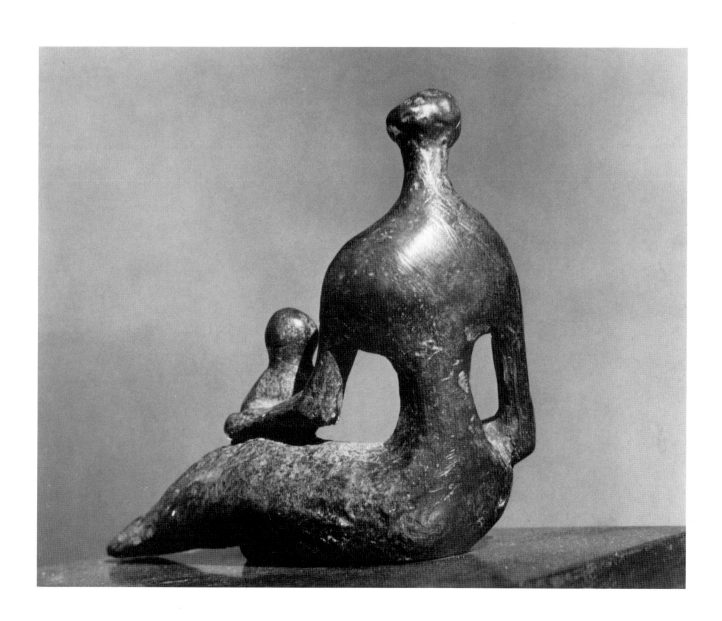

101 Another view of **Small Mother and Child**

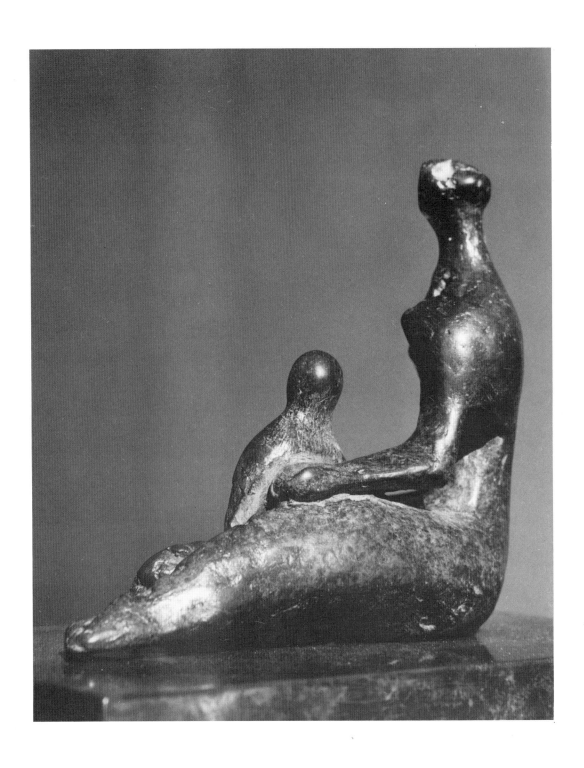

102 Another view of **Small Mother and Child**

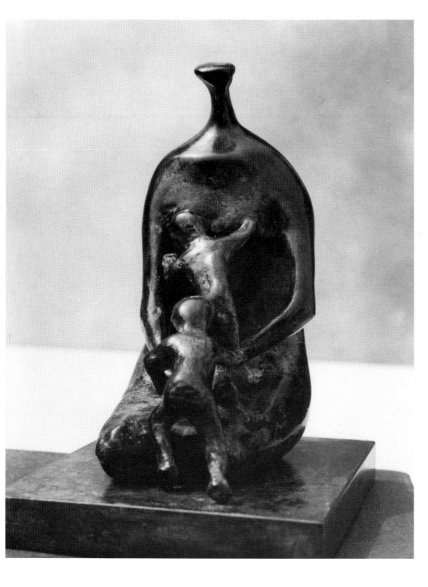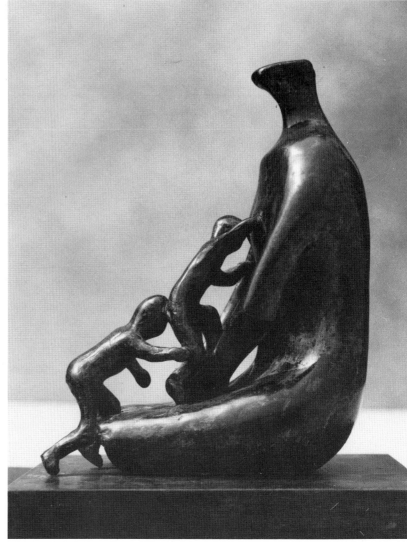

103 Two views of **Mother with Twins** (873) 6/15 H 1982

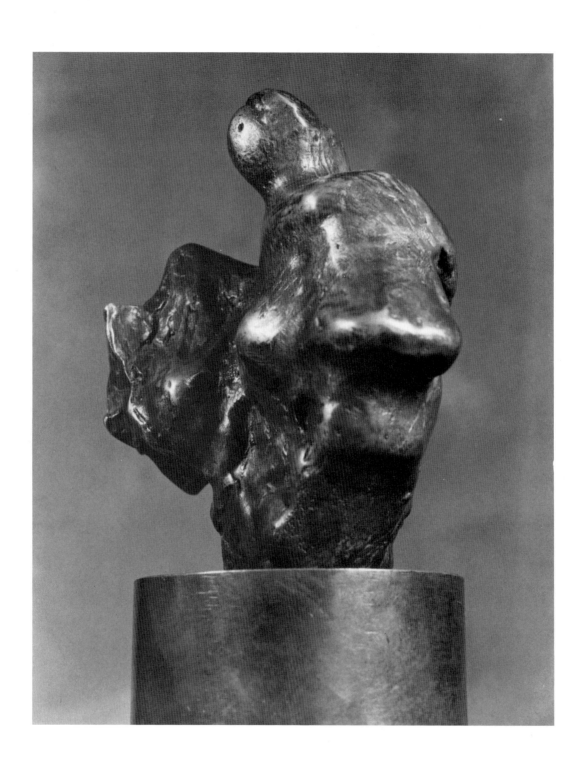

104 **Mother and Child: Rock** (877) 6½/16·5 H 1982

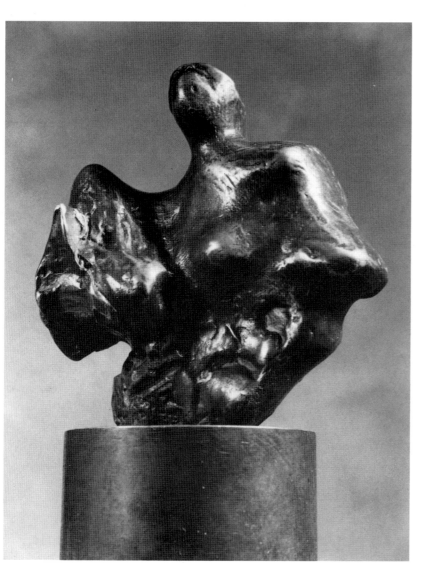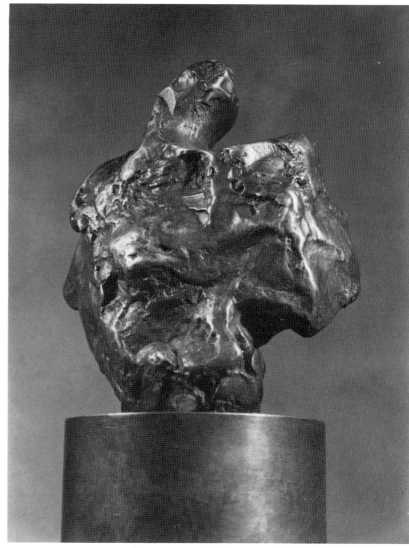

105 Two more views of **Mother and Child : Rock**

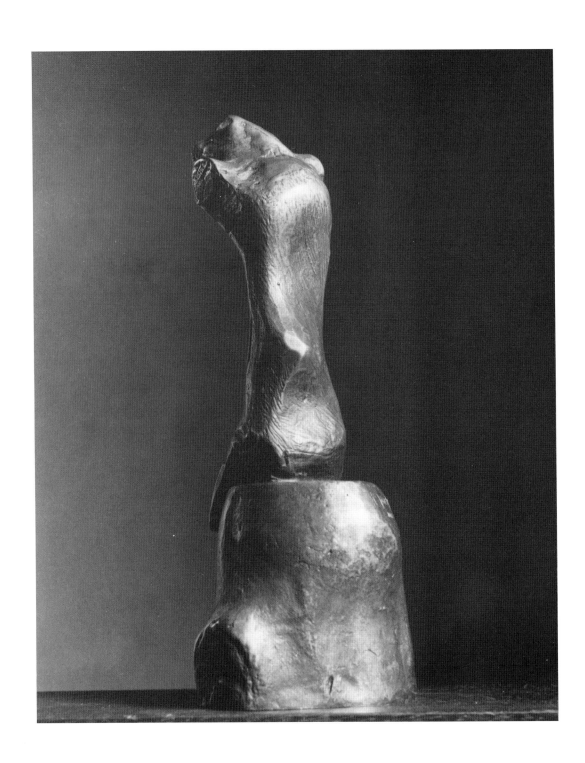

106 **Seated Figure on Log** (879) 6½/16·5 H 1982

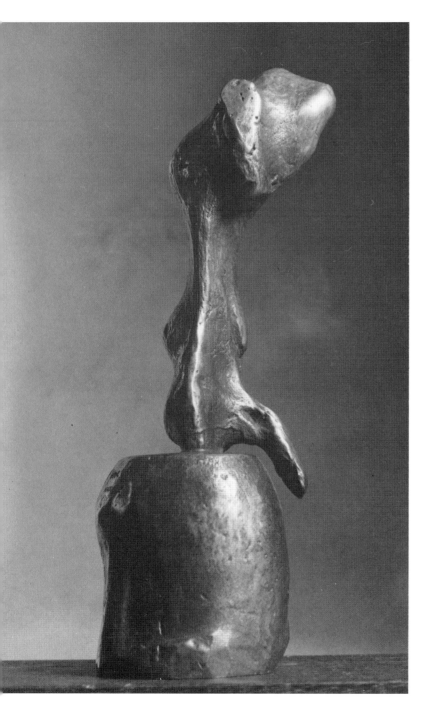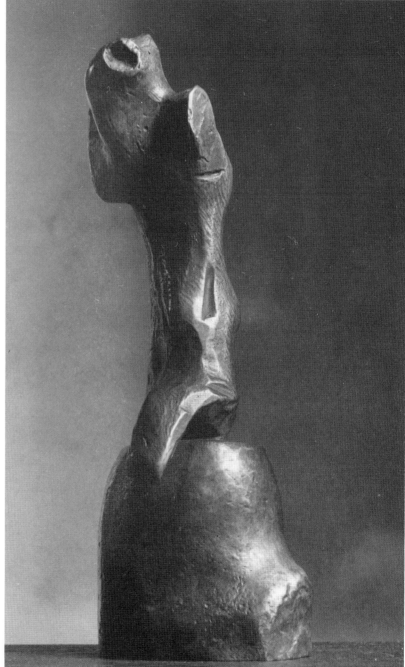

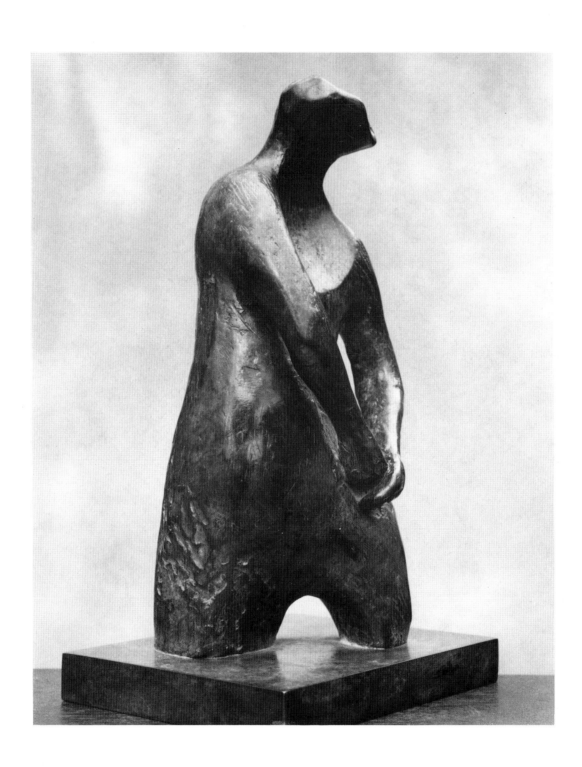

108 **Three-Quarter Figure : Cyclops** (888) 7½/19 H 1983

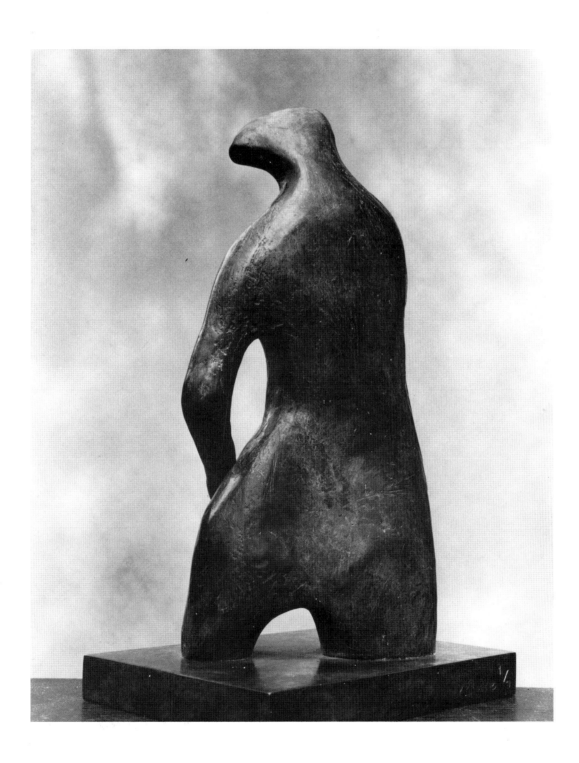

Another view of **Three-Quarter Figure : Cyclops**

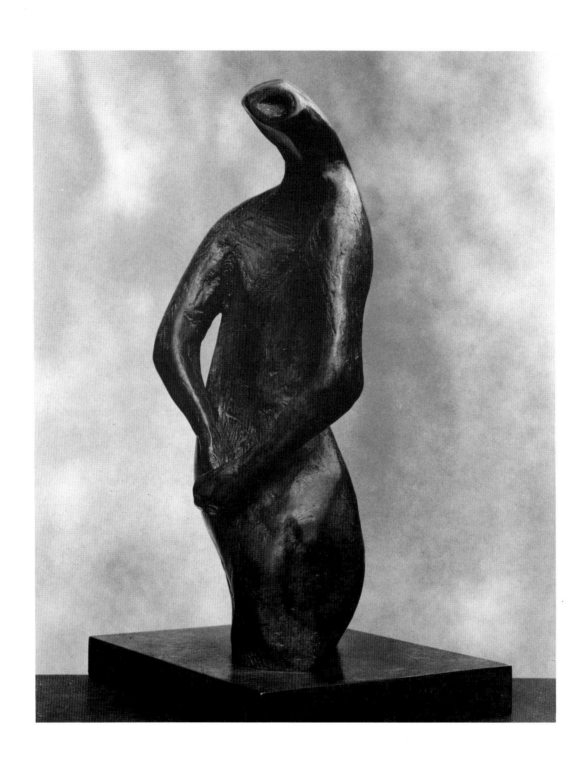

110 Another view of **Three Quarter Figure: Cyclops**

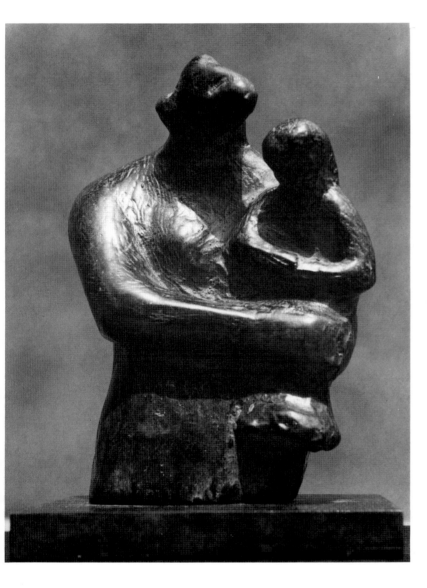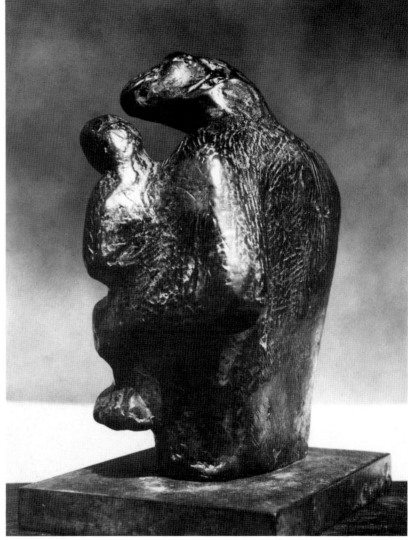

111 Two views of **Half-Figure: Mother and Child** (898) 4⅜/11·5 H 1983

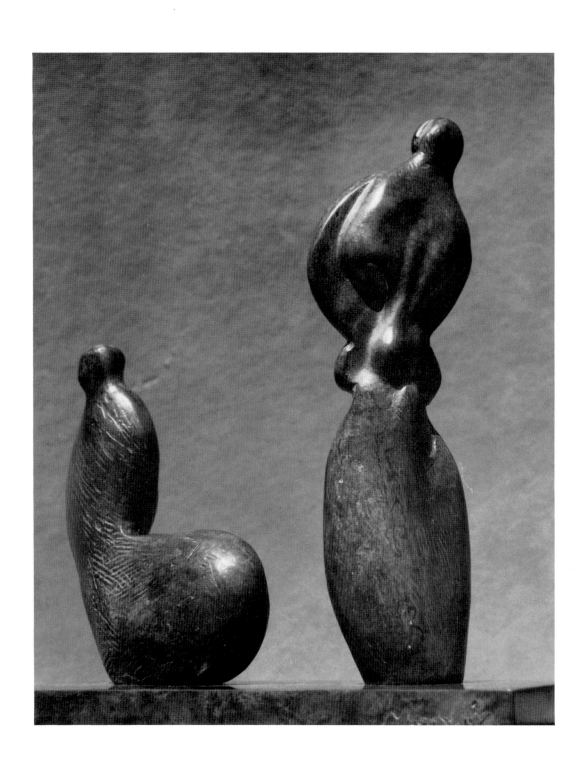

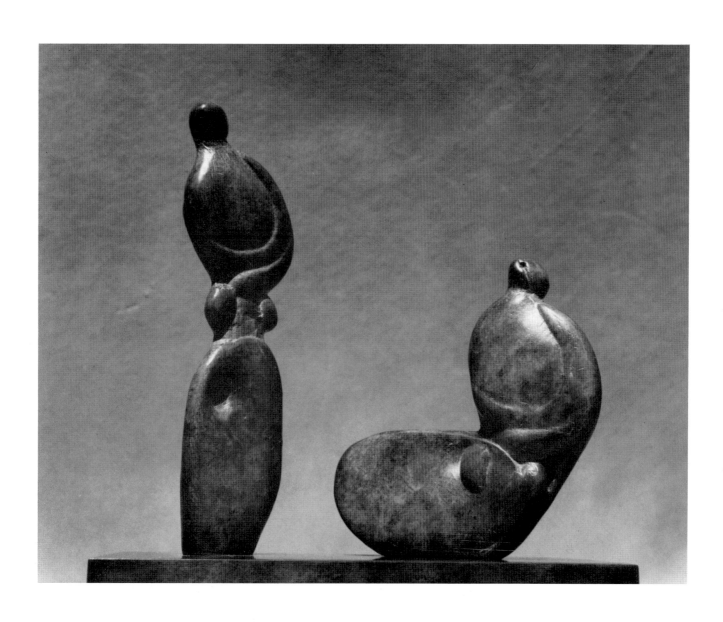

113 Another view of **Seated and Standing Figures**

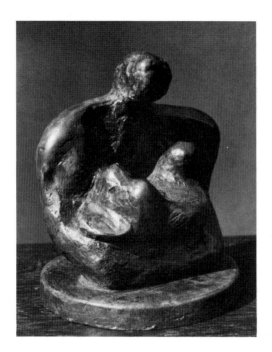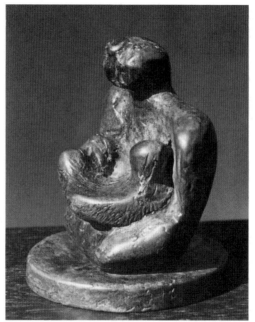

114 (above) Two views of **Small Mother and Child on Round Base** (899) 2⅝/6·5 H 1983

115 (opposite) Two views of **Reclining Girl** (901) 5/12·5 L 1983

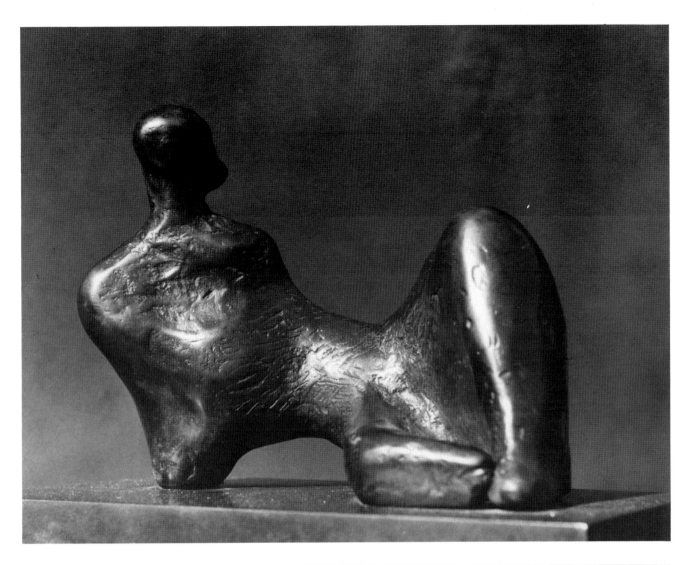

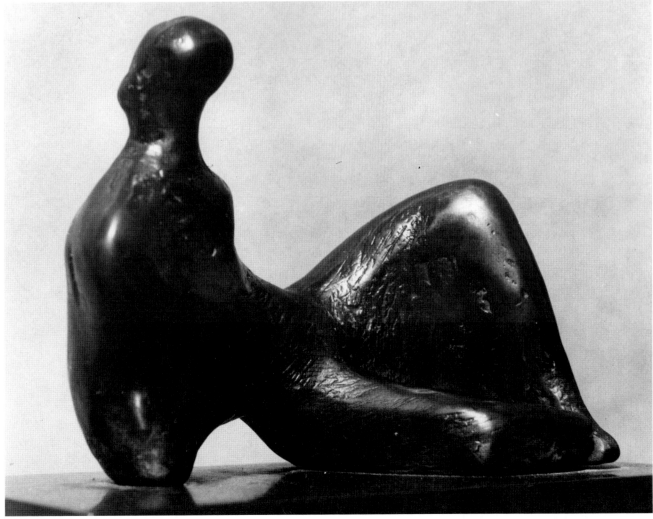

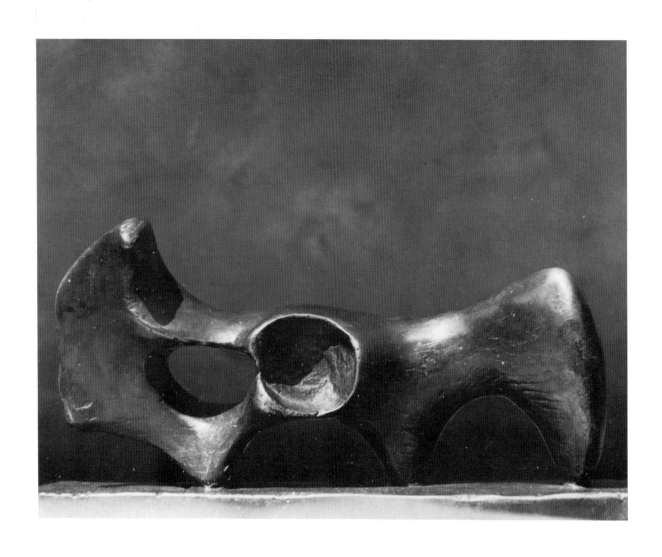

116 **Maquette for Reclining Figure : Circle** (902) 6/15 L 1983

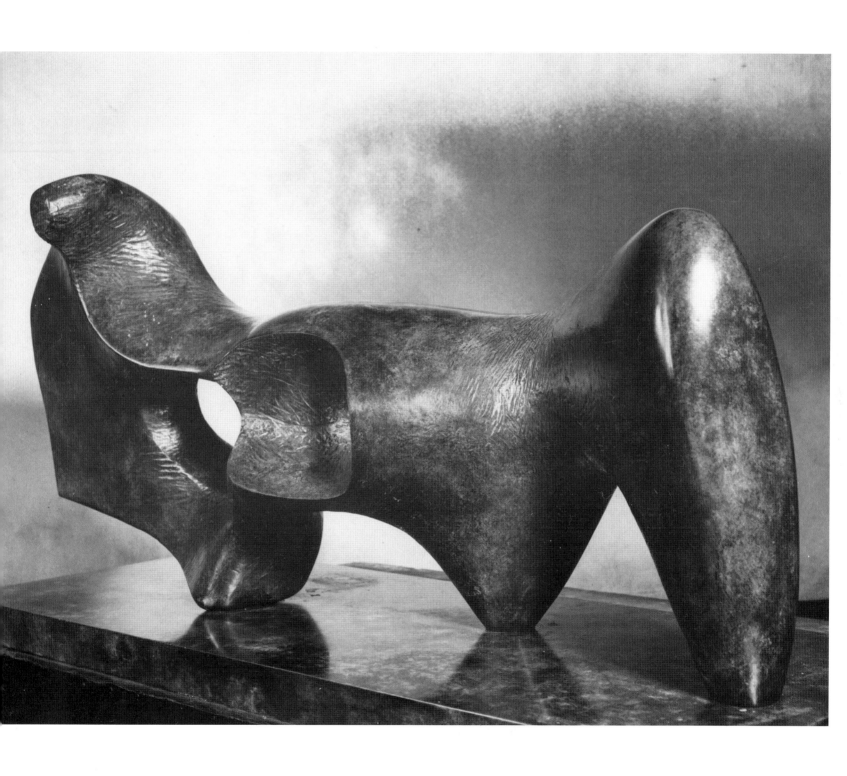

17 **Reclining Figure : Circle** (903) 35/89 L 1983

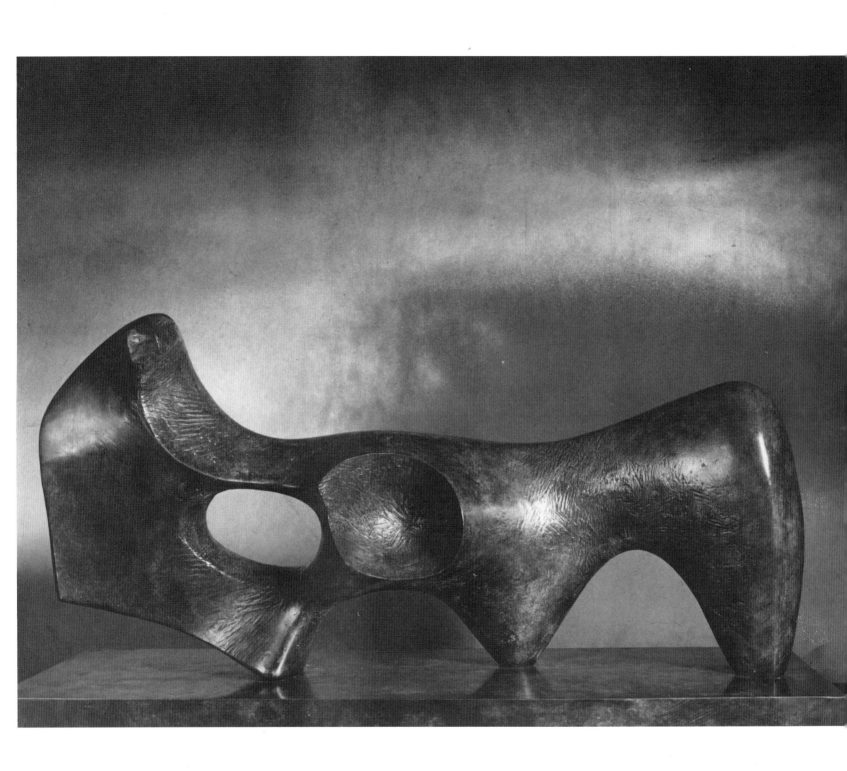

118 Another view of **Reclining Figure : Circle**

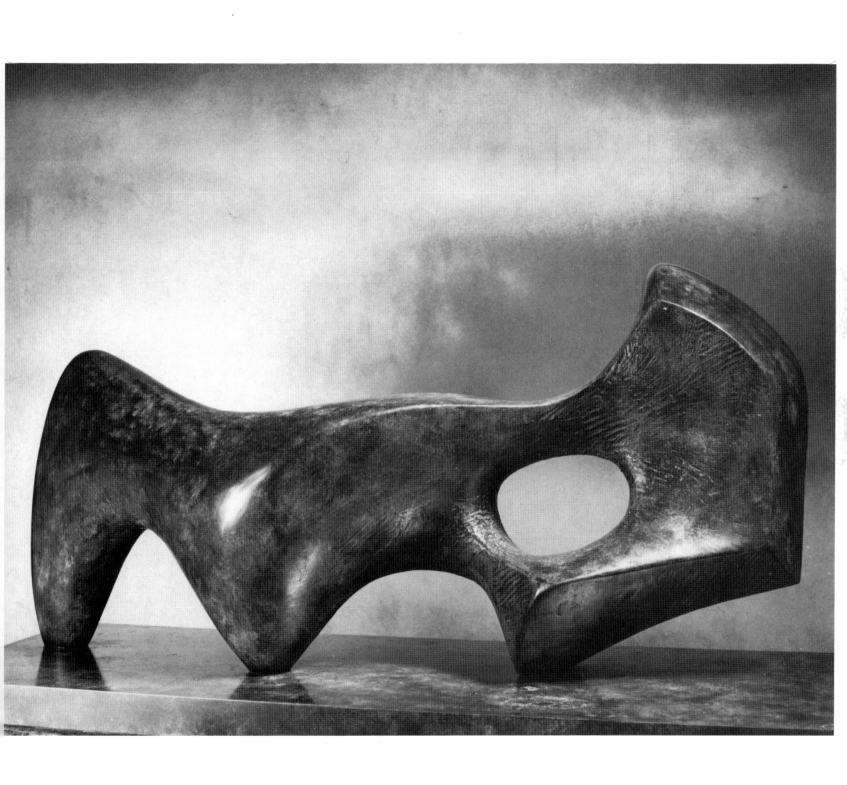

119 Another view of **Reclining Figure : Circle**

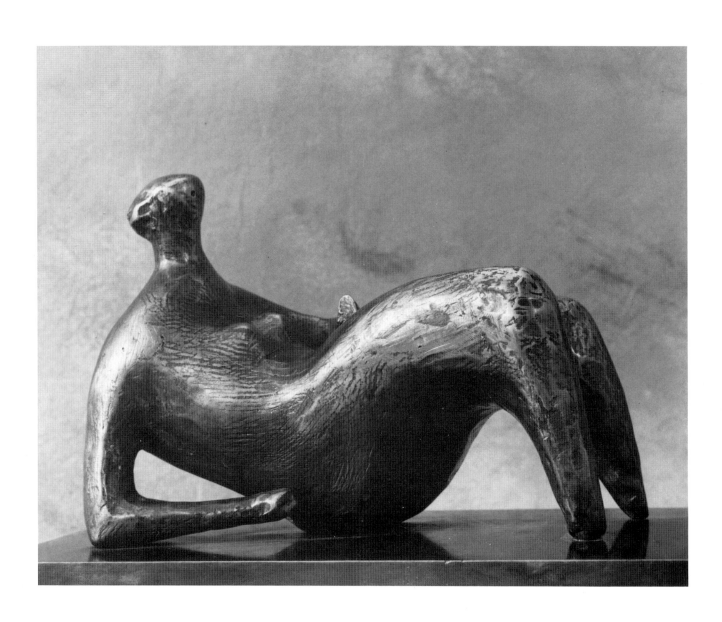

120 **Reclining Figure** (905) 7/18 L 1983

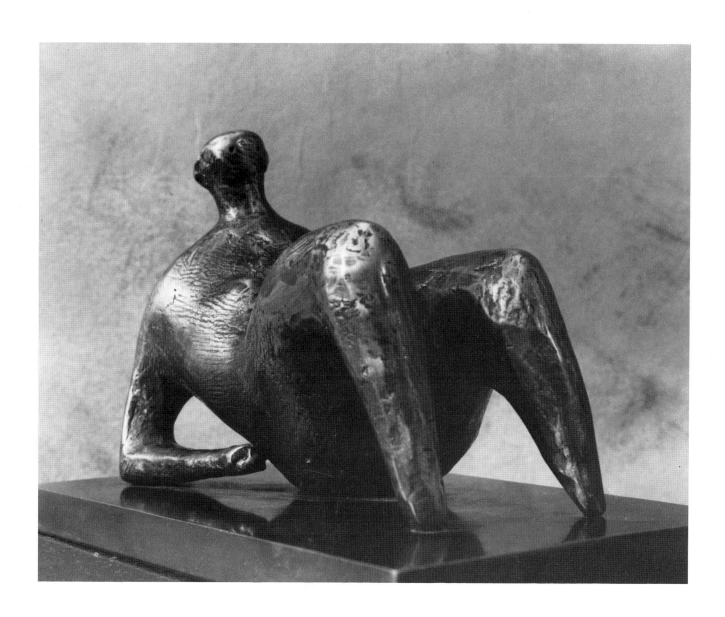

21 Another view of **Reclining Figure**

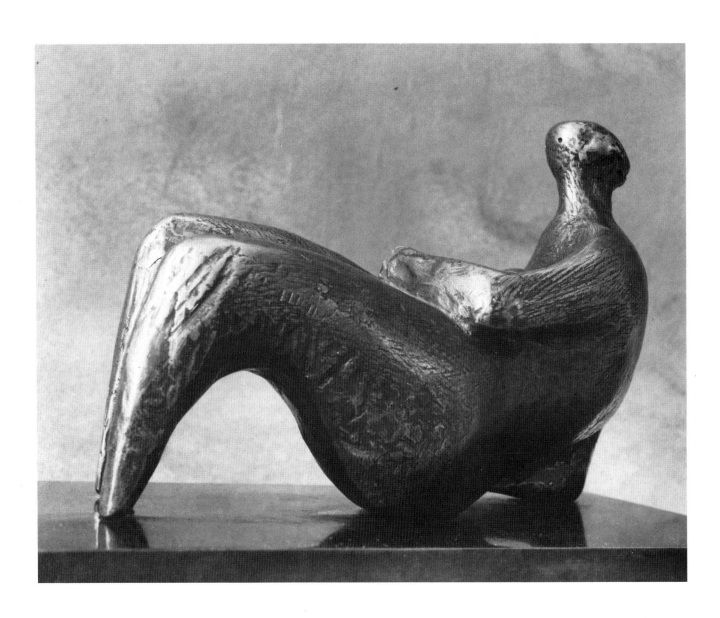

122 Another view of **Reclining Figure**

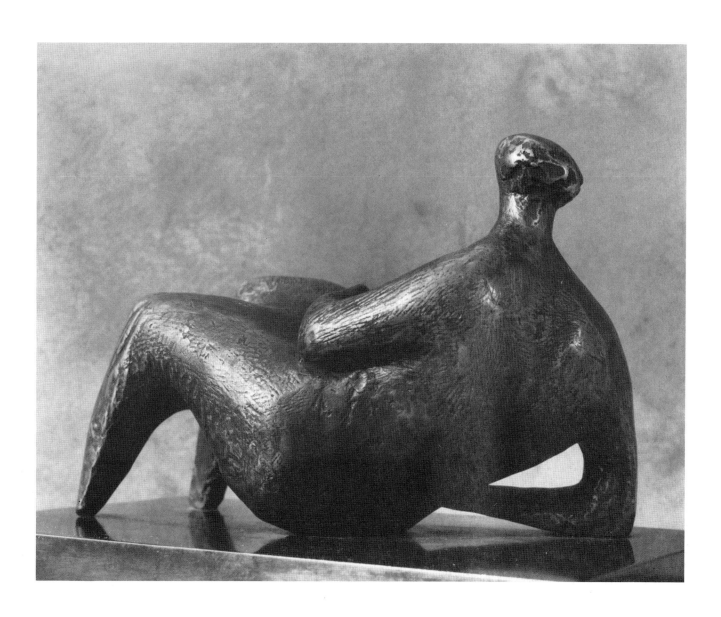

23 Another view of **Reclining Figure**

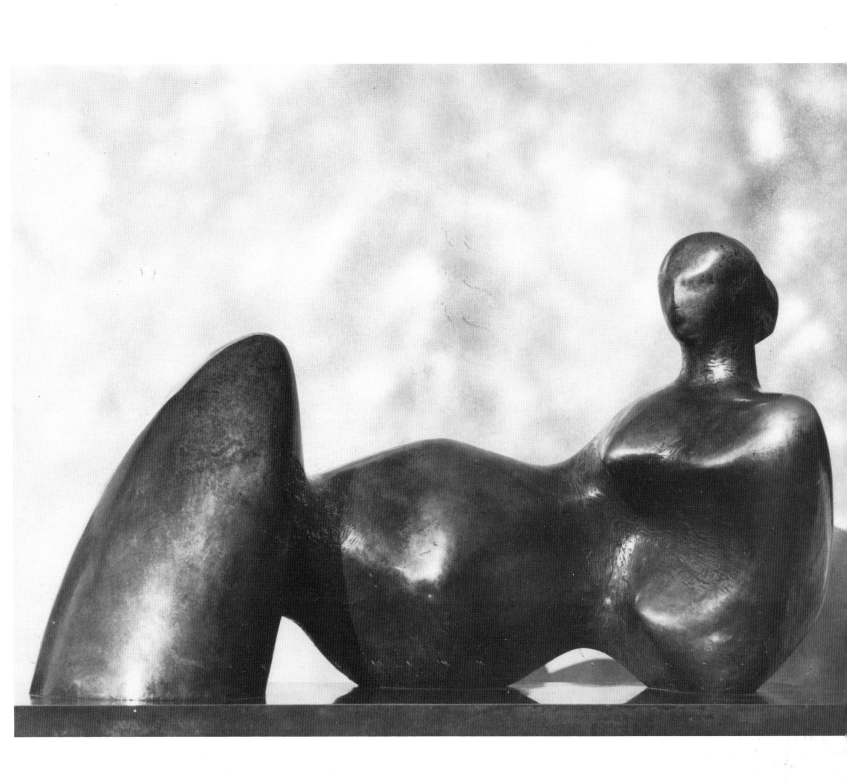

124 (above) **Reclining Figure: Umbilicus** (907) 37/94 L 1984

125 (opposite) Detail of **Reclining Figure: Umbilicus**

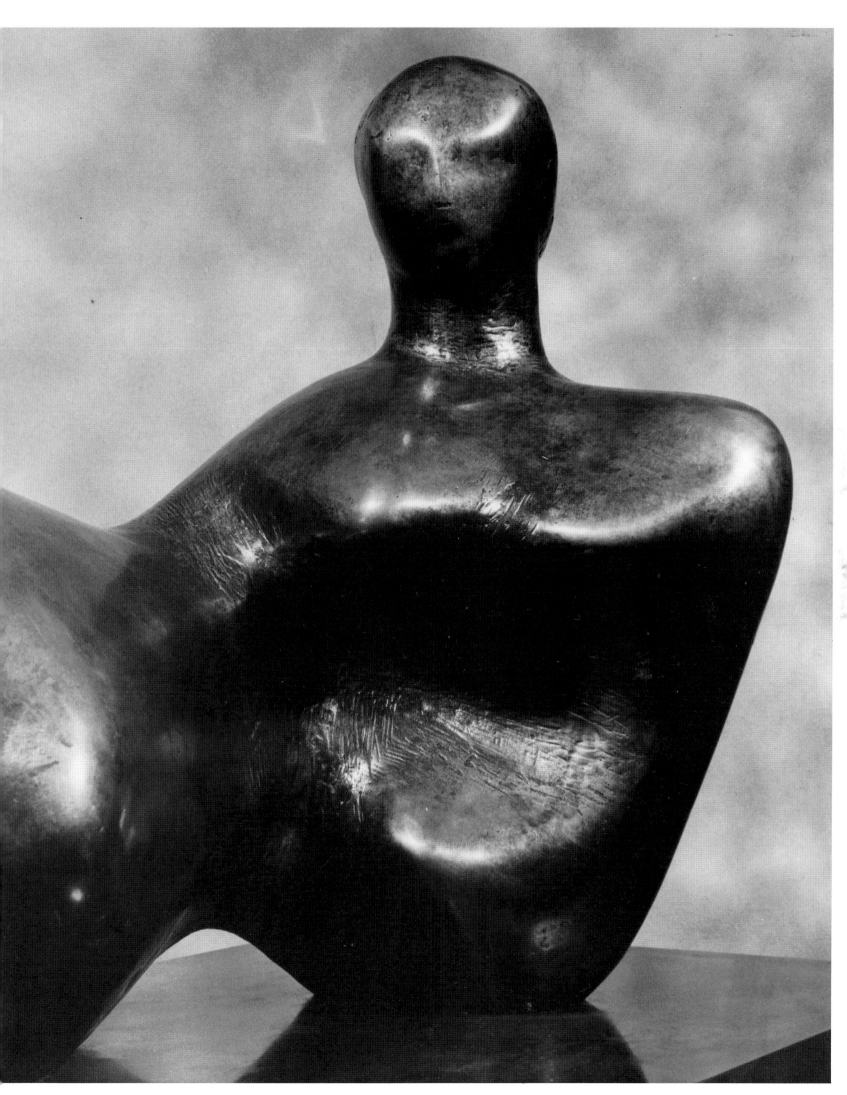

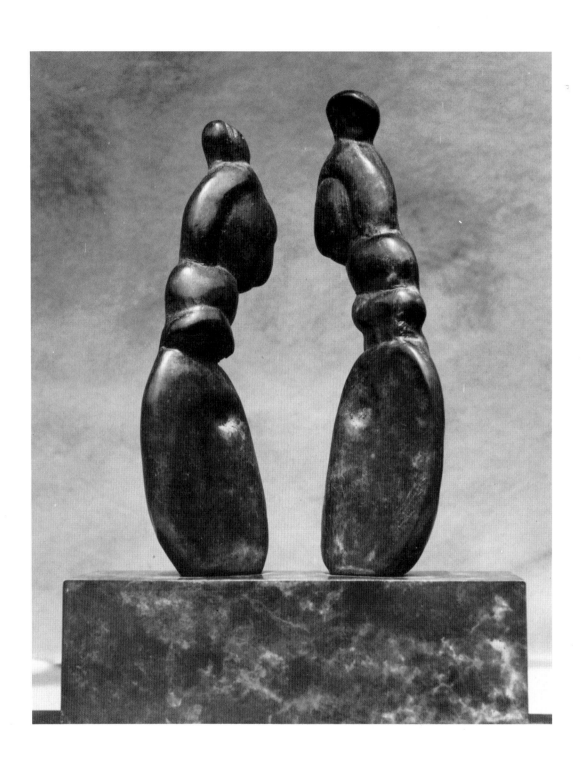

126 **Two Standing Figures: Concretions** (909) 8¼/21 H 1983

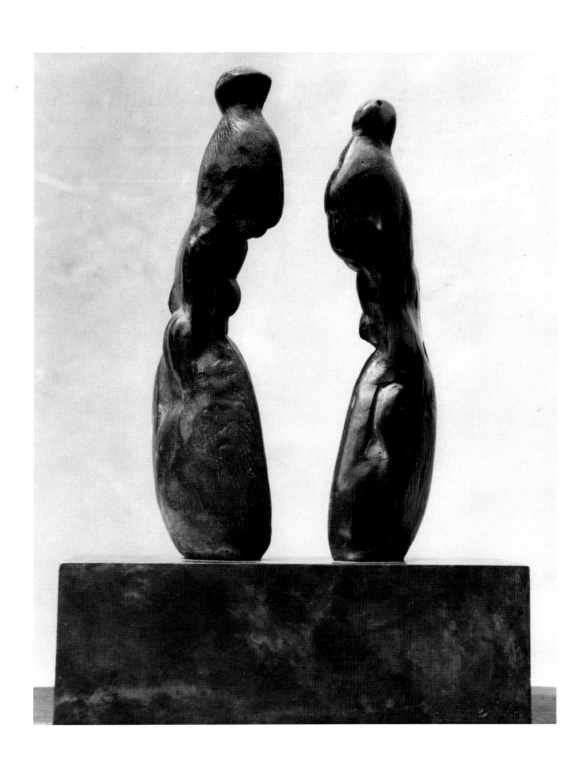

127 Another view of **Two Standing Figures: Concretions**

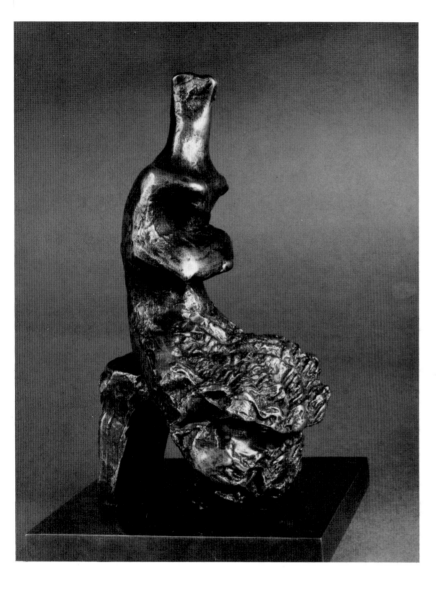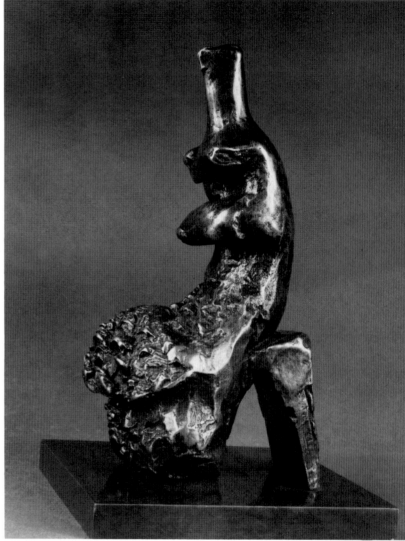

128 Two views of **Seated Woman : Shell Skirt** (911) 7/18 H cast 1984

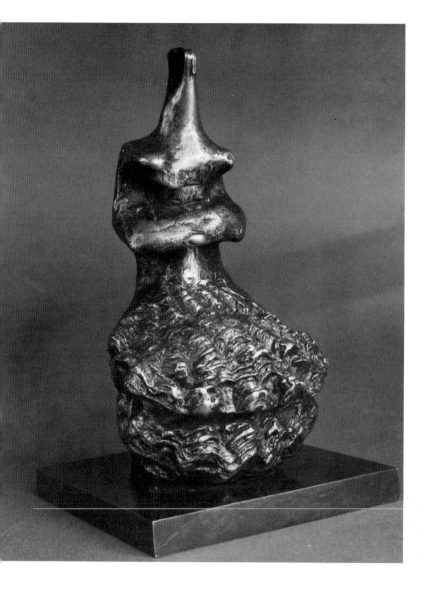 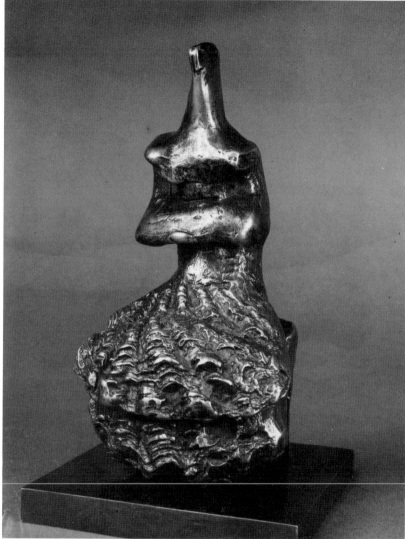

29 Two more views of **Seated Woman : Shell Skirt**

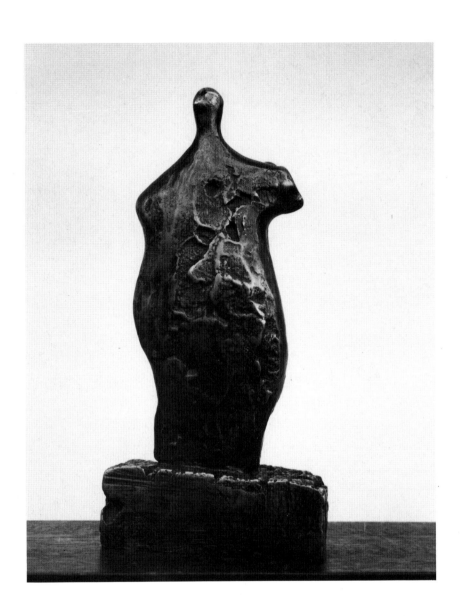

130 **Three-Quarter Figure: Hollow** (915) 6¾/17 H cast 1984

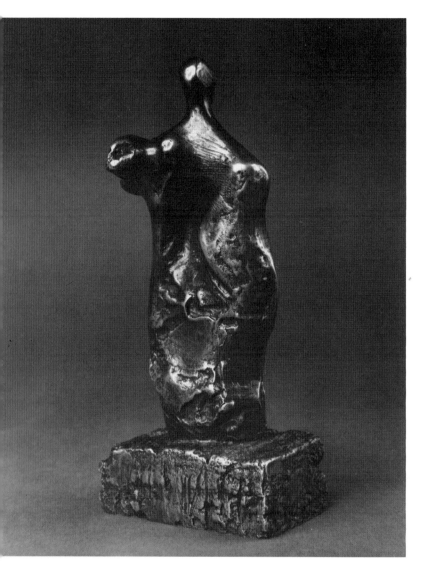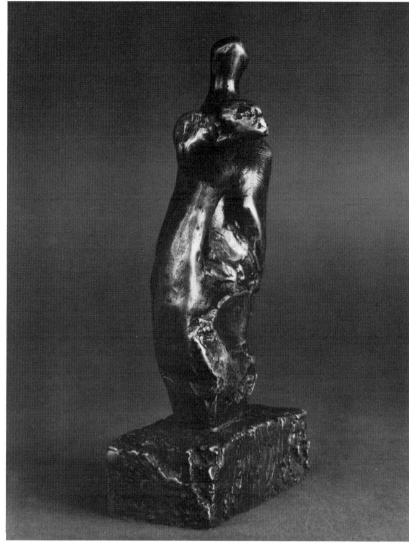

131 Two more views of **Three-Quarter Figure : Hollow**

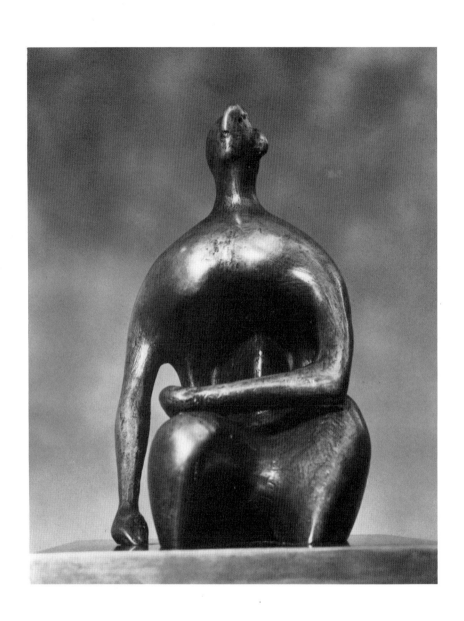

132 **Seated Figure : Thin Head** (917) 5¾/14·5 H cast 1984

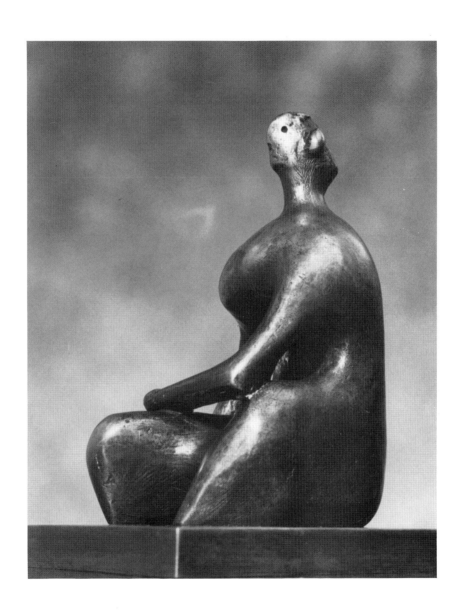

133 Another view of **Seated Figure: Thin Head**

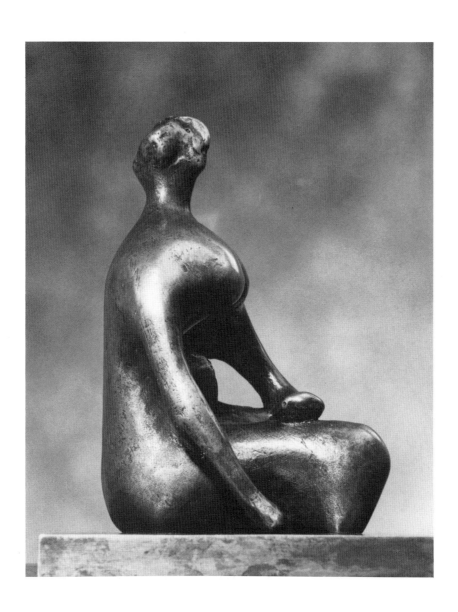

134 Another view of **Seated Figure : Thin Head**

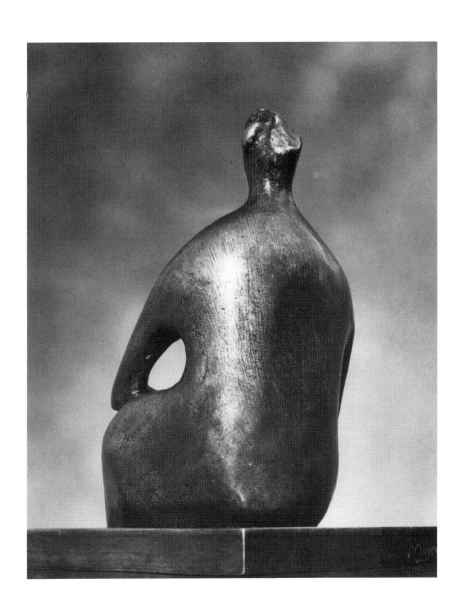

135 Another view of **Seated Figure: Thin Head**

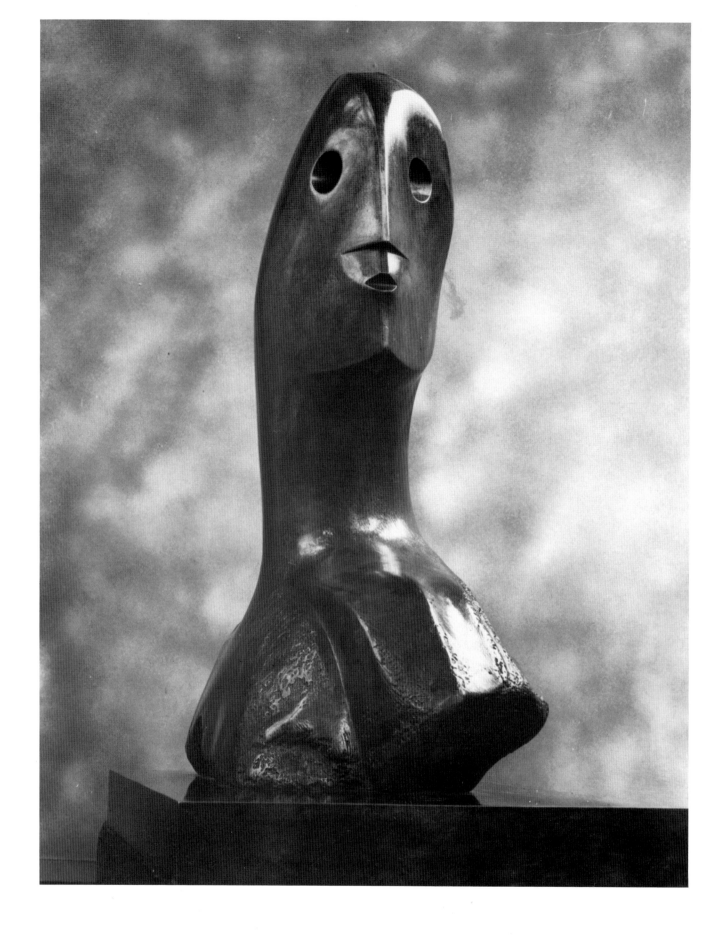

136 (above) **Head** (918) 24½/62 H 1984

137 (opposite) Another view of **Head**

On following pages:

138 and 139 Two more views of **Head**

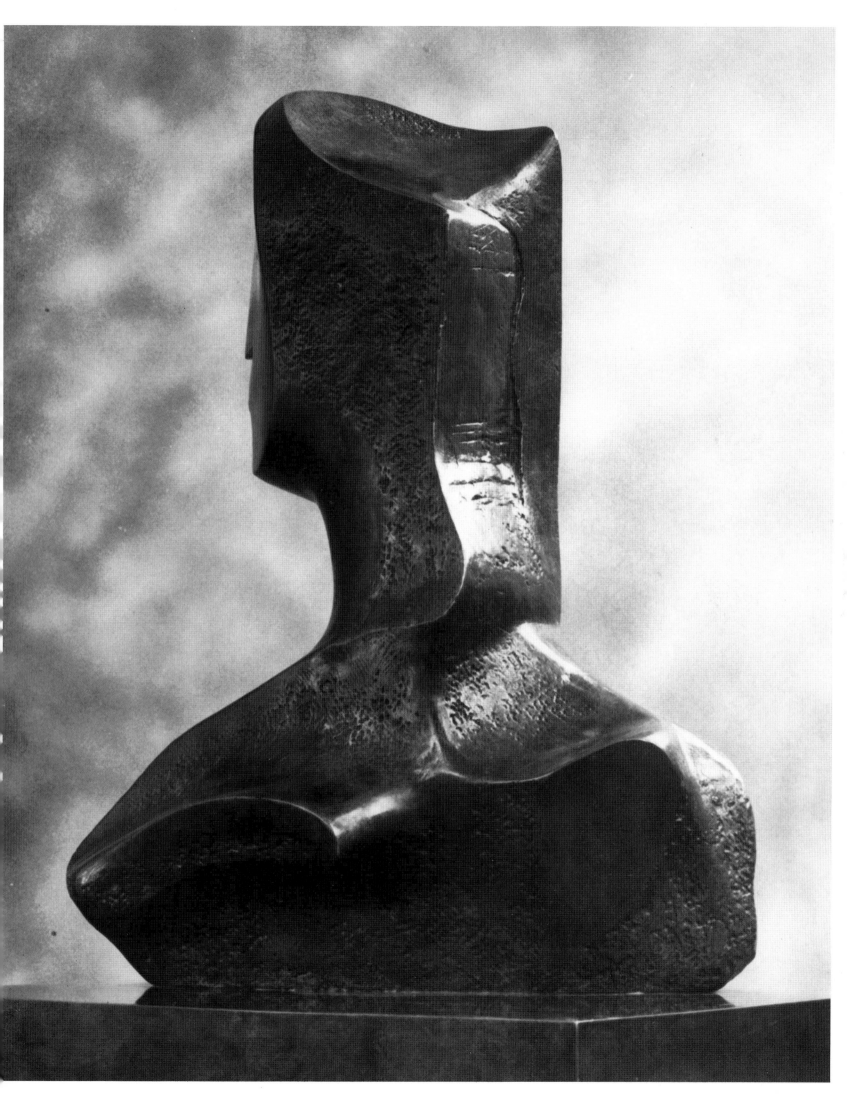

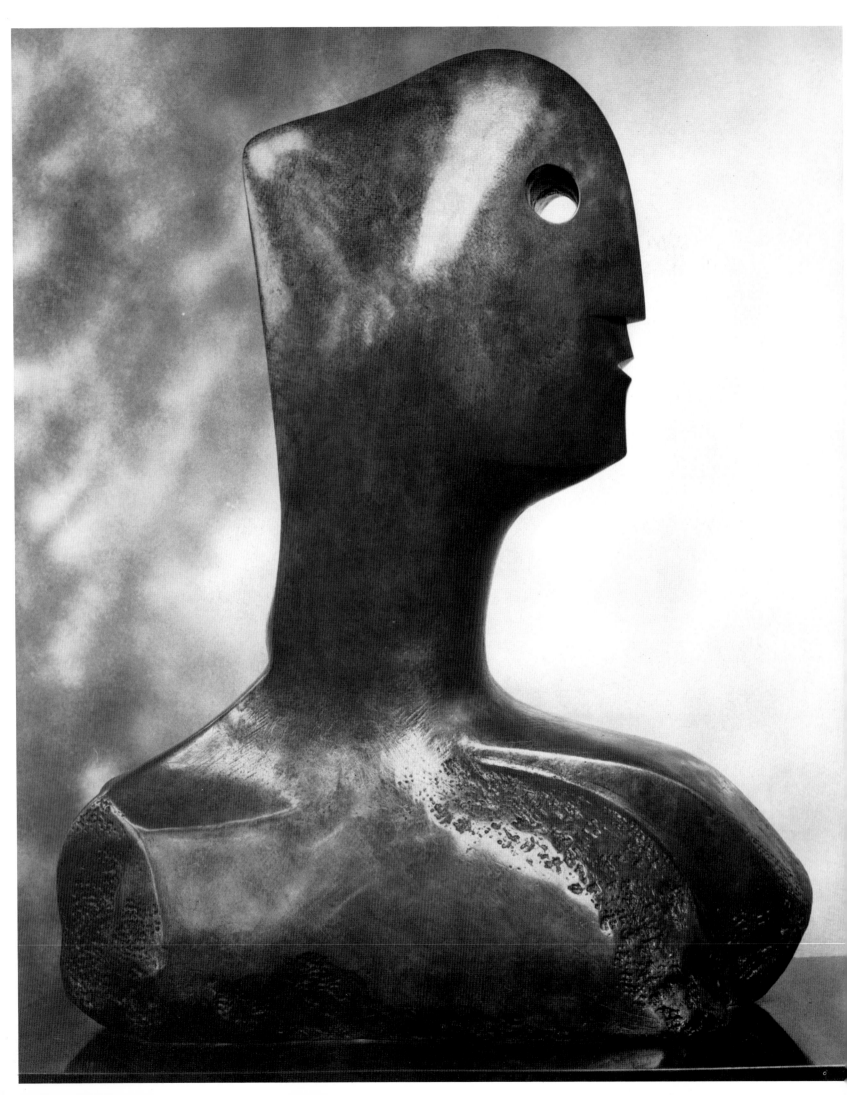

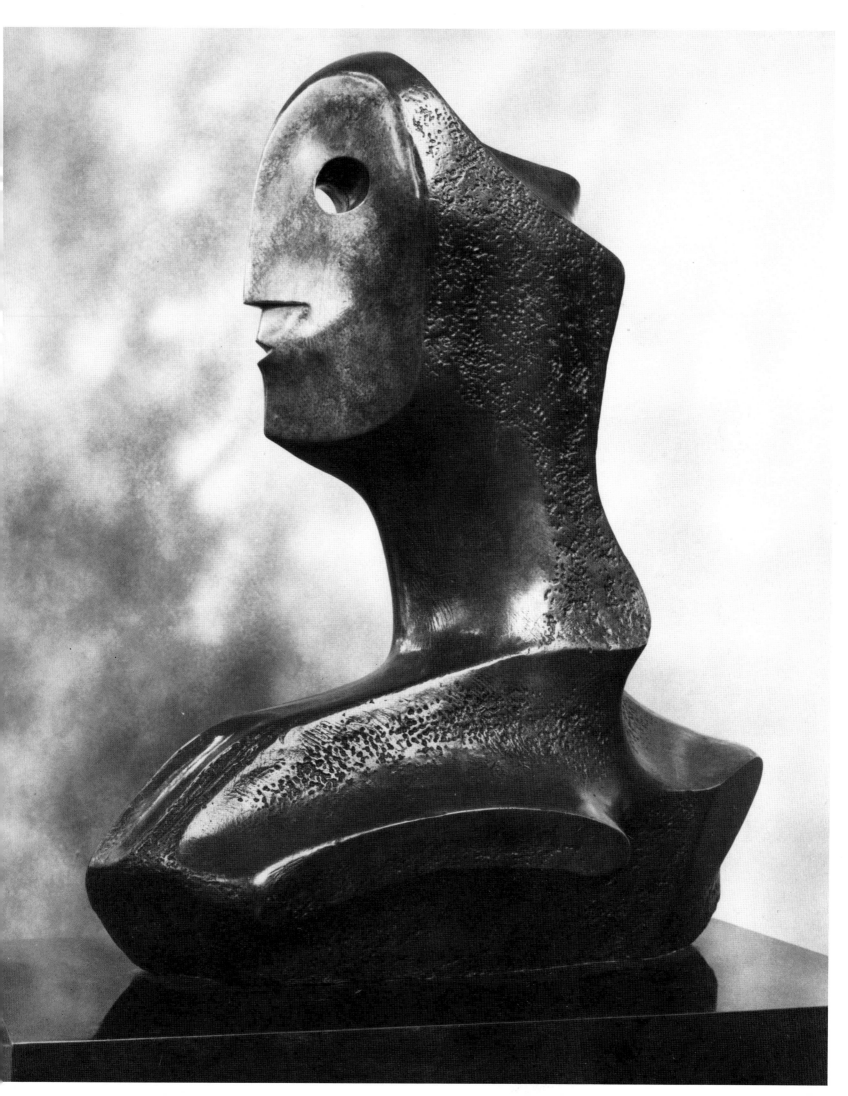